FOCUS & FILTER

FOCUS & FILTER

PROFESSIONAL TECHNIQUES FOR MASTERING DIGITAL PHOTOGRAPHY AND CAPTURING THE PERFECT SHOT

ANDREW DARLOW

Ulysses Press

To my wife Belinda and son Tyler—the two people I most enjoy having in front of my lens, and whom I feel blessed each day to have in my life.

Published in the United States by:
Ulysses Press
P.O. Box 3440
Berkeley, CA 94703
www.ulyssespress.com

ISBN13: 978-1-61243-613-5
Library of Congress Control Number: 2016934531

Printed in Korea by WE SP through Four Colour Print Group
10 9 8 7 6 5 4 3 2 1

Acquisitions editor: Keith Riegert
Project editor: Alice Riegert
Managing editor: Claire Chun
Editor: Renee Rutledge
Proofreader: Lauren Harrison
Front cover design: Ashley Prine
Interior design: Ashley Prine and Jake Flaherty
Layout: Jake Flaherty and Caety Klingman
Photographs: © Andrew Darlow except fig. 1.3 (page 7) © Milles Vector Studio/shutterstock.com; fig. 7.5 (page 30), fig. 23.1 (page 83), fig. 25.4 (page 95) © Denis McGrath; fig 7.7 (page 31), fig. 7.8 (page 31) © Belinda Darlow; fig. 8.1 (page 33), fig. 9.1 (page 38), fig. 28.1 (page 106), fig. 35.2 (page 133), fig. 40.6 (page 156) © Whitey Warner; fig. 42.12 (page 164) © Ron Wyatt

Distributed by Publishers Group West

Contents

Introduction

Welcome to the *Focus & Filter* virtual photo studio! I'm Andrew, and I'll be your guide as we navigate the world of digital photography. This book contains specific suggestions for taking photos, finding the right gear, and using traditional and nontraditional approaches to improving your photography.

This book is geared primarily toward intermediate to advanced photographers (amateurs and pros) who use cameras that have the ability to manually set the exposure, aperture, ISO and similar functions. Those cameras generally fall into these categories: digital single-lens reflex cameras (DSLRs), mirrorless interchangeable lens cameras (MILCs), digital rangefinder cameras, and advanced, compact fixed-lens cameras. You can use this guide as a reference before going on a trip or on an assignment. That assignment might come from a Fortune 500 company, a local hair salon or your significant other who has been asking you for weeks to create a family portrait. This book was not tailored for those who want to use the "P" or program mode, or "scene modes" on their cameras (usually indicated by cute little icons like flowers and fireworks). While those may be useful in some situations, I'm here to help you truly take control of your equipment and create images worthy of your passion and creativity.

I've been fortunate to make photography my profession since the early '90s, and witnessed the evolution of digital photography from its infancy. My clients (either through my own company or as the head photographer for another company) have included Brooks Brothers, The Body Shop, Kenneth Cole, Swatch International, Victorinox and many families who have asked me to help them preserve special memories in their lives.

My editorial work and photo tips have been internationally published in magazines and newspapers, and I've written three other books on photography topics. For more than 20 years I've been teaching others how to improve, edit and print their photographs, and with this book I've decided to pull back the curtain and share many of the secrets I've been using to help me get my work done efficiently and at a high-quality level.

Focus & Filter is broken down into 50 how-tos, with four main sections: Master Your DSLR, Shopping Smart, Studio Mastery and Shooting in the Field. There's no need to follow all of the tips in order, but the first 19 tips are designed to be read in order. You'll also find some overlap, such as Tip 7 (page 27), which covers how to carry equipment much easier; it also includes techniques and products that I use and/or recommend. After each tip, I invite you to delve deeper by giving you a "Pro Assignment" to help you expand upon what you've just learned. For more resources visit www .focusandfilter.com.

And with that, I look forward to spending some quality time with you behind the camera!

All the best,
Andrew

Master Your DSLR
Specific Techniques for Getting the Most from Your Camera

Photography is truly magical. And I'm certainly not alone in thinking so. Millions of people around the world take photographs with a wide range of cameras, from cell phones to large-view cameras. In this section, I will present specific tips and techniques for understanding and using many of the creative tools that can be found on all DSLR and mirrorless cameras, as well as many advanced compact cameras.

DIGITAL CAMERA TYPES

Digital cameras are sold in four main configurations: digital single-lens reflex cameras (DSLRs), mirrorless interchangeable lens cameras (MILCs), compact fixed-lens mirrorless cameras and digital rangefinder cameras. Digital rangefinder cameras are also mirrorless, but have some distinct differences.

The main difference between DSLRs and the three mirrorless camera types mentioned is that every DSLR contains an optical viewfinder that works in tandem with a mirror that's positioned at an angle inside the camera and behind the lens. This allows you to see through the lens while

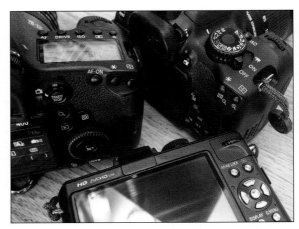

Fig. 0.1 A Canon EOS 6D (left), Canon Rebel T4i (right) and a Panasonic Lumix DMC-LX5 (bottom).

focusing and composing photographs. During an exposure, the mirror flips up and out of the way. There is also often a button you can press to see a depth-of-field preview, which gives you a preview of the sharpness in different parts of the scene.

In the three mirrorless cameras types, there is, as you may have guessed, no mirror. Instead, in almost all cases, a video image created by the image on the camera's sensor is sent in near real-time to an electronic viewfinder (EVF) located in the back top area of the camera, which allows the viewer to see an image prior to the shot being taken that approximates the final image (assuming no flash, or strobe, is being used).

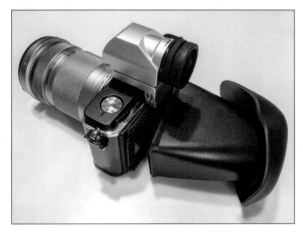

Fig. 0.2 An Olympus PEN E-P2 with an Olympus Electronic Viewfinder VF-2 and an LCD Loupe.

A fixed-lens camera means that you cannot change the camera's lens, but you can often add screw-on accessories such as close-up lenses or telephoto lenses. Some mirrorless cameras have no viewfinder at all, like the Panasonic Lumix DMC-LX5 (fig. 0.1); you just rely on the camera's LCD screen, much like you would with a smartphone. Some mirrorless cameras, like the Olympus PEN E-P2, shown in fig. 0.2 with an Olympus Electronic Viewfinder VF-2, offer

FLASH OPTIONS—Electronic flash is truly an incredible invention, and many cameras have built-in flash units. They do have some limitations, but with a bit of practice, you might be surprised at how they can affect the quality of your photographs. I cover this topic in Tip 33 and Tip 34.

optional viewfinders. One negative with that option is that the camera's hot shoe (the slot on top of many cameras usually reserved for shoe-mount flash units) will generally be used for that, making it impossible to use a shoe-mount flash at the same time in that location.

Digital rangefinder cameras differ from DSLRs primarily due to the way you compose and focus the scene. You view the scene through an optical viewfinder and line up two images until they overlap. There are some advantages and disadvantages to digital rangefinders. The greatest advantage is that their lenses (especially wide to medium focal length lenses) tend to be smaller and lighter than DSLR lenses (especially full-frame lenses).

The main negative with digital rangefinders is that the image you see in the optical viewfinder is almost never the same (as far as the coverage of the scene, or field of view) as compared with a DSLR or mirrorless camera with an EVF or live view capability. In fact, the image's field of view can be extremely off with very wide lenses and telephoto lenses.

In some cases, digital rangefinder cameras can use live view as described above via the LCD or an accessory EVF. Pictured in fig. 0.3, Leica M is an example of a digital rangefinder camera that has live view functionality via the LCD or with an accessory EVF. You can find additional details on rangefinders and specific digital rangefinder cameras, at www.camera-wiki.org,

"The Leica Mystique" article at www.blogarithms.com/2013/10/01/leica and www.thisweekinphoto.com/category/gear-episodes.

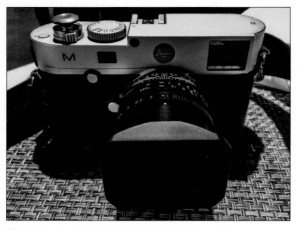

Fig. 0.3 Leica M is an example of a digital rangefinder.

A number of companies offer external EVFs and small monitors for DSLRs. These are especially popular with videographers, but they can be very useful for still photography (especially when bright sun makes it difficult to see your images on the LCD). Some DSLRs and compact mirrorless cameras also have touch-screen controls, which can be useful for changing camera settings, and especially for video (you can just touch the spot you want to focus on, as long as your camera/lens combination supports the ability to adjust focus in that manner). Touch-screen controls also usually allow image pinch, zoom and swipe for photo review, like on smartphones.

There is a lot of additional information available online that explains different digital camera types. Wikipedia.org is one good source and kenrockwell.com is another excellent option. A Google search for "digital camera types" will bring up these and other resources.

PRIMARY CAMERA MODES

Before I go into the main features for controlling exposure with the above camera types in the first few tips, picture yourself outside on a sunny day with a DSLR or mirrorless camera. Depending on the combination of aperture, shutter speed and ISO settings you use, you can create a photo that is completely white (overexposed), very dark (underexposed) or properly exposed (the image looks similar to the way your eyes perceive the scene). And even when your photo is properly exposed, there are many combinations of aperture, shutter speed and ISO that can create that image. It's a bit like adding three numbers to get to 10. There are many different possible combinations to get to 10. In addition to DSLRs and mirrorless cameras, many other cameras today have advanced features, including Aperture Priority, Shutter Priority, Manual mode and/or Auto ISO. Tip 1 to Tip 4 tackle all of these features, with some assignments that should help you to start making photos instead of just taking them. You will also find suggestions to use one or more

REFLECTIVE LIGHT METERS AND GRAY T-SHIRTS

Virtually all modern digital cameras have a reflective light meter inside. All reflective light meters measure the light reflecting off the subjects in the scene, and they basically see the world as being covered with a big medium-gray T-shirt as a baseline with which to work. Once you know that, you can make appropriate adjustments in the exposure based on what's really in front of you. If you've ever seen or used an incident light meter (they are common on Hollywood sets and fashion shoots), it works by measuring the actual light falling on it in the exact place where it is held, so it does not see the world as wearing a big gray T-shirt.

of these modes throughout the book depending on the topic I'm covering.

These modes can either be found on a camera dial (on larger, more advanced cameras) or via an internal menu (many smaller cameras).

APERTURE PRIORITY MODE—Discussed in Tip 1 (page 6) and Tip 2 (page 10), this setting allows you to select a specific aperture and the camera automatically adjusts the shutter speed (and sometimes the ISO, if your camera has an Auto ISO option, which I cover in Tip 4, page 16).

SHUTTER PRIORITY MODE—Discussed in Tip 3 (page 13), Shutter Priority is a feature that allows you to choose a specific shutter speed. The camera's aperture is then set for you automatically based on what the camera meter thinks is the proper exposure.

MANUAL MODE—This mode, discussed in Tip 4 (page 16), allows you to set the aperture, shutter speed, ISO and other settings manually.

MASTERING APERTURE PRIORITY

Knowing how to control your aperture (f-stop) instead of just letting your camera do it for you on an automatic setting is one of the most important things you can do to better control the way your photos look. This is done primarily through a setting called Aperture Priority mode. A lens's aperture is the opening in its center, usually created by a series of metal blades that overlap to create a circular shape when taking a photo. The smaller the opening, the higher the f-stop (commonly called the "f-number"). For example, f/16 and f/22 would be considered smaller apertures, and f/1.8 and f/2.8 would be considered larger apertures. Smaller apertures (higher f/stops) allow for more depth of field in your images compared with larger apertures (smaller f-stops).

APERTURE PRIORITY MODE AND DEPTH OF FIELD

There are two main reasons to use Aperture Priority mode. One is to control depth of field (the area that's in acceptable focus, or sharp enough for your needs), and the other is to control how much light comes into the camera (both always happen together). On a given lens, lower f-stops like f/2.8 and f/4 let more light in than f/8 and f/16, as illustrated in fig. 1.1 and fig. 1.2. Much more light was needed (keeping all other things constant) for the f/16 exposure with which fig. 1.2 was shot than for the f/4.5 exposure with which fig. 1.1 was shot. About four times more light, or more accurately, four more exposure value (EV) levels were needed to expose both photos in a

Fig. 1.1 Camera: Canon EOS Rebel T4i; Lens: EF 70-300mm f/4-5.6 IS @ 95mm; F-stop: f/4.5; Exposure: 1/200 Sec.; ISO: 400

Fig. 1.2 Camera: Canon EOS Rebel T4i; Lens: EF 70-300mm f/4-5.6 IS @ 95mm; F-stop: f/16; Exposure: 1/15 Sec.; ISO: 400

I photographed both of these images just a few seconds apart using Aperture Priority mode. Fig. 1.1 was shot at f/4.5 and Fig. 1.2 was shot at f/16. The look of both images is also very different due to the shallower depth of field in the f/4.5 image.

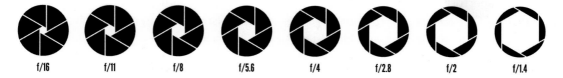

f/16 f/11 f/8 f/5.6 f/4 f/2.8 f/2 f/1.4

Fig. 1.3 Aperture scale.

very similar way. EV represents a one-stop move, like f/2.8 to f/4. As the f-stop number increases by one full step, half the amount of light is allowed into the lens. For example, a setting of f/4 will allow half as much light in as f/2.8 (see the scale in fig. 1.3).

Lenses with a wide maximum aperture (for example, 300mm f/2.8 lenses) are called fast lenses and tend to be larger and more expensive than slower lenses with similar magnification that might have a maximum aperture of about f/5.6. In many cases, zoom lenses, like an 18–135mm f/4–f/5.6 lens, have a relatively wide maximum aperture at wider focal lengths (in this example, f/4 at 18mm), but the maximum aperture changes automatically (in this example, f/5.6) as you reach the lens's highest magnification level.

SETTING YOUR APERTURE—To allow in the greatest amount of light that your lens will allow, set Aperture Priority to the lowest f-stop possible (for example, f/2.8 or f/4), which will force your camera to use higher shutter speeds compared with when you set Aperture Priority to higher f-stops. The lower f-stops are especially useful when photographing sports, birds and wildlife, since the subjects tend to move a lot and they require faster shutter speeds (see Tip 3).

DEPTH OF FIELD—The real magic of photography happens when you take control of the depth of field in your images. If you look at most photos of major league baseball players (for example, batters or pitchers), you will usually see that the batter and pitcher are sharp, but the background behind them will be very out of focus. That is shallow depth of field at work. The photographer probably used lower f-stops like f/2.8 or f/4 combined with a long lens, like a 300 or even 600mm lens. This look can be truly fantastic, and the appearance of the out-of-focus areas that a lens produces is often called the lens's "bokeh," which comes from the Japanese term for blur. (An example of bokeh is seen in Fig. 1.4 where I used a lens that was made circa 1970 by using a special adapter—I love the bokeh the lens produces.)

Fig. 1.4 Camera: Canon EOS 6D; Lens: Asahi/Pentax 50mm f/1.4 Super Takumar @ 50mm; F-stop: f/1.4; Exposure: 1/800 Sec.; ISO: 1000

The difference in the depth of field between fig. 1.5 and fig. 1.6 is very dramatic and is due to the

difference in aperture, as well as the large distance between the flowers and the buildings. If the flowers were in a window very close to a building, there would not be as much of a visual difference (not as much background blur) using the same settings.

To create photos with more depth of field (more sharpness across the image), use higher f-stops like f/8, f/16, etc. One good example of when to use higher f-stops to increase depth of field is when photographing groups of people standing or sitting in rows (like at a theater). More depth of field is also commonly desired when photographing landscapes.

That being said, it's important to note that as you reach your camera's maximum f-stop, your images will generally get less sharp, even though the depth of field will be increasing. That f-stop is usually f/16, f/22 or f/32, depending on the removable lens or built-in lens (if you have a camera with a built-in lens). That's due to something called diffraction, and to delve into some of the

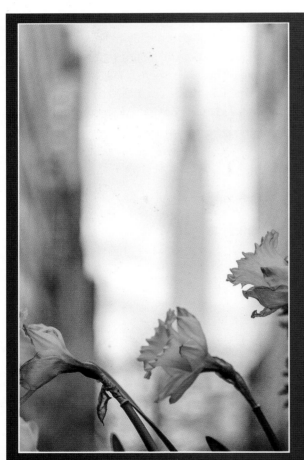

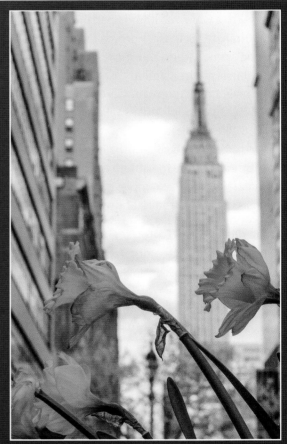

Fig. 1.5 Camera: Canon EOS D60; Lens: Canon Macro EF 50mm f/2.5; F-stop: f/2.8; Exposure: 1/4000 Sec.; ISO: 400

Fig. 1.6 Camera: Canon EOS D60; Lens: Canon Macro EF 50mm f/2.5; F-stop: f/13; Exposure: 1/350 Sec.; ISO: 400

These images were photographed just a few seconds apart using Aperture Priority mode. The left one was shot at f/2.8 and the right one at f/13. Shutter speeds were 1/4000 second and 1/350 second respectively.

science behind it, I highly recommend an article on the topic over at www.cambridgeincolour.com (just search for the word "diffraction").

To summarize this important topic, the range of items that will look in and out of focus from front to back is highly dependent on the f-stop you use, what lens you are using, how close you are to the subject(s), how much distance there is between the subjects from front to back and the size of your camera's digital sensor. The best way to see this in action is to get out and make some photos for yourself, and the Pro Assignment that follows will help you to do just that.

TIP 2

MASTERING HYPERFOCAL DISTANCE WITH APERTURE PRIORITY

In Tip 1, depth of field was covered with relation to f-stops and Aperture Priority mode. You might think that just focusing on the closest object in a photo is the best way to optimize overall sharpness. However, understanding and using hyperfocal distance techniques can help you create images with greater depth of field.

HYPERFOCAL DISTANCE—This term refers to a specific focus distance between a camera and infinity (as far as the eye can see). When you set your focus at the hyperfocal distance, anything from one half the distance between the hyperfocal distance and your camera sensor all the way to infinity, should be acceptably sharp.

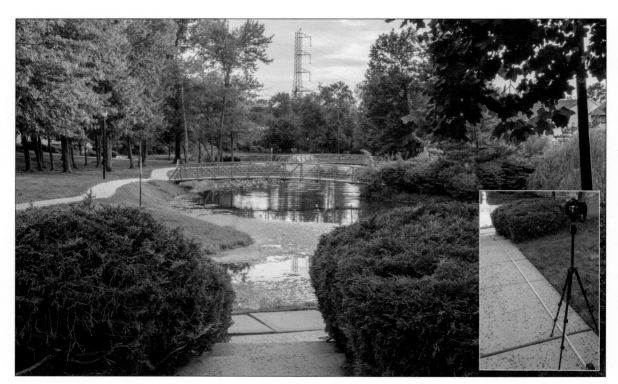

Fig. 2.1 I settled on this exposure, made at f/11, because it was a bit sharper at infinity compared with the f/8 exposures. I recommend starting at f/8 and also taking some photos at f/11 and f/16 when doing a photo session like this.

Camera: Canon EOS 6D; Lens: EF 28-135mm f/3.5-5.6 IS @ 47mm; F-stop: f/11; Exposure: 1/60 Sec.; ISO: 1600

Fig. 2.2 (inset) Notice the tape measure, which I used to make exact measurements in this outdoor scene.

When you know how to find the hyperfocal distance, you can then use that information to set your focal point and optimize the amount of sharpness in your images (if that's the look you are after). Let's say the hyperfocal distance for your camera, lens and aperture is 50 feet in front of the camera. You would then want to set your camera's focus to 50 feet to achieve acceptable sharpness from at least 25 feet in front of your camera to infinity.

For fig. 2.1, I photographed a landscape with some bushes in the foreground (about 15 feet away) and a lake in the background, using a 28–135mm zoom lens on a full-frame Canon DSLR set to 50mm. Aperture Priority mode is ideal to determine the hyperfocal distance because aperture is a critical piece of the puzzle when you plug in the data into your computer or app. You can also bracket by choosing multiple apertures without moving the lens's focal point, which will give you a range of depth of field from foreground to infinity (it's a good idea to take at least two exposures at each aperture you choose just in case there was camera movement). And don't forget: with most digital cameras, you can check the image sharpness using a magnified view in the EVF or on the LCD before and after you take the photo.

SETTING YOUR HYPERFOCAL DISTANCE—Some lenses have a built-in depth-of-field scale, but most modern lenses don't have this. You can start by first looking up the hyperfocal distance online or via a great smartphone app called Photographer's Tools Pro (see fig. 2.3). When I did this, I found that at f/8, my hyperfocal distance was 34.3 feet, which is just about where the white line is placed in fig. 2.4 (just between 15 and 50 feet), and the near limit of sharpness (the line at which I would still have acceptable sharpness) was then half that distance, or 17.2 feet. By changing the f-stop

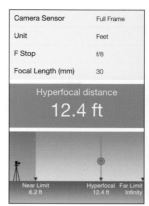

Fig. 2.3 A screen shot of the Photographer's Tools Pro app (available on iOS and Android).

Fig. 2.4 My lens has a built-in distance scale, which helps to set the focus point.

to f/11, my hyperfocal distance became 24.3 feet, and the near limit of sharpness was then half that distance, or 12.2 feet. Just keep in mind that the distance indicated is from the camera sensor's plane (near the back of a camera, where film would be if you were shooting with film).

At f/11, my hyperfocal distance was 24.3. That means that by setting my camera's aperture to f/11 and focusing on an object (or just the air) about 12 feet in front of my camera, I could get all of the bushes in focus since they are 15 feet away, as well as everything in the scene as far as the eye can see. Please note that your exact camera model may not appear on the list that's provided online or in the app. As long as you know a camera that's comparable to yours (based on the sensor size), just set it to that camera. In my case, I chose "Full Frame" for use with my Canon EOS 6D since both are full-frame 35mm DSLRs.

There are some excellent tips for determining hyperfocal distance and using hyperfocal distance effectively at www.dofmaster.com/hyperfocal.html. It's not easy at first to know exactly how far 50 feet is in front of you, but there are some tips on that page that can help. If

you are more concerned with what's very close to your camera, you can just focus on that and the background will generally go out of focus.

HOW TO SET YOUR FOCUS DISTANCE—One easy way to set the focus distance is to use the distance scale on your lenses if they have them. They are sometime printed on the focusing barrel or visible through a window on some lenses. However, that still doesn't tell you how far away specific objects are from your camera. For more accurate distance calculations (especially indoors and in darker environments), you can use a tape measure (as in fig. 2.2), or the same wireless laser distance meters used by homeowners and contractors, such as the Bosch GLM 40 (about $80).

For those who want a laser meter with a scope that allows you to determine distance through a viewfinder (very helpful in daylight), you may be able to find a used Hilti PD32, PD40 or PD42 online (they can measure down to under a few inches), though prices will range from about $200–$700. Another option that has a scope

Crop-sensor cameras are smaller than a traditional 35mm frame. Full-frame DSLRs have sensors about the same size of 35mm film. See Choose a Lens and Consider Crop Factor on page 20 for more on crop factor.

for working in daylight would be to purchase a rangefinder made for archers or golfers, such as a Nikon Aculon or Nikon Coolshot Laser Rangefinder (about $170–$225). Those products and others like it can determine distances from about 5–100 yards. As with many products like these, definitely test them first before purchasing, or buy from a company that allows returns for any reason without a restocking fee.

PRO ASSIGNMENT
USING HYPERFOCAL DISTANCE TO INCREASE DEPTH OF FIELD

1. Place your camera on a tripod, set it to Aperture Priority mode, and start with a wide lens (about 24–50mm in 35mm terms) set to any focal length that the lens allows, such as 50mm. Then set the aperture to f/5.6 and your ISO to a standard everyday shooting value, which will probably be ISO 200–800, depending on your camera, lens and the type of photos you generally like to take.

2. Frame a scene with an interesting object that won't move about 12 feet from the camera (a bicycle, child's toy, etc.), with a background that continues for a long distance. At least one object that won't move, such as a home or office building, should be in the background.

3. Use the DOFMaster website or a smartphone app and follow the instructions above for determining the hyperfocal distance. Focus to a distance roughly half the hyperfocal distance.

4. Take at least 10 photos at those settings using a wired or wireless shutter release for optimum sharpness (covered in Tip 24 on page 86).

5. Experiment using a longer focal length (100–300mm in 35mm terms) to see how the hyperfocal distance changes with different types of lenses. If you have a few different cameras with different sensor sizes (like a full-frame and crop-sensor Nikon DSLR), repeat the process to see what happens to the hyperfocal distance.

MASTERING SHUTTER PRIORITY MODE

Shutter Priority mode is a powerful feature available on many cameras. This mode allows you to set a specific shutter speed, and your camera will then set what it thinks is an ideal aperture based on its internal meter. Shutter speed is measured in fractions of a second. A fast shutter speed like 1/4000 or 1/2000 second allows you to freeze almost any motion, but fast exposures also require a lot of light, which you'll need to get from a combination of your shutter speed, aperture and ISO (if you are not using a flash). If you set your exposure too fast when using Shutter Priority mode, you may not be able to let enough light in to produce an acceptable exposure.

On the other end of the scale would be exposures of 1/2 or 1 second, which are slow shutter speeds. Slow shutter speeds let in a lot more light, so you can generally use lower ISOs (50, 100, etc.) and higher f-stops (f/11, f/16, etc.) under typical daytime lighting conditions. If you set your exposures slower than about 1/60 second (especially if you are using a medium- to large-size lens that's prone to shake), your subjects may be blurred, even if you are focusing perfectly on them.

Shutter Priority is most effective when you know what target shutter speed you want, such as when photographing birds in flight (about 1/500 to 1/2000 second), sports (about 1/250–1/2000

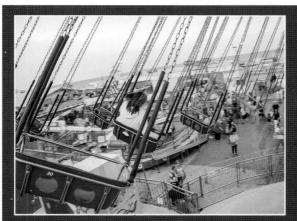

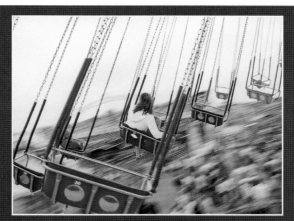

Fig. 3.1 Camera: Canon EOS Rebel T4i; Lens: EF-S 18-135mm f/3.5-5.6 IS STM @ 18mm; F-stop: f/5; Exposure: 1/125 Sec.; ISO: 400

Fig. 3.2 Camera: Canon EOS Rebel T4i; Lens: EF-S 18-135mm f/3.5-5.6 IS STM @ 18mm; F-stop: f/10; Exposure: 1/25 Sec.; ISO: 400

I took these two photos within 30 seconds of each other. The camera was set to Shutter Priority, with a setting of 1/125 for the top photo and 1/25 for the bottom photo. Apertures (adjusted by the camera based on the camera's meter) were f/5 and f/10 respectively. ISO for both photos was ISO 400. In both cases, the focus point was the woman sitting in front of me, and I switched to manual focus after locking in my focus point due to the speed at which I was moving.

second) or running water (1/4 second to 20 seconds or more). I cover tips for using Shutter Priority in some specific situations in Tips 15, 23, 24, 42 and 50. Some of the most beautiful things to capture using long shutter speeds are amusement park rides, as you can see in fig 3.1 and fig 3.2 from a ride I took with my son (he liked the ride much more than I did!), and moving water (fig. 3.3 to fig 3.7). Fig. 3.8 is also a long exposure tracking shot using Shutter Priority mode.

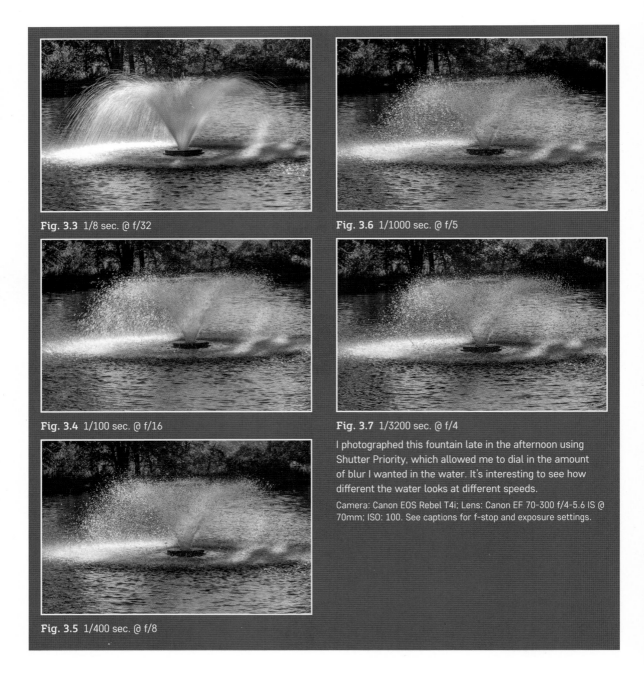

Fig. 3.3 1/8 sec. @ f/32

Fig. 3.6 1/1000 sec. @ f/5

Fig. 3.4 1/100 sec. @ f/16

Fig. 3.7 1/3200 sec. @ f/4

I photographed this fountain late in the afternoon using Shutter Priority, which allowed me to dial in the amount of blur I wanted in the water. It's interesting to see how different the water looks at different speeds.

Camera: Canon EOS Rebel T4i; Lens: Canon EF 70-300 f/4-5.6 IS @ 70mm; ISO: 100. See captions for f-stop and exposure settings.

Fig. 3.5 1/400 sec. @ f/8

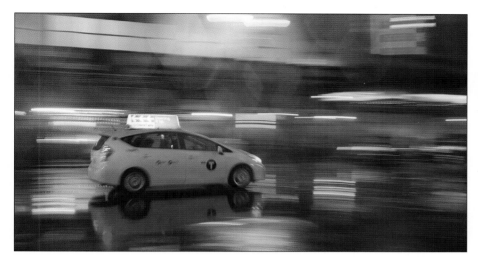

Fig. 3.8 Camera: Canon EOS 6D; Lens: Canon EF 28-135mm F/3.5-5.6 IS @ 28mm; F-stop: f/7.1; Exposure: 1/8 Sec.; ISO: 1250

CONTROLLING THE LOOK OF THINGS THAT MOVE

1. Place your camera on a tripod, set it to Shutter Priority mode and start with a wide lens (about 20–50mm in 35mm terms) set to any focal length that the lens allows, such as 50mm. Then set the shutter speed to 1/125 second and your ISO to a standard everyday shooting value, which will probably be ISO 200–800, depending upon your camera, lens and the type of photos you generally like to take.

2. Frame a scene with an interesting object that moves, such as a waterfall, fountain or amusement park ride. Focus on the moving object and take at least five photos. Use your camera's live view or EVF and manually focus while viewing a video image zoomed in. This can help dramatically to attain sharp focus. Most cameras have this option, and some only have live view via an LCD (no viewfinder). If your camera does not have an EVF, an LCD loupe (an accessory that can be placed over the LCD that contains a hood and an eyepiece) can be invaluable, especially if it is bright outside. (See Tip 8 on page 33 for some specific loupe recommendations and a step-by-step description of this technique.) Also, a wired or wireless shutter release can really help reduce camera shake and improve optimum sharpness when taking long exposures (see Tip 24 for more on this topic).

3. Change the shutter speed to the following: 1/30, 1/15, 1 and 2 seconds (you may have to reduce your ISO as you increase your exposure times). Aim for apertures in the f/8 to f/16 range for optimum image sharpness. You can see what your aperture values will be before you take a photo by looking at the live view with image information displayed, or by looking through the optical or electronic viewfinder at the information listed across the bottom of the image. You can also see what your aperture was after taking a photo by reviewing the image on your LCD screen and bringing up the image data.

4. Next, use a longer focal length (100–300mm in 35mm terms) and photograph either people or animals in motion handheld. Try to freeze the motion by taking photos at very fast shutter speeds, starting at 1/1000 second down to 1/250 second. For tips on setting different focus and exposure options, see the checklist in Tip 5 on page 19.

5. Try some tracking shots of people, animals or objects, like a train. This technique works best at about 1/8, 1/4 or 1/2 second depending on how fast the subject is moving and how steady you move the camera while the shutter is open. For the best effect, pan your camera to match the movement of your subject.

TIP 4

MASTERING MANUAL MODE AND AUTO ISO

Manual mode on most cameras means that you set both the aperture and shutter speed yourself. However, there is a super tip that you may not know regarding Manual mode. On most cameras, as you view the image in Manual mode and change aperture, shutter speed or ISO, the camera's internal meter keeps working, letting you know (via a small indicator in the viewfinder or LCD that looks like a digital fuel gauge on a car) whether your exposure is correct based on what it's currently metering. That can be very useful and can save a lot of time, since you don't have to take a lot of pictures to see if your exposure is correct. This won't work for flash exposures (just continuous light), but Manual mode is often the best option when using flash.

WHEN TO USE MANUAL MODE—Use Manual exposure mode with natural light photography in situations where your exposure won't change, such as in a workshop with fixed lights and models who are staying in a specific area.

USING YOUR CAMERA'S LIVE VIEW—This can be useful when in Manual mode since the camera's LCD image will usually correspond well with the exposure in the final image. In daylight (especially bright sun), you will definitely want to have an LCD loupe to more easily judge the image.

UTILIZING AEB—With many cameras, you can also use Auto Exposure Bracketing (AEB) in Manual mode (see fig. 4.1), which is worthwhile if you want to capture multiple photos of the same scene, but with different exposures, such as for High Dynamic Range (HDR) photography, which combines multiple images with different exposures to optimize highlight and shadow detail while minimizing noise. See Tip 6 (page 24) for more on AEB.

Fig. 4.1 This is the Quick Control Screen on a Canon 6D DSLR (accessed by pressing the "Q" on the back of the camera). It is currently set to Manual exposure mode. Just under the M is the Exposure Compensation/Auto Exposure Bracketing Indicator.

Fig. 4.2 This screen is located under the Custom Functions I Exposure section on a Canon EOS 6D DSLR.

Fig. 4.3 This screen shows the ISO speed settings for a Canon EOS 6D DSLR.

On most Canon cameras, the parameter that will change when using AEB in Manual mode is the shutter speed, which is ideal for HDR photography and for compositing (bringing multiple images into one digital file) because you don't want the depth of field to change in those situations. A change in the aperture would probably change the depth of field in the image.

Other cameras may handle this auto adjustment differently, and the only way to know is to read the manual, or do a test. To delve much deeper into this topic, visit www.pointsinfocus.com and search for "bracketing guide" for an excellent overview of bracketing options on many Canon DSLRs. And for those who want to really delve into bracketing and HDR (especially if you use Nikon cameras), I recommend visiting www.farbspiel-photo.com (search for "HDR").

AUTO ISO FEATURES

ISO is a lot like a dimmer switch. Depending on how you set it, you will be changing the overall exposure value of your image (similar to letting more or less light into the camera by changing the shutter speed or aperture, but with no effect on the depth of field or amount of time the shutter is open). Higher ISO numbers increase the overall exposure (images get lighter), and lower ISO numbers decrease the overall exposure (images get darker). By choosing Auto ISO range under the ISO speed settings menu (see fig. 4.2), I'm giving my camera permission to adjust the ISO when needed.

HOW TO SET YOUR ISO—You might say, "For action photos or when it's dark outside, I'll just set my ISO to the highest number it will go." However, at a certain point, if the ISO is too high for your camera, noise (digital grain) will degrade overall image

quality. Most crop-sensor cameras (even those with sensors smaller than those found on Micro Four Thirds cameras) do just fine up to about ISO 800, but I generally set them to ISO 200 or 400 as an everyday setting, unless I'm photographing models with flash, photographing moving water or doing tracking photography. Then I might set the ISO to 100.

Most full-frame DSLRs do exceptionally well at ISO 800, 1600 and, in many cases, even ISO 3200 or higher. In fig. 4.3, the camera is set at an Auto ISO range of 100–3200. I generally keep my Canon EOS 6D and Sony A7R cameras set at ISO 400-800, except in situations described above (photographing moving water, indoor flash photography), and I've been very happy with the lack of visible noise in my images. If there is some noise, it often either adds a film-like quality, or you can reduce it in Adobe Lightroom, Adobe Camera Raw, Photoshop or a special application, like Topaz Lab's excellent DeNoise application (www.topazlabs.com).

ADJUSTING ISO IN SHUTTER PRIORITY MODE—Through advancements in camera technology, many DSLRs and other cameras now have sophisticated ways to adjust your ISO behind the scenes so that you can still get the shot, even if you've set a shutter speed too high under Shutter Priority mode, or set too low an aperture number for your fastest shutter speed. This issue comes into play very often when in Shutter Priority mode.

Let's say you want to capture a bird in flight, so you set your shutter speed to 1/1000 second. If your aperture and standard ISO setting (let's say, f/4 and ISO 400) can't combine to give you enough light to get a good exposure, Auto ISO can come to the rescue and bump up your ISO to a range that you set in advance. This setting is

particularly useful for people who take pictures at events like weddings because it avoids the need to constantly change the ISO manually. However, it's easy to forget that you've bumped up your ISO to 3200 when taking photos inside. If you do forget, you might then take all the outdoor portraits at ISO 3200, introducing a lot of noise into your images and not realizing it until later. Some cameras, like the Canon EOS 6D, also have the option of choosing a minimum shutter speed in conjunction with Auto ISO. This is useful if you are handholding the camera or if you want to avoid movement in the scene. For example, you might set the minimum shutter speed to 1/60 second. If you are shooting in Aperture Priority mode, the ISO will be increased up to the limit you've set as soon as the camera meter calls for a 1/60 second exposure. Auto ISO even works in Manual mode on some cameras.

It's important to note that I'm not advocating setting your camera's ISO to the auto setting (if it has one), which means your camera could select a different ISO setting for every photo even if it does not hit the limits as you've set them as described above. However, on some cameras and in some cases, you must set the camera to Auto ISO in this way to get the camera to perform the way you want, and it can work out very well. The best way to learn how to set up Auto ISO is to go through the process in a step-by-step fashion by first checking if your camera has the feature, and then by reading the manual or an article on the topic. I usually choose an Auto ISO range from 200–1600 on a crop-sensor camera and about 400–3200 on a full-frame camera.

PRO ASSIGNMENT

USE YOUR CAMERA'S POWERFUL AUTO ISO CAPABILITIES

1. Set up a portrait or still life using natural light and set your camera to Manual mode. Choose an ISO of 200–800, depending on your camera, then make adjustments to produce a good exposure, testing how the internal meter level changes as you change aperture and/or shutter speed.

2. Set up Auto ISO based on your camera's manual. Move from inside to outside and take photos in both locations in Aperture Priority mode, Shutter Priority mode and Manual mode with a range of apertures from about f/4–f/22 to see how the ISO changes in different situations. Keep in mind that you may have to enable a custom setting inside the camera's menu system, as I demonstrated on my Canon EOS 6D.

CREATING A PHOTO CHECKLIST

One of the fastest ways to get out of P mode (program mode) or move beyond point-and-shoot mode is to craft and follow a checklist so you can develop good habits while still at your home, office or studio. Below, I've provided a standard checklist for all shooting situations, followed by a blank checklist that you can copy or re-create on your own for endless situations. This checklist is focused on the technical side of photography, but I'd be remiss not to recommend that you create another, just-before-you-leave-home checklist for items like sunscreen, extra batteries, media cards, etc. The last two are showstoppers, as they say, and I will admit that I've forgotten one or the other at least one time in the past (but luckily, not for paying jobs!).

GETTING YOUR CAMERA READY FOR ACTION

SETTING UP EQUIPMENT

Choose a Camera (or Cameras), and Find the Button that Displays Many Settings

This is obviously an important consideration, and there are many resources (online and offline) that can help. Let's assume you have in front of you a DSLR, mirrorless interchangeable lens camera (MILC) or mirrorless fixed-lens compact camera that has Aperture Priority, Shutter Priority and Manual exposure modes. If that's the case, you probably can adjust most of the features.

Virtually all DSLR and mirrorless cameras have an option that brings the majority of settings all together on one screen. I can't fully express how much faster and easier it is to adjust settings via a central control screen like this compared with trying to navigate through multiple menus.

Set to Raw for Maximum Control

Today's cameras can produce outstanding images in JPEG mode, and there's nothing wrong with capturing images in JPEG mode. However, with JPEG, you will not be able to recover the brightest tones in your images and bring out details in the dark areas as well as if you had shot in a Raw capture mode. You will also have more challenges with regard to adjusting the white balance of your images compared with shooting in the Raw mode.

I recommend setting your camera to save images as only Raw or only JPEG, and not Raw + JPEG. This is primarily to save time and space. By creating a JPEG file with every Raw file, your camera will take more time to write to your media card, and each extra file adds to the number of images you will need to download and archive.

The only exception to using JPEG in addition to Raw is if you need to quickly review large numbers of images for critical sharpness and detail because you don't have time for a large, high-quality preview of the photos to render in the background in a program like Adobe Bridge or Adobe Lightroom. In this case, rendering is a process that makes it possible for each Raw file to be viewed in a large size on your screen. Some cameras have two card slots, which allows you to write Raw files to one card and JPEG files to another. This may have a small effect on write speeds, but it allows you to hand a card off to an assistant or to your client during time-sensitive events where you want to keep shooting, but when you also want to start posting images on social media sites. One of the fastest and most popular applications used by photojournalists to import, view and add captions to their photos is Photo Mechanic (www.camerabits.com).

Choose a Lens and Consider Crop Factor

Crop factor is usually expressed as 1.5x or 2x. It means that compared to an image from a full-frame 35mm camera, the camera's lens covers a smaller area due to a sensor (the digital version of film) that's smaller than a 35mm frame. The end result is a slight-to-moderate telephoto effect—a 100mm lens will approximate the look of a 150mm lens on a full-frame camera when using a 1.5x crop-sensor camera such as the Canon EOS 80D, Canon EOS Rebel T6i, Sony a6300 or Nikon D5600.

This can be beneficial for those who photograph birds and other wildlife, because you can zoom in closer to your subjects with a smaller (and often much lighter) lens. The popular Micro Four Thirds format found on cameras such as the Panasonic Lumix DMC-GH4 and Olympus OM-D line has a 2x crop factor, so a 70–150mm lens will produce a similar field of view to a 140-300mm lens on a 35mm camera. However, that advantage can be lessened by the fact that your image quality may be lower if you want to make large prints or crop into your images with a camera that has a sensor considerably smaller than a full-frame digital camera. Only through research or by testing with a different camera lenses and at different ISO levels can you truly determine the image quality in different situations. I discuss this topic more in Tip 20 (page 68).

READING YOUR SCENE

Set Your Starting ISO

Determine the overall quantity of light you plan to have (natural or artificial) so that you can set a starting ISO. If you aren't using a tripod and if the scene is dark (or if you want to capture fast motion without much blur), you will probably want to use higher ISO values. See Auto ISO Features on page 17 for more on this.

Set the White Balance

Determine the color temperature of the light so that you can set the white balance using a preset auto or custom white balance setting. See Tip 9 (page 36) for more on this topic.

ADJUST YOUR CAMERA SETTINGS

Determine Your Shooting Mode

A number of shooting modes can be selected. The primary ones are Aperture Priority, Shutter Priority and Manual. These are all explained in detail in Tips 1–4.

Determine Your Exposure Compensation and Light Metering Mode

Most cameras have a built-in reflective meter, which means that they measure light reflecting off of objects. They also assume that the world is a medium-gray tone, so you may need to make adjustments depending upon the brightness of your subject by using exposure compensation. Many cameras have an exposure compensation dial right on the top of the camera, and in some cases, you'll need to use a thumb wheel, touchscreen or internal menu to find and adjust it.

If you are photographing something that has a large area of white in the scene (like a tree covered in snow), your image will probably look too dark if you don't use exposure compensation. You can remedy this by dialing in an exposure compensation adjustment of about +1 EV to +1.5 EV. Conversely, if you have a large area of dark colors in the scene (like a black car in a forest), your image will probably look too light if you don't use exposure compensation (-.5 EV to –1.5 EV is recommended in this case).

The metering mode I usually recommend is an "intelligent" metering mode that takes many things in the scene into account. It's called different things by different manufacturers, including: matrix (Nikon), evaluative (Canon) and multi-segment (Sony). Other metering mode options include spot (just a very specific area in the frame determines the exposure) and center weighted (similar to spot, but with a wider area).

If you are using an on-camera flash or a wireless TTL flash that can communicate with your camera, flash exposure compensation is a powerful tool that allows you to quickly adjust the power of the flash without touching the actual flash unit.

Determine Your Focus Mode

More advanced cameras (when paired with an autofocus lens made for the camera) have the ability to focus on an object and lock focus, or have the focus continually adjust as the action moves. AI Focus (Canon) and AF-C (Nikon and Sony) are continuous-focus modes, and One Shot (Canon) and AF-S (Nikon) are single-shot focusing modes. If you prefer to use Manual focus, make sure that you switch to the Manual focus option on the camera body (if available) as well as the lens (or via the camera's internal settings). Many Nikon cameras have a Manual/AF switch on the camera body, but most Canon cameras don't have this. This concept and examples for when you might use one or the other is explained in Tip 10 (page 41) and Tip 11 (page 44).

Determine Your Shooting Mode/Drive Mode

Most cameras (even compact cameras) have a single or continuous shot burst mode option, and some have sophisticated options, such as continuous shooting at medium or high speed. The advantage of a burst mode is that you can capture many frames in just one second, or a few seconds. Here you will also often find options to set a self-timer or to use a wired or wireless remote shutter release (see Tip 24 on page 86 and Tip 34 on page 126 for more on this topic). On Canon cameras, this is called the Drive mode.

Determine If You Want to Use Auto Exposure Bracketing (AEB)

If your camera has Auto Exposure Bracketing, it's a very powerful option that allows you to take a series of photos with different exposures by varying the shutter speed, aperture or, on some cameras, the ISO. See Tip 6 (page 24) for a description of Auto Exposure Bracketing.

Set Your Autofocus Points and Consider Touch-Screen Options

Many camera/lens combinations allow you to set a wide or very small area of the viewfinder so that your camera can autofocus on the subjects you want it to. It's similar to choosing a focus area on a smartphone with your finger. The main advantage of this is when there are many objects in the scene. A small area allows you to pinpoint a specific section so that you can make sure it's in focus. A larger focus area can be useful when photographing fast-moving subjects like birds. Some DSLRs and compact mirrorless cameras even have touch-screen controls as I mentioned early in the book, but I generally don't use them for still photography (except to sometimes adjust camera settings). However, touch-screen controls can be very useful for video, especially if the lens was designed to be silent as it changes focus. I almost always use center point focus, but sometimes I'll change it if the area of interest is consistently somewhere other than the center of the frame. I cover this topic in much more detail in Tip 10 (page 41) and Tip 11 (page 44).

Viewfinder, Screen or External Monitor?

Choosing to frame your images with a viewfinder or your screen is an important decision because the approach you use (optical viewfinder, electronic viewfinder, LCD screen or external monitor), determines how you see the world. Your camera will dictate your options. DSLRs have OVFs and LCDs, and mirrorless cameras use EVFs and LCDs, or just LCDs. Here's more on how each option works:

OPTICAL VIEWFINDER (OVF)—The main advantage of OVFs is that you see through the lens right away in real time (no delay at all) without having to wait for the camera to start up or wake from sleep, plus the image in an OVF is often clearer compared with electronic viewfinders (EVFs).

ELECTRONIC VIEWFINDER (EVF)—EVFs keep improving, and they offer a look at what you will be capturing (much like a typical DSLR's optical viewfinder, but with a depth-of-field preview that's always "live" and not darkened when you adjust the aperture). EVFs also allow you to zoom in on an area to check details and focus instead of having to use a loupe over the LCD. This is especially useful with manual focus lenses.

LCD OR EXTERNAL MONITOR—Most cameras, like smartphones, have LCD screens. External monitors are also available for many cameras. They operate either via a cord or wirelessly, and they allow you to see what you are shooting much like a built-in LCD screen.

USE YOUR PHOTO CHECKLIST

1. Make five copies of the checklist, and write five different shooting scenarios down that cover topics in which you are interested. Also, add any specific items to the checklist that might apply to your gear. For example, if you are using a tripod, most lenses that are image stabilized should have the Image Stabilization feature switched off.

2. Test yourself! Cover up the checklist items for each scenario and see if you can set your camera correctly for each one. This will help you to learn your camera's settings so that you can concentrate on making great photos.

CHECKLIST FOR GETTING YOUR CAMERA READY FOR ACTION

Setting up Equipment

❑ Choose a camera (or cameras):

❑ Set to JPEG, Raw or JPEG+Raw:

❑ Choose a lens and consider crop factor:

Reading Your Scene

❑ Set your starting ISO:

❑ Set the white balance:

Adjust Your Camera Settings

❑ Determine your shooting mode:

❑ Determine your continuous light metering mode: _____

❑ Determine your focus mode:

❑ Determine your shooting mode:

❑ Auto Exposure Bracketing (AEB)?

❑ Set your autofocus points:

❑ Use an optical or electronic viewfinder (OVF/EVF), LCD screen or monitor? _____

TIP 6

MASTERING AUTO EXPOSURE BRACKETING

Auto Exposure Bracketing (AEB) is an extremely useful option that's available on most DSLRs and mirrorless cameras. Setting this option will tell your camera to take multiple pictures consecutively at different exposure levels (you can choose many different bracketing options) based on the camera's internal metering system (or starting from the settings you choose in Manual mode).

For example, you can set your camera to take a picture as if you were taking just one exposure. Your next shot will be taken at -1 EV, and the next will be at +1 EV without your having to do anything other than pressing the shutter release. As mentioned previously, EV stands for exposure value and represents a one-stop move, like f/2.8 to f/4 or 1/2 second to 1 second. When you review your images using a 3-EV AEB bracket, you will see three images, all with a different brightness range (in this example, a middle exposure, followed by one that's less bright, and then one that's brighter). Right off the bat, that means you have three different images with which to work. And they can be combined in different ways.

As I mentioned in Tip 4, a very popular technique known as HDR (High Dynamic Range) photography works extremely well with Auto Exposure Bracketing. It's generally best to use Aperture Priority mode with AEB (as I've done in the photos shown here) so that your depth of field does not change from one photo to the next.

Here are a few tips for getting the most from AEB:

BURST SHOOTING—Setting your camera to continuous (burst) shooting mode (as opposed to single shot mode) is a good idea when using AEB because you may want to borrow elements from one photo (for example, a sky) and paste them into another, or you may want to create a High Dynamic Range image. This technique works better when you use a tripod, but the Continuous Shooting (a.k.a. Burst) mode can also work wonders if you are handholding. Just be sure to hold your camera very steady, and realize that you may have to crank up the ISO and/or shoot at lower apertures to get usable images. Most cameras will stop after the AEB sequence is done even if the camera is set to Continuous Shooting mode.

SELECTING A SHOOTING MODE—Choosing a shooting mode (for example, Aperture or Shutter Priority) will determine whether the camera changes the aperture or shutter speed when it brackets. In most cases, when shooting in Raw, I would recommend a +/- 2 EV for AEB because shooting Raw already allows you to recover highlight detail and open up shadows in post-production. You can process the same Raw file multiple times and merge the files together to expand the highlight and shadow details in your images. However, very overexposed or underexposed areas of some types of images (e.g., photos with skies and dark

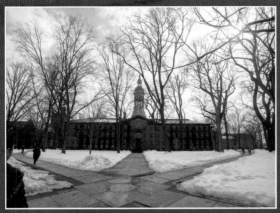

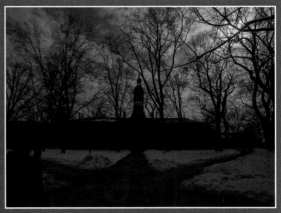

Camera: Canon EOS 6D; Lens: Canon EF 16-35mm F/2.8L @ 16mm Camera: Canon EOS 6D; Lens: Canon EF 16-35mm F/2.8L @ 16mm

I took these two photos within a few seconds of each other using AEB. For both images above, the camera was set to Aperture Priority, with a setting of f/7.1, and ISO was set at 160. The resulting exposures, set by the camera during AEB, were 1/2000 for the lighter photo on the left and 1/4000 for the darker photo on the right.

The photo below is a composite of both images. I used both Adobe Lightroom and Photoshop to create it. It's often possible to get a similar effect with one photo by just "brushing" sections inside of Lightroom to make them lighter or darker. This is not possible, however, if you have a sky that is very overexposed. That's where AEB really shines.

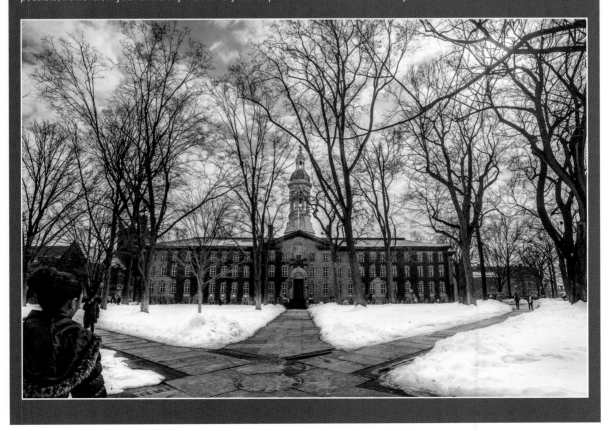

foregrounds, and indoor scenes lit primarily with window light) will really need to be captured in separate exposures to bring out details without experiencing a lot of noise in the dark areas or lack of detail in the bright areas.

SELECTING TWO AEB EXPOSURES—Some cameras allow you to choose just two AEB exposures (instead of a minimum of three), and when I saw that my Canon EOS 6D had this feature, I was a happy camper! The reason is because although I like AEB a lot, I don't like having to take three or more exposures every time I press the shutter. Having just two exposures allows me to choose either a plus or minus EV setting. In almost all cases when I'm using my camera outdoors without a flash, I want more highlight detail in my photographs so that I can bring back detail in skies and other bright areas. Because of that, I set it to 0 and -2 EV. If I was in a location with a lot of bright scenes, such as a snow-covered village without a bright sky, I would probably choose 0 and +2 EV instead.

CARRYING YOUR GEAR COMFORTABLY

Four- to six-pound telephoto lenses and three- to four-pound pro cameras can definitely help you get sharp photos, but when you add them to a camera bag with even more equipment, the weight can be a real burden. Even if your gear weighs much less, it can often be bulky and difficult to deal with on hikes or when traveling.

Another important consideration is the question of whether you can get to your gear without placing a bag on the ground or holding it in an awkward way while you search for something. There are many times that you will not want to put your gear on the ground, and being able to quickly change lenses and get to things like media cards, a microfiber cloth or a water bottle has many advantages.

Here's another question to ponder: "Can you eat or just relax with a coffee or tea at a restaurant or outdoor café and comfortably keep all of your gear safely attached to you?" This can be challenging, but I have a solution to this common problem below.

Here are several ways (and specific product suggestions) to lessen the impact of camera equipment, with some ideas for how to carry less but still get great images. All of these options take the weight of the camera off of your neck (avoiding the traditional camera neck strap). No solution is perfect in every situation and for every camera/lens combination. I would look over all of the options and think about which ones might work for you.

USE A CAMERA SLING OR A CAMERA/GEAR HOLDER— Camera slings that attach to your body help reduce the weight on your neck and transfer it more comfortably to your back and shoulders. BlackRapid is a company that popularized the camera sling, and they make more than 15 different straps (including some specifically made for left-handed people). With BlackRapid straps, the big change compared with traditional straps is that the attachment point of the strap to the camera is moved from the standard metal neck strap loops to the tripod socket.

I've been using a BlackRapid Sport R-Strap for years, and I love it. I especially like how the shoulder strap is curved, which allows it to sit nicely across my shoulder. I also like how I can set "stops" using simple plastic sliders that clip in place along the camera strap to keep the camera from moving too far behind my back. Another great option is the BlackRapid YETI Dual Camera Harness with a GoPro Chest Mount Harness. As you can see in fig. 7.1, a GoPro is mounted in the center. Below that is a small LCD loupe for viewing images on DSLR's LCDs when it's too bright outside.

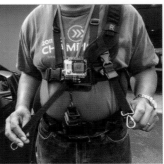

Fig. 7.1 This is my friend wearing a BlackRapid YETI Dual Camera Harness with a GoPro Chest Mount Harness.

There are many other camera slings available from BlackRapid and other manufacturers. I would just be very wary of any camera sling that has a quick release button (or common two-pronged release) that could be pressed by accident.

USE THE METAL RING OF A QR PLATE WITH A CAMERA SLING CARABINER—Because I use the Manfrotto RC2 QR system (see fig. 7.2) on a number of tripod and monopod heads, I often use the metal ring of an RC2 plate (used to tighten down the screw on the bottom of the camera) to attach my BlackRapid strap. Some other QR plates also have metal rings like this, but some may not be built strong enough to support the weight. To use a tripod with a Manfrotto RC2 plate, I just remove the carabiner from the BlackRapid strap and I'm good to go.

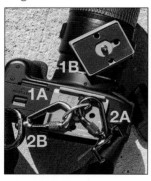

Fig. 7.2 1A/1B: Both sides of a Quick Release (QR) plate that's compatible with any QR adapter that accepts Manfrotto 200 PL-14 (RC2) plates. 2A/2B: Carabiners with locking mechanisms from two different sling straps are shown here attached to the metal ring usually used to hand tighten the QR plate to the camera.

CREATING EASY ACCESS TO SHORTER LENSES

For easier access to shorter lenses that will sink to the bottom of some bags' pockets, place stress balls or tennis balls under your lenses at the bottom of the pockets. Or, instead of the tennis balls, you can place a beanbag at the bottom of one or both pockets that can be used for extra stability, as described in Tip 42.

Some of my favorite carabiners are the metal Nite Ize S-Biners (fig. 7.3), which are very strong and versatile. They are especially good for hanging items off of belts, Peak Design Anchors, bags, jackets, photo vests and the like.

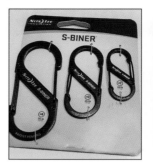
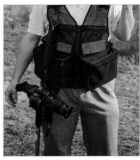

Fig. 7.3 (left) Nite Ize S-Biners in three sizes

Fig. 7.4 (right) Pictured is how I carry a camera and lens mounted on a monopod with an LCD loupe attached. The strap is the Peak Design Slide.

CONSIDER A PEAK DESIGN CAMERA STRAP—Peak Design's Leash and their newer (and heftier) line of camera straps, called Slide (see fig. 7.4), both allow me to have the features of a camera sling without obstructing the tripod socket. To make them work, I just attach the company's innovative anchors (they look like a coin attached to a small rubberband) to my camera's metal neck strap rings. I can then attach either of their straps to the anchors. I can even use another strap from a different company (or one I make myself) by using Peak Design Anchor Links. Anchor Links are quick connectors that are designed to be attached to the ends of any standard neck strap.

CONSIDER A COTTON CARRIER SYSTEM—Cotton Carrier (www.cottoncarrier.com) makes quite a few products to help keep equipment securely attached to your body, including a few highly rated vests that are designed primarily to support one or two camera/lens combinations. Their vests are especially useful if you will be very active when out with your gear, like riding a bike. Their system is also quite innovative in that no button needs to be pressed to release the camera

(just a turn of the camera is required). Cotton Carrier also makes a camera belt/holster system called the Carry-Lite that includes a camera hand strap for extra stability. The company also has a solution for adapting their products for tripod use while still retaining their main function of being able to be carried with little effort. It's bulkier than the Peak Design CapturePRO clip that I mention below, but it is a solid system and definitely worth considering. Search for the Cotton Carrier Universal Adapter Plate and L-Bracket on YouTube for an excellent video showing how to configure and use it.

USE A CAMERA BELT SYSTEM—One of the first companies to create a belt system with an integrated holster was Shai Gear, with their Spider Pro (www.spiderholster.com). Like the Cotton Carrier system, with the Spider Pro, no button has to be pressed to release the camera from the clip. The company has really thought out ways to carry one or more cameras on your belt or on one of their belt systems, from their Black Widow (for lighter cameras) to their Spider Pro for heavier, pro cameras and lenses. Shai Gear also sells a $20 belt accessory holder called the Spider Monkey (it reminds me of a heavy-duty cell phone clip), and a nicely designed $75 Large Lens Pouch that can hold lenses the size of a Canon, Nikon or Sony 70-200mm f/2.8 lens (or smaller), complete with a tether cord for attaching a rear lens cap so that you can quickly put the cap on when you're on the go.

I like to carry small camera bags with one size #4 Nite Ize S-Biner attached to two D-Rings on the back of the bag as seen in fig. 7.5. I'm using a Peak Design Anchor that has been threaded onto my belt. This approach holds the bag much more sturdily than just letting it swing from one D-Ring or a loop commonly found on bags. Alternatively,

you can attach the S-Biner to the belt loop found on most small camera bags. Just be careful if the belt loop has a hook and loop closure instead of being sewn shut, because it can come apart over time, resulting in the bag falling to the ground. In those cases, you can sew it or have it sewn shut for added security.

When carrying a camera or other accessories on your hip, you need to be very careful going through doorways! Also, one of the main negatives with

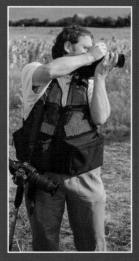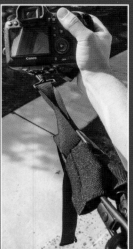

QUICK ACCESS TO YOUR CAMERA

Camera vests, clips and belts not only enable you to carry more gear in an efficient manner, but they also allow you to have quick and easy access to your camera.

In the photo on the left, I'm demonstrating how to take photographs with the camera mounted to a Peak Design CapturePRO clip. This is a great feature that makes it super easy to grab quick shots at any time without worrying about dropping the camera. The clip also makes changing lenses much easier.

Another benefit is being able to steady your camera. In the figure on the right, I'm demonstrating how you might hold a camera attached to a vest to get additional stability (I would of course have my left hand on the camera as well!).

many belt systems or products that attach to belts is they can get in the way when nature calls and you need to use a restroom. Backpacks and sling packs can have an advantage in these situations, especially if you are using less-than-perfect accommodations.

USE A PHOTOGRAPHER/VIDEOGRAPHER'S VEST TO CARRY CAMERAS AND/OR ACCESSORIES—There are many vests on the market specially made for photographers and videographers. They tend to look like military/police or fisherman vests. This is definitely something to consider before you buy one since you will definitely stand out in a crowd. They also add a layer of material that feels similar to wearing a light jacket, but in my experience, a heavy backpack with similar gear can be even more uncomfortable in high temperatures. That being said, some photo vests on the market are nicely designed and offer custom configurations and different color choices.

The photography vests from The Vest Guy (www .thevestguy.com) stand out in this regard. They are highly configurable and allow you to add just what you want to them. All of the photo vests come with a hydration sleeve that allows water to be placed in a bag that sits in the arm or back of the vest. I own their Wedding Photographer Vest and find it to be fantastic for when I want to carry a few cameras and lenses, and want maximum mobility (see fig. 7.6). To the right of the vest in fig. 7.6 is a Peak Design CapturePRO clip attached with a Peak Design Pro Pad, which helps give the clip more stability and makes it possible to take photos without removing it from the clip. On the left is a sturdy camera strap that came with the vest.

One of the advantages of vests like these is that you can often forgo a backpack completely by placing all of your gear in the vest's pockets. All of The Vest Guy's photo vests also come standard with one camera strap, which offers both hands-free carrying as well as an added tether for security. Additional straps can also be ordered.

Fig. 7.5 A small camera bag with a size #4 Nite Ize S-Biner attached to two D-Rings on the back of the bag.

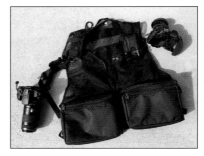

Fig. 7.6 Wedding Photographer Vest, made by The Vest Guy.

USE A BACKPACK OR SLING PACK WITH A CLIP OR HOLSTER SYSTEM—A few companies make special clips that attach to backpack straps (like Peak Design's CapturePRO clip) or to specially made pads (like Peak Design's Pro Pad). Those clips then attach to a plate on the bottom of a camera or other accessory, with the goal of making carrying easier and allowing fast access to the gear.

Cotton Carrier makes an innovative product called the StrapShot that attaches to virtually any backpack strap. A compatible camera hub is then attached to the bottom of a camera so that it can hang securely and be removed for quick access without having to press any buttons. StrapShot

also comes with both a safety tether strap and hand strap to help secure your gear.

Peak Design's CapturePRO clip is a product I've been using for a few years, and I think it's fantastic. For years I had been looking for a way to carry a DSLR and lens, but also have easy access to a bag without having to fight with straps getting intertwined with a camera sling. Pairing a compact but versatile camera bag with a CapturePRO Camera clip allows a camera to hang from it as if it were on a quick-release tripod head. A push of a button releases it, and when you are ready to return it to the clip, it clicks in securely with virtually no effort.

I often carry a single camera with the CapturePRO clip attached to a backpack (see fig. 7.7). It's hands-free, and I can take photos without removing it from the clip (though I will admit vertical shooting can be a bit difficult without removing the camera).

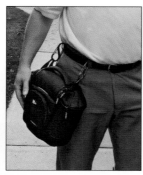

Fig. 7.8 Carrying the Case Logic Medium SLRC-202 SLR Bag using two size #4 Nite Ize S-Biners directly on my belt. I then attached them to loops on the top of the bag.

Fig. 7.7 Carrying a single camera with a Peak Design CapturePRO clip attached to a backpack.

I often pair the Case Logic SLRC-202 Medium SLR Camera Bag with the CapturePRO clip. This combination allows me to support a heavy camera and lens on the strap over my left shoulder but still get to my gear, which often includes a second camera and two more lenses (or one lens and a bottle of water). The front pocket holds my media cards, extra batteries, microfiber cloths and other accessories. The back pocket is much flatter—perfect for holding an X-Rite ColorChecker Passport for color balancing photos and custom camera profiles.

Another way to carry the Case Logic Medium SLRC-202 SLR Bag is shown in fig. 7.8. I've attached two size #4 Nite Ize S-Biners directly to my belt and then attached them to loops on the back of the bag. Or you can attach the S-Biners to some other object that creates two loops around your belt, such as Peak Design Anchors. Just be sure not to attach the S-Biners to belt loops! They can easily break.

Peak Design's CapturePRO clip is sold with one QR plate, called the ARCAplate. The MICROplate is made for smaller width/compact cameras. The company's newest QR plate is called the PROplate, which will work with both Arca and Manfrotto RC2 tripod heads (two small adapters are needed for RC2 compatibility).

Alternatively, Peak Design has a slightly lighter clip, the Capture clip, which is slightly less expensive than the CapturePRO clip, has no tripod hole drilled in it, and only supports the ARCAplate and MICROplate (not the DUALplate).

The reason I spent time discussing this combination (Case Logic bag and Peak Design clip) is because it allows you to carry all the camera bodies and lenses you need for most personal projects and assignments without having to put your gear down anywhere. You can even sit down for a while with all the gear on you and have a drink or a snack, though eating a full meal with everything still attached is not the most

comfortable experience. I've heard too many sad stories about gear being stolen from pros at various social functions. Knowing that your gear is on you at all times can be a big weight off of your shoulders (pun intended!).

STERNUM STRAP—Instead of attaching the CapturePRO clip to both backpack straps, you can attach it to one of the two main backpack straps and then offset most of the weight by attaching an adjustable sternum strap that can be quickly released when you need to take off the pack. Search online for sternum straps to find a number of options. An advantage to using a backpack is that you can attach two CapturePRO clips (one to each shoulder support).

TELECONVERTER—Another way to reduce the weight of your gear is to use a teleconverter instead of carrying multiple telephoto lenses. This is because teleconverters are much lighter and more compact than most lenses (especially telephoto lenses). I discuss the pros and cons of teleconverters in detail in Tip 47. Replacing standard lens hoods with collapsible rubber lens shades is another way to reduce the length and bulkiness of your equipment (if you've seen the size of some lens hoods for long lenses, you will know what I'm talking about!).

And some lenses have their own carrying straps, as in fig. 7.9.

Fig. 7.9 This Sigma 50–500mm f/4.5–f/6.3 lens actually ships with a neck/shoulder strap, a very rare, but useful bonus! The strap attaches to a metal rod located near the tripod collar's tripod mount. The lens weighs in at just over four pounds and also comes with a sturdy case and another neck/shoulder strap.

PRO ASSIGNMENT

PLAN WHAT TO BRING AND HOW TO CARRY IT

1. Imagine that you are going sightseeing for a few hours in very hot weather with all of your photo gear. Decide what equipment you will need, and see what combination of products (or similar products) you can use from the list above to make it as enjoyable as possible. Then consider what would be an ideal carrying setup for a 10-day trip in which you leave every morning and don't return to your room until the evening.

2. Now imagine that you are going out for a day with your family and friends at a nearby park or a family member's home. Think about what gear you would like to bring and how you would want to carry two cameras.

3. Visit a large photo retailer or some of the booths at a photo trade show to test out some of the camera slings, backpacks, vests, etc. There's no better way to determine if a product is right for you than to test it firsthand. Be sure to walk around the booth for a few minutes to get a feel for how it weighs you down. Also, sit on a chair and see if you can keep the gear on you while eating or having a snack.

FOCUSING WITH LIVE VIEW

One characteristic that most people look for in a photo is some detail on which to focus. Here are my preferences for focusing depending on the camera.

If you have a DSLR, look into the traditional optical viewfinder and focus on a single point, usually placed in the center of the screen (using autofocus with an autofocus lens).

For mirrorless cameras that have no EVF or optical viewfinder, use a magnified viewfinder attached to the LCD screen, which helps to focus, see the screen more clearly in bright light and stabilize the image. Compared with holding a camera out in front of one's face, the stabilization effect with a magnified viewfinder is much more effective.

The following tips cover how to deal with common problems related to using live view, and how to achieve focus faster and more effectively.

TRY OUT A POP-UP SHADE—If you prefer not to look through an LCD viewfinder (one reason might be because you want to keep the touch-screen controls on your camera), Delkin Devices makes a number of detachable Point & Shoot Mini Pop-Up Shades that stick onto camera LCDs. For more protection, I recommend first covering your LCD with a removable crystal clear glass cover. I've used and highly recommend the GGS Optical Glass LCD Screen Protectors (available at many retailers for under $10).

LCD HOODS—LCD hoods generally have three sides with no glass in the front. They are made primarily for video cameras, but they also fit many popular DSLR LCD sizes as well, as long as your camera has a flip-out, articulating screen (one that can twist and angle like a TV mount).

MAGNIFIED LCD VIEWFINDER—There are many magnified viewfinders on the market. A good search term for them is "LCD viewfinder," and they are sometimes called "LCD loupes." As I mentioned, I use these primarily when I'm not using an optical viewfinder on a DSLR or an EVF on a mirrorless camera. You should choose one with a built-in diopter if you wear glasses but don't want to keep your glasses on while taking pictures. Just keep in mind that the diopter will generally add about an inch to the overall length of the viewfinder.

Fig. 8.1 Here I am at a photo trade show testing out a HoodCrane with a HoodLoupe LCD viewfinder. Photo credit: Whitey Warner

Popular brands include Hoodman, Zacuto and GGS. One of the nice things about the Hoodman

products is that many of their HoodLoupes have a ¼- to 20-inch thread at the bottom of the loupe, which can be attached to a bracket on the bottom of a camera. Hoodman also makes an innovative and inexpensive HoodCrane that allows their viewfinders (possibly others as well) to be attached to the hot shoe of many cameras. See fig. 8.1 for a sample of Hoodman products.

ELECTRONIC VIEWFINDER—Many companies that make mirrorless cameras either build EVFs into their cameras, or they make accessory EVFs that can be inserted into their cameras' hot shoe and accessory ports. EVFs transmit a tiny video screen image to a small eye-size viewfinder. In some cases, these can provide a better overall image than a traditional viewfinder (especially in low light), and most will allow you to review your images and adjust the menu settings just as though you were looking at the LCD. This can be particularly useful for people who wear glasses or have slightly less than 20/20 vision because they can then look at both the image they are shooting as well as the images they've photographed through a diopter setting matched to their eye.

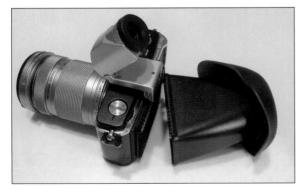

Fig. 8.2 An Olympus PEN E-P2 with the Olympus Electronic Viewfinder VF-2. To the right is an LCD viewfinder loupe.

All that being said, EVFs that are not included can be costly, so you might prefer the magnified LCD viewfinder option (as shown in fig. 8.2 with the

Olympus PEN E-P2), especially if you plan to use the camera's hot shoe for another accessory, like an on-camera flash or microphone adapter set like the SEMA-1 made for all Olympus digital cameras with an accessory port (search for "SEMA-1" on the Olympus website for more information on that product).

USING LIVE VIEW EFFECTIVELY—Now I can address the nuts and bolts of using live view effectively. It's almost always represented by a small- to medium-size box on the screen, and I recommend using as small an autofocus (AF) area as possible. That will give you the most control and allow you to use the live view for things like focusing on a person or item, pressing the shutter button halfway down to set the autofocus using the AF point, then recomposing so that the area you focused on is sharp.

This tip works best if you place the camera on a tripod. By zooming in and manually focusing on a subject while in live view mode, you can easily focus on any object, especially if you have a very high-resolution viewfinder or EVF. After setting your focus point, return to the non-zoomed-in view, and as long as the subject(s) are not moving, you can shoot for as long as you like. This technique works particularly well when photographing fireworks, waterfalls and landscapes.

An example of viewing a live image for composition and playback can be seen in fig. 8.2. The example demonstrates two ways to do so with an Olympus PEN E-92 camera. The first is using the Olympus Electronic Viewfinder VF-2, located in the hot shoe. The second is an LCD viewfinder loupe, which I can easily attach and remove thanks to a few thin strips of 3M's very strong Dual Lock Reclosable Fasteners. Before attaching any fasteners, I recommend attaching a self-

adhesive glass LCD screen protector to your LCD like those made by GGS. Skip the fasteners along the bottom edge of the LCD (just use the other three sides), or you might find it very difficult to remove the loupe, as I've learned the hard way!

In fig. 8.3, I moved the focus point on my Olympus PEN E-P2 camera while viewing the image on the camera's LCD screen (the red arrow is pointing to the focus area). This looks very similar to many other cameras, and it can also be done if you are viewing the live image through an electronic viewfinder.

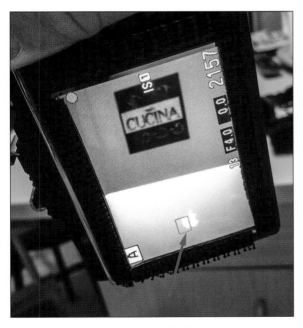

Fig. 8.3 A red arrow is pointing to the focus area on my Olympus PEN E-P2.

LIVE VIEW FOCUSING

1. Attach an LCD hood, magnified viewfinder or EVF to your camera. Now set the autofocus to as small an area as possible and use autofocus mode to take a series of photos indoors and out, at a range of different apertures. Test how well you can focus on an object that is not in the center of the frame, then refocus and take the photo. Also practice moving the focus area box around. For example, if you are doing a vertical portrait of one or more people, you can turn the camera to the vertical position and move the focus area box up so that it is close to your subjects' faces.

2. If you have a DSLR or other camera that allows you to focus manually, place your camera on a tripod and photograph a scene outside with a few different lenses. You don't have to use a magnified viewfinder over the LCD, or an electronic viewfinder, but those will usually help (especially in bright sun). Turn off autofocus and start by focusing on a large object in the foreground without zooming into the frame. Then zoom in one or two zoom levels while in live view to see a close-up of the image. You should find it much easier to focus on objects with this technique. Now zoom back out and take a few photos with a wireless shutter release or a wired cable release.

TIP 9

CONTROLLING COLOR WITH WHITE BALANCE

When color film (especially slides or transparencies) was the tool most photographers used to capture images, the film type determined the color balance of the images. If you wanted a person wearing a gray shirt to look as though his or her shirt were gray under daylight at noon outside, you had to use a daylight-balanced film. If you wanted that same person's shirt to look neutral gray indoors under the light of typical home lightbulbs, you had to use a tungsten-balanced film.

Fast forward to digital cameras. White balance settings like Daylight, Cloudy and Tungsten allow us to have an almost unlimited number of film types. What's so interesting about white balance is how different a photograph can feel just by making relatively small adjustments to the white balance settings either in-camera or in an application like Adobe Photoshop or Adobe Lightroom. I think this is partly due to the fact that we as humans are heavily influenced by color, especially when it comes to skies. A blue versus amber sky evokes different emotions, and when a rainbow is added to the mix, the combination of hues makes the images quite distinct from each other.

Taking photos in your camera's Raw mode allows you to adjust the color temperature of your images after the shot with no loss of quality. That's not the case if you shoot in JPEG mode. That being said, you can still make adjustments and get good results after the shot if you shoot in JPEG mode. Though I'm not a big fan of auto white balance (AWB), an option on virtually all digital cameras, it often does a great job in guessing what lighting condition you are in, and there's no harm using it, especially if you shoot in Raw. The advantage of AWB is that you don't have to make any white balance adjustments while you are shooting (even if you go from a high school gym to a restaurant to an outdoor car show) to see relatively good color in your EVF or LCD.

Super Tip: A good default white balance setting for most outdoor situations is Cloudy (about 6000K). The reason is that all your photos will be slightly warm when choosing this setting under daylight conditions. You should then get a very subtly suntanned, late-afternoon look in your images.

TOOLS TO GET YOUR LIGHT BALANCE JUST RIGHT

There are many tools to help you calibrate color and set white balance accurately. Some even help you to create color profiles for any lighting situation, and that can do wonders when you take photos under the likes of fluorescent or mercury vapor lights. These lighting types can produce unnatural or over/undersaturated colors across the color spectrum, especially when shooting in places where they are widely used, including

I photographed this rainbow in Raw using the Cloudy white balance setting. I then adjusted it in Adobe Lightroom by setting the white balance to 3333K.

With the white balance adjusted to 4444K.

With the white balance adjusted to 6000K. I also adjusted Clarity and the Tone Curve in Lightroom.

Camera: Canon EOS Rebel T4i; Lens: Canon Macro EF 50mm f/2.5; F-stop: f/4; Exposure: 1/4000 Sec.; ISO: 3200

gymnasiums, retail stores, and city streets. A few of my favorite tools include the X-Rite ColorChecker Passport, Datacolor SpyderCheckr, Datacolor SpyderCheckr 24 and Datacolor SpyderCube (see fig. 9.1 for a photo of me holding two of these).

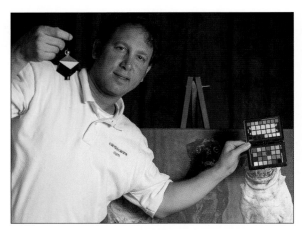

Fig. 9.1 In just one shot, the Datacolor SpyderCube (in my right hand) can give me two gray surfaces, two white surfaces and a black area with a black hole to help me set a maximum black. In my left hand is an X-Rite ColorChecker Passport. Photo © Whitey Warner

THE X-RITE COLORCHECKER PASSPORT—This is a durable, passport-sized color calibration tool with two sets of color patches (one for making a custom profile and one for white balance when using software that has a white balance option). It also has a 20 percent gray target that is useful for making an in-camera custom white balance. Cost is about $90.

THE DATACOLOR SPYDERCHECKR & SPYDERCHECKR 24—Both of these products contain color patches that can be captured and used to make a set of corrections that can be preset in Adobe Camera Raw or Adobe Lightroom. They both also contain a large gray target for white balance (especially good for in-camera white balance). The SpyderCheckr 24 is much smaller and has just one sheet with two sides, instead of two sheets with two sides each.

That makes it less expensive and much easier to carry around. However, you will need to zoom in or get much closer to the SpyderCheckr 24 target because you need to include a fairly large portion of the target in the frame for best results. Cost is about $110 and $50.

THE DATACOLOR SPYDERCUBE—This small, simple, but powerful product makes it easy to set highlights, midtones and shadows once you import your photos into an image editor like Photoshop. It comes with a tripod socket, which I usually attach to a small tripod. That makes it easier to place on the ground or a table. Cost is about $50.

The term "gray card" is used to cover a wide range of items that can help create a proper gray balance by taking a photo of the card and clicking on a specific area in post-production, or establishing a proper exposure by just metering off of the card by including it in photos and using your camera's reflective meter as you take the picture. You can find white, gray and black reference cards online and in camera stores for as little as $10, but you often get what you pay for so I recommend reading reviews and doing some testing before using them for important work. I also recommend keeping any of the gray balance tools you purchase in a plastic zipper bag or bag made for preserving photo prints, along with a small desiccant pack, like those described in the Small Zipper Bags section on page 96.

HOW TO CAPTURE IMAGES OF TARGETS/GRAY CARDS CORRECTLY

As I mentioned before, shooting in your camera's Raw mode allows for maximum color adjustment flexibility and image quality. However, this process also works well if you are shooting in JPEG mode.

Make sure that you are capturing the gray card or other target in the same light as your subject (if possible, it's best to have your subject hold the card). If there is mixed light (for example, daylight from a window and indoor lighting from traditional lightbulbs, take a few photos with the target angled toward each light. Unlike all the other tools I've seen on the market, the Datacolor SpyderCube allows you to get light readings from different angles in one shot (see fig. 9.1). You can use auto white balance, but I prefer to choose a white balance setting if I know what the lighting is in the scene. I can then apply corrections to all the other photos taken in the same lighting conditions.

To help ensure that you get a properly exposed image, set your camera to Auto Exposure Bracketing and choose a 1- or 2-stop bracket. Then set your camera to Continuous Shooting mode so that you can take three quick shots of the target. You can then choose the best photo later in Adobe Lightroom, Photoshop or Camera Raw. Once in the program you plan to use, just place the white balance eyedropper tool over the gray or white patch and click to set the white balance.

Remember that accurate color is not necessarily pleasing color. Often, perfectly accurate color is a bit too cool (bluish) for us humans, so after getting perfect color balance, I recommend moving the color balance slider just a bit toward a warmer setting, or adding a bit of warmth to your photos until they look their best.

HOW TO MAKE AN IN-CAMERA CUSTOM WHITE BALANCE ADJUSTMENT

An in-camera custom profile can help you save time later and allow for a very accurate image on your camera's LCD. Each camera is slightly different, so follow the instructions for your camera to create a custom white balance. I recommend at least a 2 x 3-inch target so that your camera is not fooled by not having enough of the gray card in the image. You usually don't have to fill the frame with the target, but it helps. Also, the target does not have to be sharp, which can help if you are holding it in your hand with a lens that can't focus from just a few feet away.

You can find a useful step-by-step white balance/gray balance process for most Canon and Nikon cameras by searching for "Custom White Balance" on www.digitalphotomentor.com.

A NOTE ON SCREEN AND PRINTER CALIBRATION

I would be remiss not to mention screen/monitor calibration. Both X-Rite and Datacolor make high-quality hardware devices that help you calibrate and then create monitor profiles to help make the color, brightness and contrast of what you see on your monitor as accurate to the actual data as possible when compared with a known set of standards. In other words, if you calibrated and profiled 10 different monitors using a hardware device with included software (examples include the X-Rite i1 Display Pro and Datacolor Spyder5Pro), each display (as long as they are all capable of displaying the same number of colors) should look very similar when viewed side by side. A properly calibrated screen can also help you to produce prints (either on your own printer or by a lab/service bureau) that closely match when viewed next to your screen, as long as they are placed under daylight or a daylight-balanced light.

It's also possible to make custom profiles for printers, which includes printing a target (a set of

color patches) on a printer, then reading them into the computer with a product like the X-Rite ColorMunki Photo or Datacolor SpyderPrint, and creating a custom profile. I've written a book on this topic called *301 Inkjet Tips and Techniques*, and you can find more on color management at www.imagingbuffet.com.

ONLINE RESOURCES

Both Datacolor (www.datacolor.com) and X-Rite (www.xrite.com) post excellent tutorials online for using their products, as well as Adobe Photoshop and Adobe Photoshop Lightroom, in the field. A search for any of the color management product names and the word "review" will also bring up some excellent reviews and how-tos, including a particularly good one of the Datacolor SpyderCheckr by Keith Cooper of Northlight Images (www.northlight-images.co.uk). X-Rite's many video tutorials hosted by Joe Brady are also excellent and frequently include in-depth tips for making better photos. Datacolor also has many useful videos on different color management and photography-related topics.

PRO ASSIGNMENT

30 WELL-BALANCED PHOTOS

Take at least 30 photos using these parameters:

1. Take photos of the same scene using at least four different in-camera white balance settings. This will be easier to do if your camera is on a tripod. You may be surprised at how interesting some of the images will look using the "wrong" white balance settings.

2. Take a photo of a gray card or other white balance tool as described in this tip and the recommended online resources. Then set your camera's internal white balance based on your manual's instructions (the setting is called custom white balance). Just remember that if you change lighting situations, you'll probably need to make a new custom white balance.

3. Bring your files into a photo editing application and experiment with the gray balance tool to correct the scene. This is especially powerful if you did not set a custom white balance in your camera.

4. Adjust the color balance a bit to taste (usually by making the image a bit warmer), and apply that setting to all the photos you shot in the same light.

5. View the corrected image in your photo editing application using at least four different white balance settings or color temperature numbers so that you can see how the look and feel changes as you adjust the color balance.

MASTERING BACK BUTTON FOCUS

Autofocus (often abbreviated as "AF") on modern DSLR, mirrorless and compact cameras has made the once-difficult process of achieving focus much faster and easier. Back button focus is a very popular technique that sets the focus point in your scene with the press of a button (generally located in the top right back of the camera, as shown in fig. 10.1) as opposed to the more traditional half-press of the shutter button. Back button focus allows you to quickly lock focus on an object in the scene, much like aiming at a target in a video game. Virtually all DSLRs and mirrorless cameras support back button autofocus.

Fig. 10.1 A back button capable of setting autofocus is circled on three different cameras (left to right, clockwise: Canon EOS 6D DSLR, Canon EOS Rebel T4i and Panasonic Lumix DMC-LX5).

Once focus is locked, you can release the back button and keep shooting a subject without having to constantly refocus, as long as your camera and the subject don't move forward or back very much. If they do, they may no longer be in focus.

This is especially useful if your focus point is off-center, as is the case when photographing one or two people or animals for a horizontal or vertical portrait.

Fig. 10.2 Camera: Canon EOS 6D; Lens: Canon EF 28-135mm f/3.5-5.6 IS @ 38mm; f-stop: f/7.1; Exposure: 1/200 Sec.; ISO: 500; Lighting: off-camera flash in an umbrella

A vertical portrait generally requires you to focus on the subject's eyes. For optimum sharpness, this would require changing your focus repeatedly to the top of the frame by either moving a focus point to the area where a face is located, or focusing using a center focus point, then recomposing, which wastes valuable time. The back button focus technique will work whether you are using an autofocus mode that locks focus and doesn't change until you release your

finger from the back button (called One Shot AF on Canon, and AF-S on Nikon), or one that allows you to track a moving subject (called AI-Servo on Canon and AF-C on Nikon).

Some cameras have the ability to detect heads and/or eyes, which can avoid the need to adjust your focus point. Like anything else, it's best to test any features and see if they work well for you.

Fig. 10.2 is a good example of when you might set the focus point in a place other than the center of the frame, whether or not you also use back button focus. I used a single center autofocus point and back button autofocus to lock focus on one of the dogs' heads, then recomposed because

I was taking a number of different photos from many different angles, with both dogs and with each dog separately. However, when you intend to take many photos of subjects like this (especially if the camera is on a tripod), it makes sense to move an autofocus point in your viewfinder (represented by a bright-colored box on most live view LCDs and EVFs) over the area where one of the subject's heads is located so that you can avoid having to lock focus using a center point, followed by recomposing the shot over and over.

Spot focusing points are usually represented by small red dots or small, brightly colored boxes in your OVF, EVF or live view LCD. Setting a single spot focusing point can also be useful if you have your camera on a tripod set at one zoom

Fig. 10.3 Camera: Canon EOS Rebel T4i; Lens: Canon EF 70-300mm f/4-5.6 IS @70mm; F-stop: f/4; Exposure: 1/400 Sec.; ISO: 400; Lighting: Late afternoon daylight and tungsten-balanced garden lighting

level and focused on one area, like a jump at an equestrian event (or second base on a baseball field). And this technique works exceptionally well if you have two cameras. The one focused on a specific location can be triggered by a remote shutter release while you are following the action with another camera because the remote release will not cause the camera to refocus. (See page 91 for more information on remote shutter releases.)

An example of how I used back button focus to lock focus can be seen in Fig. 10.3. I moved a single focus point to the left of my viewfinder. I then released the back button so that I could compose the shot and take multiple photos of the water lily and lily pads from the same position.

BACK BUTTON FOCUSING IN ACTION

1. Check your manual, a book or an online video to learn how to turn on back button focus (first, without the shutter button focus active, which will cancel out the back button focus if you lock focus with the back button and release the button to take a picture). Some mirrorless and compact cameras allow you to have the autofocus on and "live" at all times without pressing any buttons (often called "Full-time AF"), so be sure to turn that off. The next tip covers "both button" focus, where both the back button and shutter button can control autofocus.

2. Change your autofocus mode to the one that allows you to lock focus—called One Shot AF (Canon) and AF-S (Nikon and Sony)—and position the autofocus area to a single center point or square. An example for using back button focus can be seen in fig. 10.3. In this example, I used back button focus to lock focus on the water lily to the left using a single focus point in the center of my viewfinder. I then released the back button so that I could compose the shot and take multiple photos from the same position.

3. Take some photos of two people in horizontal orientation and a single person in vertical orientation. Notice that when you lock focus on one of the two people and then take your finger off the back button, focus will stop being adjusted, but you can take sharp pictures using the shutter release. For the single person, change your focus point to an area near the person's face, and focus on their eyes. Then release the back button and take a few photos. You won't have to reframe your shots much using this approach.

4. Set your autofocus mode to the setting that allows you to follow an object while the camera adjusts the focus. For example, AI-Servo on Canon and AF-C on Nikon and Sony. If you keep holding down the back button, you can continuously track a subject until you take the photo, and the camera will stop focusing any time you take your finger off the back button.

5. Set up your camera on a tripod, homing in on a specific area that has repeatable action happening around it, such as a bird feeder, the goal on a soccer field, etc. Lock focus using the back button and a specific AF point or square, then use the shutter button to take a series of photos. Then set up a remote shutter release for the first camera so that you can take photos handheld with another camera. Using live view on the tripod-mounted camera's LCD screen as the action gets close to the target area can help you get a higher percentage of great shots.

MASTERING BOTH BUTTON FOCUS

What's both button focus? Both button focus is a term I came up with that describes how you can use back button focus while continuing to use the shutter button for traditional half-press focus. Most people think that's impossible because they believe that the shutter button will override the back button focus. But here's the trick: keep your finger pressed on the back button focus while you take a photo or multiple photos, and the shutter button will not change the focus point even if you move your camera. The key is to keep your autofocus mode set to the autofocus setting that locks focus (called One Shot AF on Canon cameras and AF-S on Nikon and Sony cameras), but not set to a continuous autofocus option such as AI-Servo on Canon cameras, Continuous-Servo AF (AF-C) on Nikon cameras and Continuous AF (AF-C) on Sony cameras.

The Canon EOS 6D DSLR allows a lot of button customization, including autofocus control using the shutter button and AF-ON (back button) for both button focusing. In fig. 11.1, I chose the AF-On menu item to set it. Fig. 11.2 shows how to adjust the AF-ON button.

Fig. 11.1 The Custom Function III menu on a Canon EOS 6D DSLR.

Fig. 11.2 Here, I set the AF-ON button to control autofocus. I did the same for the shutter button, which allowed me to use both button focus.

The ability to use both buttons for focus is not available on all cameras, but if your camera supports it, I recommend trying it out. Like with traditional back button focus, your photos taken without a tripod should be a bit sharper at lower shutter speeds compared with photos taken with shutter-button focusing because you'll be creating extra stability with your thumb on the back of your camera while pressing the back button. The other main advantage is that, when combined with spot focusing (choosing one focus point or square in the viewfinder or EVF), you can lock focus more easily and precisely than using a half-button press. As I mentioned in Tip 10, it's a lot like aiming at a target in a video game.

The one negative aspect of this approach is that unlike the traditional back button focusing technique, if you take your finger off the back button any time while taking photos, your shutter button will take over control of the focus. That means that if you want to put your camera on a tripod and lock down focus on an area outside the highlighted autofocus zone (such as a goal on a soccer field), you'll need to switch to manual

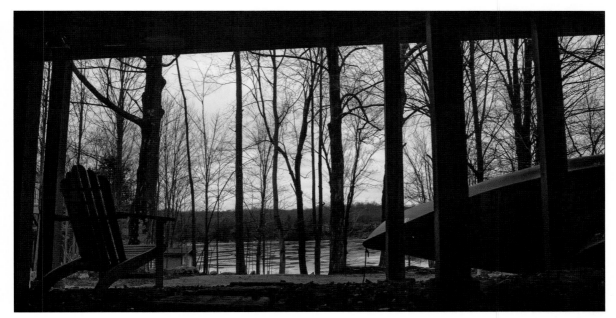

I took this photo at about 7 p.m. in January in the Pocono Mountains of Pennsylvania with my camera set to both button focus.
Camera: Canon EOS 6D; Lens: EF 28-135mm f/3.5-5.6 IS @ 28mm; F-stop: f/5.6; Exposure: 1/250 Sec.; ISO: 1600

focus or change to the traditional back button autofocus technique. For me, that's a small issue, since I'm almost always shooting handheld, and I feel more confident that what I'm shooting will be in focus when using the both button focusing technique. With the traditional back button setup, it's possible to forget that you are using back button focus, resulting in pictures that are not properly focused, especially at lower f-stops like f/2.8, f/4, etc. (See Tip 1 for more on f-stops and aperture).

MASTERING MOTION PHOTOGRAPHY WITH STILL PLUS ZOOM

Capturing motion in an image is like having a personal time machine. Photography allows us, in a single frame, to produce images that cannot be seen in the real world. Whether taken day or night, the results can be unique and captivating. The "still plus zoom" technique (that's not an official name for it, but I like the description) is one that's been used by photographers for many years.

By exposing an image for a short time in a still position (for example, when on a tripod), then zooming your lens in or out during that exposure, you can produce very interesting results. You will need to use a camera that allows manual zoom to produce this effect.

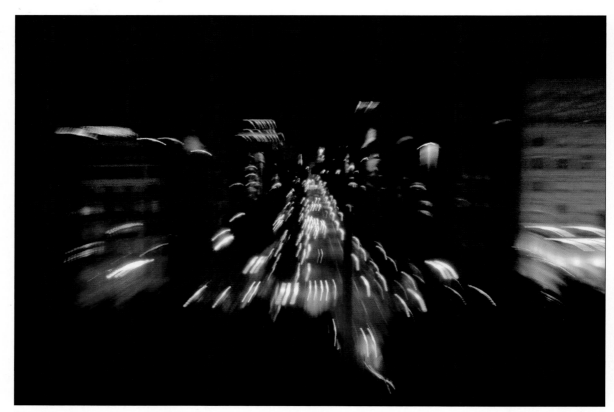

Fig. 12.1 Camera: Sony DSC-F828; Lens: built-in Carl Zeiss 28-200mm @ 28mm; F-stop: f/5; Exposure: 1/5 Sec.; ISO: 200; Lighting: evening daylight, vehicle lights and city street lighting

Fig. 12.1 was photographed from the top of a hotel in Barcelona, Spain. I held the camera still on a ledge, then adjusted the zoom ring during the exposure. I took more than 30 photos of the scene, and every one of them is quite different, which makes this technique unpredictable and a lot of fun.

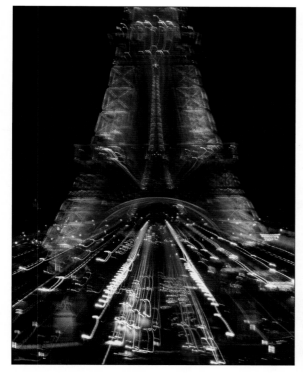

Fig. 12.2 Camera: Sony DSC-F828; Lens: built-in Carl Zeiss 28-200mm @ 28mm; F-stop: f/8; Exposure: 1.6 Sec.; ISO: 100

PRO ASSIGNMENT

STILL PLUS ZOOM PHOTO SESSION

1. On a day or evening shoot, place your camera on a tripod with something interesting in the scene. Something with point light sources, like the Eiffel Tower at night (fig. 12.2), can be especially interesting. Well-known landmarks are excellent subjects because people will recognize them even if they are blurred or distorted in some way due to the motion effect.

2. Set your lens to manual focus; it's generally the best option because you are taking a long exposure photo on a tripod or other stable support. However, if you plan to adjust your zoom level a lot, then manual focus may get tedious. A quick tip is to use AF to set focus quickly, and then switch your lens over to manual focus.

3. Set your shooting mode to Aperture Priority, Shutter Priority or Manual. Keep the ISO fairly low (e.g., ISO 100 or 200) because the exposure will need to be relatively long (1/5 second to about 3 seconds). Shutter Priority and Manual modes will give you the most control over the look of the images, and you will see in advance exactly what your shutter speed will be when you take a picture.

4. Place your camera on a tripod or other firm support and set your zoom lens to any zoom setting. I prefer setting the zoom to a wide setting and then zooming in during the exposure to create the effect seen in fig. 12.1.

5. Assuming you are using Shutter Priority or Manual mode, set your shutter speed to 1/2 second and take some photos first without making any zoom adjustments so that you can more easily set focus and a proper exposure. If you are using Aperture Priority, check to see what the shutter speed will be at different apertures and change apertures as you take a series of photographs.

6. Set your camera's shooting mode to single shot to avoid taking multiple exposures while zooming.

7. Wait about half the exposure time (e.g., 1/4 second if your shutter speed is set to 1/2 second) then carefully start manually zooming in or out while minimizing camera shake. Try the same technique with the shutter speed set to 1 second, 2 seconds and 3 seconds. There's no right combination of time for the lens to be still and zooming in or out. If you know what lens setting you started at, you can easily return to that setting and take many photos that will be sharp. Experimentation is key!

MASTERING MOTION PHOTOGRAPHY WITH ROCKING OR SWINGING

Not only is rocking back and forth on a swing or hammock a stress reliever, it can also provide an easy place to practice creating striking images of motion. To create the photo shown in fig. 13.1, I relaxed on a hammock and did my best to keep the camera still as I looked up into the sky and peered through the viewfinder. I got the most interesting results when I rested the camera on my chest and used my body as a makeshift tripod. My body, the hammock and my feet stayed relatively sharp because they were moving in tandem with my camera. Set to Aperture Priority mode, the camera automatically adjusted for an interesting range of shutter speeds and blur amounts based on what the meter was seeing as I was moving. Depending upon the focal length

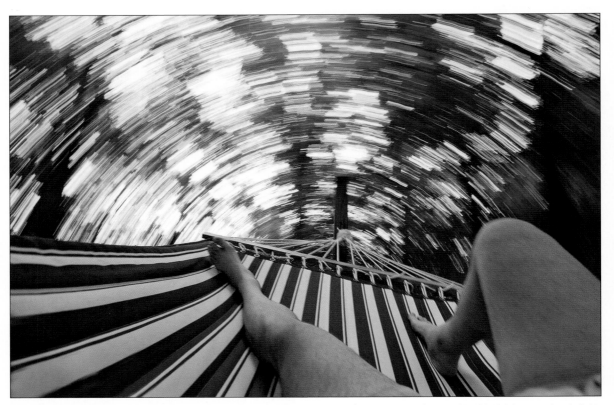

Fig. 13.1 Camera: Canon EOS 20D; Lens: Tamron 11-18mm Di II @11mm; F-stop: f/4.5; Exposure: 1/2 Sec.; ISO: 400; Lighting: morning daylight streaming through trees

and shutter speed of your lens, and the speed at which you are moving, the look will be very different.

Shutter Priority and of course Manual exposure mode also work well in this type of situation. Shutter Priority allows you to determine how long your exposures will be (the aperture will then be adjusted for you). The advantage of that mode is that the amount of blur should be fairly consistent if you are rocking or swinging at a similar speed from shot to shot.

A variation of this technique could be called "still plus snake," which is the technique I used in the photo of the Eiffel Tower in fig. 13.2. Instead of zooming the lens during the exposure, after about a second, I jostled the camera left and right to create the look you see.

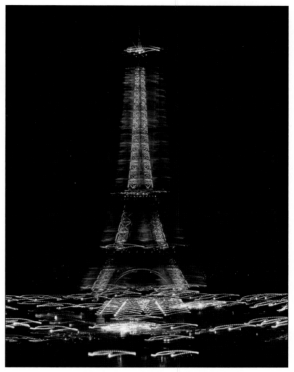

Fig. 13.2 Camera: Sony DSC-F828; Lens: built-in Carl Zeiss 28-200mm @ 28mm; F-stop: f/8; Exposure: 1.6 Sec.; ISO: 100

PRO ASSIGNMENT

ROCKING OR SWINGING PHOTO SESSION

1. Position yourself on a swing, hammock, rocking chair or other object that moves back and forth.

2. Set your lens to manual focus and your shooting mode to Aperture Priority, Shutter Priority or Manual. Manual focus and exposure gives you the most control because you can easily fine-tune the exposure, then lock it in for the scene. Because the exposure will be relatively long, you will probably need to keep ISO at a fairly low setting (e.g., ISO 100 or 200).

3. If you are lying on a hammock, place your camera firmly against your body (over your head in a normal shooting position if shooting upward, and over your stomach or chest for photos of what's in front of you). Include a part of yourself in the photo. If you have a pet resting on your lap or sitting next to you, that can make for some great images.

4. Set your zoom to any setting. I generally prefer a very wide view, but it all depends on the scene.

5. Assuming you are using Shutter Priority or Manual exposure, set your shutter speed to 1 second and take some photos first without making any zoom adjustments so that you can more easily set focus and adjust the aperture or ISO for a proper exposure. Then try 1/2 second and 1 second.

6. Set your camera's shooting mode to Continuous Shooting (burst) or Single Shot mode. Both will work just fine, but you'll get more photos starting from different points in your rocking or swinging when using a Continuous Shooting mode.

7. Now that you know your exposure is good, start rocking or swinging, and take at least 100 photos (a friend can come in handy here to give you a little push, especially if you are on a hammock)!

TIP 14

REDUCING AND USING FLARE CREATIVELY

Lens manufacturers work hard to create products that show as little flare as possible in captured images. Lens flare manifests itself in the form of reduced contrast, blown-out areas and bright circles of different sizes and colors. That being said, flare can also add drama and character to both photographs and video. These tips are designed to both help you reduce flare and use it at select times to add style to your images.

REDUCING FLARE

DON'T SHOOT DIRECTLY INTO THE SUN—The best way to avoid flare is to not shoot directly into the sun. The sun can also indirectly affect the scene and cause flare, such as when it produces bright reflections on buildings or a body of water.

UTILIZE A LENS HOOD—Another way to reduce flare is to use a lens hood (also known as lens shades). These can do wonders, though they have their negatives, including sometimes being bulky (especially with telephoto lenses) and causing vignetting, or a reduction in brightness (sometimes very pronounced) around the edges of images (especially with wide-angle zoom lenses). You can quickly test if vignetting is a problem by setting your camera to live view and viewing a bright scene like a cloudy or blue sky while you zoom to your lens's widest setting. My favorite lens hoods are rubber because they collapse and extend quickly and easily. (Figs. 14.1 and 14.2 show

Fig. 14.1 A fully extended collapsible lens hood attached to my Canon 28-135mm IS lens.

Fig. 14.2 An overhead view of the same lens with the hood fully retracted.

two views of a fully retracted collapsible lens hood.) Other lens hoods can take up so much space that they won't allow a camera and lens to fit in a bag unless the shades are removed or reversed.

VIGNETTING: ONE EASY FIX

Some lenses show vignetting around the corners of the image even without a lens shade, and that problem can often be fixed by shooting in your camera's Raw format and checking the box that applies a camera lens profile available from inside an application like Adobe Lightroom or Adobe Camera Raw. Lens profiles are custom adjustments used in conjunction with a software application that can correct imperfections with specific lenses. Sometimes the amount of vignetting removed is truly incredible. You can also manually adjust the setting using the same software, and you can easily undo all or some of the adjustments.

USING FLARE CREATIVELY

SHOOT DIRECTLY INTO THE SUN OR BRIGHT LIGHTS—Be careful when you do this, though, especially with telephoto lenses because they can intensify the light and lead to eye or camera damage. To reduce the chances of damage to your camera, consider using a polarizing filter or a neutral density (ND) filter like the very high-quality, yet affordable Tiffen 77mm 0.9 Neutral Density Filter (it provides three stops, or more accurately, a 3 EV exposure reduction). That means that it reduces the amount of light coming into the camera just as if you had reduced the f-stop from f/2.8–f/8. I took the photo in fig. 14.3 at a concert with no lens hood and aimed the camera toward the bright lights, which added to the flare effects.

COLD CLEAR CONDITIONS—Some of my favorite times to include the sun and encourage flare are on cold, clear mornings in the fall and winter when there are leaves and/or snow on the ground. Other times include early mornings and late afternoons when the sun is not as strong, as well

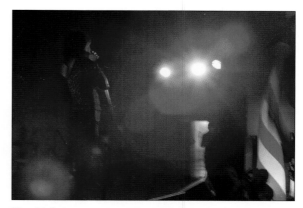

Fig. 14.3 Camera: Canon EOS 40D; Lens: EF 16-35mm f/2.8L @ 35mm; F-stop: f/16; Exposure: 1/8 Sec.; ISO: 1250

as in a studio when I'm photographing people or pets. By including a light or two in the scene during a studio session, flare (subtle or significant) can really add to the look and feel of the image. You can achieve a similar look outside by placing the sun behind your subject and taking photos as the sun shows up just a bit, or very significantly. You'll probably want to use a flash in these cases (or a large reflector that's reflecting light back) to give your subjects a proper

These two photos show how a small change in camera position or a change in the sun's location can have a big effect on the overall look of an image, as well as the amount of flare. In this image, there is no flare.
Camera: Canon EOS 6D; Lens: EF 16-35mm f/2.8L @ 16mm; F-stop: f/8; Exposure: 1/1000 Sec.; ISO: 400

The flare is not very apparent in this image, but it's there, and the sparkle of the sun helps to make it look interesting. In this case, the flare would be easy to remove, but I like it so it's staying!
Camera: Canon EOS 6D; Lens: EF 16-35mm f/2.8L @ 16mm; F-stop: f/8; Exposure: 1/1000 Sec.; ISO: 400

Fig. 14.4 Camera: Canon EOS 6D; Lens: EF16-35mm f/2.8L USM @ 16mm; F-stop: f/7.1; Exposure: 1/2000 Sec.; ISO: 1000

exposure. Fig 14.4 was captured just after sunrise at a sunflower field. I used no lens hood and included the sun in the frame, which, combined, produced the flare in the photo.

AEB—Auto Exposure Bracketing is your friend whenever the sun and flare are involved because your camera's meter will probably cause your camera to change exposure often as you refocus and recompose in these situations. I would recommend a normal, as well as a +2 and -2 EV AEB, for a total of three exposures for each scene. Tip 6 (page 24) has more on AEB.

Tip 6 (page 24) has more on AEB.

PRO ASSIGNMENT

LENS FLARE CONTROL

1. Take a few photographs outside, with and without a lens shade on each of your lenses, facing toward and away from the sun (taking into account the safety suggestions about looking through a viewfinder when zooming into the sun). To better distinguish between the photos you take with and without the shade, you can jot down the file numbers for the photos in which you use the lens shade, or you can take a picture of a sign or something like one of your hands or feet when you begin each set so you know which photos were taken with a lens shade.

2. Play peek-a-boo with a tree and the sun! This can produce absolutely stunning results. Start by focusing on one or more trees that have the sun behind them, then start taking pictures of the trees with no sun spill and some with progressively more sun peeking through.

3. Take photos very early in the morning and late in the day as the sun rises and sets, being sure to include the sun in different ways (vertical and horizontal, wide and telephoto).

4. Use a raw processing program like Adobe Lightroom or Adobe Camera Raw to apply a profile for your camera/lens combination. If one does not exist, you can make manual adjustments that can also help reduce vignetting. This will generally remove darkness in the corners of the frame and correct some distortions created by some lenses.

CAPTURING GLARE-FREE PICTURES THROUGH WINDOWS

Whether trying to capture the perfect image of a bird, bear, street scene, window display or cityscape, sometimes the best shots are presented through glass. Here are some tips for getting photos that will make people think there was nothing between you and your subject, as well as some that explain how to use reflections to create dramatic effects and self-portraits.

PROTECT YOUR LENS *AND* THE WINDOW—This simple, inexpensive tool is crucial for any pro photographer, but is too often overlooked: a collapsible rubber lens hood. You don't want to smash your lens or lens hood into (or through) a glass window (it's not hard to scratch or even break glass, depending on its thickness). My favorite way to avoid catastrophe is to cushion the lens when it is against the glass using a rubber lens hood

For this photo, the camera's live view was very helpful in framing because it allowed me to experiment with interesting angles.
Camera: Panasonic Lumix DMC-LX5; Lens: Built-in 24-90mm @24mm; F-stop: f/2; Exposure: 1/4 Sec.; ISO: 400

(retracted back), like you see in fig. 15.1. The added cushion will allow you to move around the window in search of the perfect shot without damaging anything. Just search for "rubber lens hood" online or ask for one at a camera store. Your lens's filter size (usually 39–77mm) can usually be found printed or embossed on the inside of your lens cap, or on the lens's front barrel. A small microfiber cloth can also be used as a cushion, but keeping it out of the shot can be cumbersome.

SHOOT AT A 45-DEGREE ANGLE—By placing your camera lens at a 45-degree angle against or very close to the window, you will stabilize your camera, and at the same time, dramatically reduce reflections. Your autofocus should also still work fine when you use this technique, but some autofocus lenses don't focus internally, so the front element may rotate. In this case, you should focus manually, or avoid touching the window so that you don't damage the lens. You should also turn off your flash. If your camera has live view and/or an articulating screen (one that can twist and angle like a TV mount), you can often position your camera in spots that a viewfinder cannot reach, but that you can still see.

Fig. 15.1 I've positioned the camera at a 45-degree angle against the glass to reduce reflections. Note how a retracted Kalt rubber lens hood gets compressed a bit while it protects the lens and window.

NOT ALL REFLECTIONS ARE BAD

Often, the window through which you're shooting will contain a distinctive feature that will help the viewer better understand the location, or it will just give the photo an interesting look and feel. Photographing one can be absolutely beautiful, especially when you see what's inside a window, but also what's on the other side reflecting back. If you step back a few feet from the window, you can create amazing images, and depending on how you frame them, you can also capture self-portraits of yourself hard at work, or even a few friends or family members.

While experimenting with different angles, I found it interesting to include some subtle reflections from inside the building where I was taking photos. You can see a similar example in Tip 46.

Camera: Canon EOS 40D; Lens: EF 17-40mm f/4L @ 17mm; F-Stop: f/4; Exposure: 1/5 Sec.; ISO: 1000

FOR MORE STABILITY, USE A MONOPOD—A monopod, which rests on a single leg, can do wonders in window photography situations. Position it so that it offers more stability than handholding while still allowing you to keep the front of the lens against, or very close to, the window.

USE LONGER EXPOSURES TO CAPTURE MOVING CARS OR PEOPLE—Since you are using the window or a monopod to help stabilize your image, experiment with longer shutter speeds if there are things that move in the scene. Light trails at night are a good example, and slightly blurred people can be very interesting, too. To keep the image sharp for fig. 15.2, I leaned against the side of the window while positioning the camera at a 45-degree angle against the glass. Yes, that's a six-second exposure!

REDUCE REFLECTIONS WITH A BLACK CLOTH—Another trick to really cut down reflections off of glass is to hang a black cloth on the window with a hole just large enough for your lens, or work in a darkened location. Painter's tape can really save

Fig. 15.2 Camera: Canon EOS 40D; Lens: EF 16-35mm f/2.8L @ 16mm; F-stop: f/22; Exposure: 6 Sec.; ISO: 640

Fig. 15.3 Camera: Canon EOS 5D; Lens: EF 28-135mm f/3.5-5.6 IS @ 28mm; F-stop: f/3.5; Exposure: 1/1250 Sec.; ISO: 500

the day in these cases because it probably won't leave any residue on the glass, especially if you don't keep it on the window for days. A jacket or piece of dark fabric placed over your head like an old-fashioned photographer's focusing cloth can also do the trick, but it probably won't be quite as effective. The photo in fig. 15.3 was taken from the cabin of a plane; it shows very few reflections on the glass because it was relatively dark inside.

PRO ASSIGNMENT

100 WINDOW PHOTOS

Take at least 100 window photos using these parameters:

1. Take photos from a window at a home, hotel or office building, as well as from the sidewalk on a street. Start by using Aperture Priority mode to control your depth of field, and aim to have shutter speeds of about 1/60 second or faster. You may have to increase your ISO to do that if you are shooting at night.

2. Take photos of something that includes moving objects on the other side of the window. For these, Shutter Priority mode gives you the most control. Try some slower exposures, such as 1/30, 1/15, or even 1 or 2 seconds. Be sure to check focus since it won't be easy to handhold at

those speeds, even when up against the window. Use a monopod as described above for better stability.

3. Take photos in both vertical and horizontal orientations, and adjust your zoom if you are using a zoom lens.

4. Take photos from a moving car or plane. Take some that use the techniques above to eliminate reflections, and also some that show the windows or parts of the windows, which can be very interesting.

5. Take some photos a few feet away, then many feet away from the glass. Include the window, and include yourself in a few of them. Once you have the overall scene set, move the camera away from your face and smile in at least one of them!

TIP 16

HOW TO GET THE MOST OUT OF CROPPING AND ZOOMING IN

Zooming into a scene while you are taking photos is the best way to get the most detail from an image, but it's not always possible. That's where cropping comes in. I've always been amazed at the photographs that I find "hiding" inside other photographs, and today's 16–30+ megapixel cameras give us a tremendous amount of data to search through and find hidden treasures. Until you see how powerful cropping can be, you probably won't believe what can be achieved. Here are

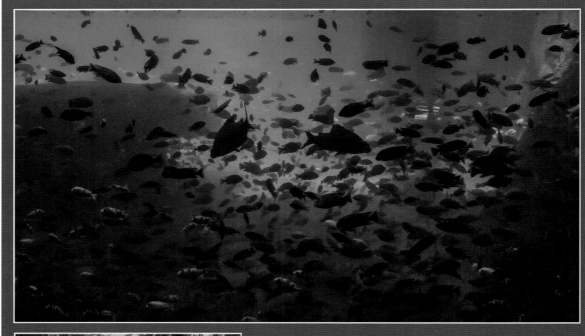

The location where I took this photo (top) had a large glass aquarium with the ability to see above and below the water line (left). The lighting was natural light from the sun. I chose a Cloudy white balance and did not have to change it at all when post-processing.

Camera: Panasonic DMC-LX5; Lens: Built-In 24-90mm @ 24mm; F-stop: f/5.6; Exposure: 1/60 Sec.; ISO: 800

a few tips for getting the most out of cropping after the shot.

DON'T DELETE YOUR PHOTOS TOO FAST—Sometimes, a simple crop with a slight rotation to level a horizon will transform a "ho-hum" photo into a winner. I like using Adobe Lightroom for almost all of my cropping because I can easily revert back to the uncropped version. One thing you can't do in Lightroom, though, is crop outside the bounds of a photo after rotating it, so for that, I use Photoshop. I can then preserve important details, and then use a tool like Content-Aware Fill or the Rubber Stamp to fill in the area(s) that need to be filled after the crop.

MAKE VIRTUAL COPIES—Often, you'll find strong vertical or square images inside photos that you've shot in the horizontal orientation, or horizontal images in vertical photographs. By using Virtual Copies in Lightroom, you can quickly make different versions of the main image and then crop to your heart's content. This can also be done in other applications by duplicating the photograph and cropping it multiple times. If you do use Lightroom, I recommend optimizing the image's brightness, contrast, color, sharpening, etc.,

On the left is an uncropped image. To the right of it is a good example of how you can crop an image to create a more dramatic look and feel. Of course, there are limits to how much you can crop and still get acceptable detail and sharpness for your needs, since your pixel count will decrease.
Camera: Canon EOS Rebel T4i; Lens: EF-S 18-135mm f/3.5-5.6 IS STM @ 135mm; F-stop: f/5.6; Exposure: 1/1600 Sec.; ISO: 800

before making Virtual Copies, or create a Preset that has the corrections in it so that you can quickly apply the corrections to the final cropped versions.

USE AN ADJUSTABLE MASKING FRAME FOR VISUAL CROPPING

—If you've printed in the analog darkroom, you will be familiar with a masking frame, which is an item that allows you to mask out a square-shaped area in many different sizes on a baseboard under an enlarger head. A traditional darkroom enlarger head holds a lens, lamp and film carrier, and travels up and down to allow for different size prints to be exposed on photo-sensitive paper.

You can create your own masks with two L-shaped pieces of paper, foam or illustration board (black is the best color to use because it allows you to focus on what's inside the crop area). Make the sides of the Ls at least as long as the largest print you plan to crop, or you can make a set that matches the size of your computer screen so that you can visually crop anything on your screen. In that case, both Ls will look like capital Ls, with one side being the width of your screen and the other side being the height of your screen. A good width for the Ls is 2–3 inches (5–6 centimeters). You can also adhere a flexible ruler to each side

for when you want a specific cropping ratio, like a perfect square, 2:3 or 16:9, or you can draw your own measurement marks on all four sides.

One of the most effective uses for an adjustable masking frame is when you are planning to make prints, a book, etc., and want to crop a series of images either on-screen or as prints. It's faster and often easier to start with a "real-life" cropping tool, and it allows anyone to share their opinion, even if they don't know how to use a specific program.

I often use a homemade adjustable mask when showing my portrait clients 4 x 6 printed proofs of selected photographs. It's common for me to crop to a square or other size for various prints, and the way I do this with clients is to place the cropping Ls on the print until the crop looks just right. Fig. 16.1 shows black illustration board that I cut into four moveable strips on a cutting mat using a utility knife. I recommend using a safety ruler to help reduce the chance of getting cut. When you have your strips cut, attach 3M Dual Lock Reclosable Fastener TB4570 Low Profile Clear Mated Strips to the entire length of one side of each strip of illustration board (fig. 16.2). This will help make adjusting the mask very easy (like using Velcro Hook and Loop) while still allowing

Fig. 16.1 My preferred tools for creating the cropping Ls are an Olfa Gridded Cutting Mat with the awesome Olfa Pistol Grip Ratchet-Lock Utility Knife (L-1).

Fig. 16.2 The completed mask with 3M Dual Lock Reclosable Fastener TB4570 Low Profile Clear Mated Strips attached to the entire length of one side of each strip of illustration board.

Fig. 16.3 Homemade adjustable mask covering a 4 x 6 printed proof.

Fig. 16.4 The final panoramic image after using the cropping technique on four images.

them to easily separate. I then take a photo of the mask covering a print (fig. 16.3) with my smartphone so that I can use that as a quick reference later. The whole process moves very quickly, and no computer is needed.

Fig. 16.4 is a finished example of how I worked with a client to choose square crops from 4 x 6 prints for a canvas composite print. The key is to take pictures from right above the print with the cropping Ls so that you can refer to them later when making final crops.

TAKE A STEP BACK—Sometimes you may be in a situation where you want to take a portrait of one or more people, but you don't have a medium to telephoto lens (about 50–200mm), which makes faces look less distorted than with wide focal

lengths (10–40mm in 35mm terms would be considered wide focal lengths). As long as you have a camera with enough resolution to retain the detail you need, you can just step back a few feet and crop the photo later to approximate the look of a longer lens. Similarly, you can crop into photos of birds or other small animals when you can't get quite as close as you'd like with your camera/ lens combination. Just keep in mind that the resolution and detail will be lower than if you had zoomed in, but with many of today's cameras it won't make a huge difference, especially if you are not making large prints.

PRO ASSIGNMENT

CROPPING AND ZOOMING WITH STYLE

1. Go through your collection of images and select any 10. Try cropping each of them in at least two different ways on the computer using the suggestions above. Popular crop ratios include 1:1 (square), 3:2, 4:3 and 16:9. By cropping to standard ratios, you'll find more print options available to you from photo labs. Use Photoshop or another editor that supports cropping outside the main image area if you need to do any cropping that includes rotating the image. Then fill in any areas that need attention.

2. Create an adjustable masking frame out of black paper, foam or illustration board. Then, use the mask on your computer screen as well as on a few prints to see how helpful it can be.

3. With a wider-than-normal lens (about 30–40mm in 35mm terms), do a portrait session of someone. First, fill the frame as you normally would (take the photo in both the vertical and horizontal orientations). Then, step back a few feet, leave some extra room and crop into the image later so that you can see the effect side-by-side next to the first image.

TIP 17

HOW TO UTILIZE NATURAL AND MAN-MADE FRAMES

Whether it's a heavy, gilded gold frame holding a Monet oil painting or a modern, refined white wood frame in a photo gallery, a frame can contribute to the overall presentation of an image in a profound way. The same can be said of in-camera framing. Over the years, I've been drawn to natural and man-made frames when taking photographs. Windows, tunnels, people standing in a crowd, and even your own hands can help to make ordinary images extraordinary. By looking for frames in your environment while you're shooting, you can often present a subject in a way that makes it look new and unique.

Here are a few tips for including frames in your photographs:

USE WINDOWS AS FRAMES—One of the most common in-camera framing techniques used by photographers is to include a window (or multiple windows) in a photo. This can be very dramatic because it creates a sense of depth and place, giving the viewer the feeling of looking out the window(s), like in fig. 17.1. In many cases, the challenge with photos like these is balancing the light inside a space versus outside a space so that there is a natural balance of light between them, which can be done via a number of techniques. One technique is to shoot multiple exposures at different shutter speeds or apertures in Manual mode or by changing the exposure compensation when in Aperture Priority or Shutter Priority

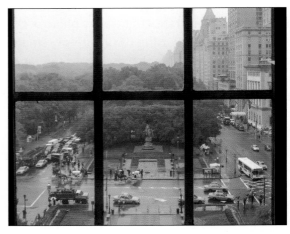

Fig. 17.1 I captured this image in New York City at about 11 a.m. on a rainy day in June. I'm often drawn to scenes like this.
Camera: Canon EOS D60; Lens: 28-135mm @ 28mm; F-stop: f/19; Exposure: 1/30 Sec.; ISO: 400

mode (a tripod works best with this technique) so that you can later combine the inside and outside parts of the image without sacrificing detail.

Auto Exposure Bracketing also works very well in these situations (covered in Tip 6 on page 24). Another technique is to post-process an image twice: The file can be adjusted so the inside of a room looks its best, and another version of the same file can be adjusted for the window frame and the outside scene, which will probably be blown out if the inside was exposed properly. They can then be combined in a program like Photoshop.

I photographed these buildings at Princeton University in New Jersey. I like how the arches repeat and create one frame after another.

Camera: Canon EOS 6D; Lens: EF 28-135mm f/3.5-5.6 IS @ 135mm; F-stop: f/10; Exposure: 1/125 Sec.; ISO: 500

I am amazed at the number of interesting framed images that can be captured when on a plane. You can find similar opportunities on boats, trains, cars, etc.

Camera: Canon EOS D60; Lens: EF 16-35mm f/2.8L @ 16mm; F-stop: f/19; Exposure: 1/180 Sec.; ISO: 200

FIND A FENCE—Fences of all types can offer interesting framing options. For example, chain-link fences, commonly found surrounding many tennis and basketball courts, offer great opportunities for framing, as seen in fig. 17.2. One approach is to get very close to one of the openings in the fence, then manually focus on something inside or outside depending upon which side you are on (or use autofocus if you can make it work under those conditions). Or, fill the frame with the diamond-shaped openings on the fence and take some photos at different apertures while focused on the fence. Then focus on something beyond the fence so that the fence becomes blurred. In both cases, I recommend using manual focus.

Fig. 17.2 In this photo, I was drawn to all of the snow, and I wanted to give the impression that I'm outside the fence thinking about summer and anxiously waiting for the pool to open.

Camera: Canon EOS 6D; Lens: EF 28-135mm f/3.5-5.6 IS @ 28mm; F-stop: f/5.6; Exposure: 1/3200 Sec.; ISO: 400

FRAMING PHOTOS EFFECTIVELY

1. Do a window framing photo session: include a car, train, plane or building window in a photo while still showing some detail from the inside of a space. First, use a tripod and Auto Exposure Bracketing to capture multiple images at three to five different exposure values (EVs). At least one should clearly show the detail inside, and another should clearly show the detail outside.

2. Combine the photos in Photoshop, Photoshop Elements or another application so that the final image looks the way you saw the scene with your eyes.

3. Do a fence framing photo session: Shoot through a fence from as close as you can get to it, showing something interesting behind the fence while still showing the fence in the frame. Aperture Priority usually works best for this, so experiment with a range of apertures, which will give your images a range of looks.

4. Move back a few feet from the fence, focus on the fence and take a few photos at different apertures in Aperture Priority mode.

5. Change your focus to the subject behind the fence and take a few photos at different apertures in Aperture Priority mode.

6. Next time you are at an event, such as an outdoor concert or county/state fair, zoom in close and include some people's backs in the frame with an interesting subject in the background so that they frame the object in front of them.

CREATING A SENSE OF SCALE

Scale, specifically the relationship of one object to others in a photograph, can have a dramatic effect. Some examples include a golfer teeing off with the expansiveness of a manicured golf course in the background (fig. 18.1), a toy car sitting on the hood of a full-size automobile or a close-up of a person's hand holding a small animal or just about any object. Once you start looking for these types of photos, you'll see how they not only help convey the size of an object, but in many cases, help to tell a story and showcase the relationships between people, animals and their environment. This concept is illustrated in fig. 18.2 and fig. 18.3. It shows how people can really help give an image scale. The low perspective and wide-angle view (16mm on a full-frame 35mm digital camera) add to the effect. (Fig. 18.2 shows the diversity of the canine world!)

Fig. 18.1 The placement of the golfer (my dad) in the frame gives this image a sense of scale, and though I probably could never time the shot so well again, the ball is visible as a dark speck just below the skyline, which also helps gives the image a sense of scale.

Camera: Canon EOS 6D; Lens: EF 16-35mm f/2.8L @ 16mm; F-stop: f/7.1; Exposure: 1/2000 Sec.; ISO: 1000

Fig. 18.2 This photo just happened during a photo shoot at a Pet Expo (I don't think you can ever plan these types of shots!).

Camera: Canon EOS 6D; Lens: Canon EF 28-135mm f/3.5-5.6 IS @ 85mm; F-stop; f/5.6; Exposure: 1/200 Sec.; ISO: 500

Fig. 18.3 Union Station, Washington, D.C. Note: I cropped the image and corrected its perspective slightly in Photoshop.

Camera: Canon EOS 5D; Lens: EF 16-35mm f/2.8L @ 16mm; F-stop: f/5; Exposure: 1/15 Sec.; ISO: 1000

USE A WIDE-ANGLE LENS—For a very dramatic look when showing scale, a wide-angle lens will often do the job well because it allows for an expansive background to be shown. However, less is more; focus on just one or two people or objects to tell a stronger overall story.

USE MEDIUM-TO-TELEPHOTO LENSES (ABOUT 50-200MM)—This can provide interesting scale opportunities, especially if there are just a few subjects. A shallow depth of field (smaller f-stop numbers) and Aperture Priority mode is usually the best option for these photos because it helps to isolate your subjects. Once you set your aperture to a smaller f-stop number, if the subjects are sharp and if the background is at least a few feet behind them, the background should then be out of focus.

PRO ASSIGNMENT

CREATE A DRAMATIC SENSE OF SCALE

1. Take a series of photos (vertical and horizontal) that include a single person who takes up no more than about an eighth of the frame. Take some very wide photos (15–30mm) and some photos at a more standard focal length (30–60mm).

2. Take a series of photos with a telephoto lens of a few subjects together that shows differences in scale. A large and small pet, a parent and child, or two stuffed animals are all commonly found in many homes. Also take a photograph of one, two or three people from a distance outdoors (see fig. 18.3) to practice framing and scale in different ways.

3. Take a series of photos of a person's hand or hands holding something. For example, have someone place his or her hand on top of another person's hand that's a very different size. Take photographs from different angles, at different zoom levels and at a few different apertures.

USING REPETITION EFFECTIVELY

They say practice makes perfect, and I would agree (especially if you keep learning and honing your skills). By returning to specific locations at different times of the day, or by photographing the same people on a consistent basis, you will not only learn more about your equipment, you will be able to compare how your photographs look over time. Believe it or not, fig. 19.1 and fig. 19.2 were taken just steps away from each other, but in different months, and about 12 years apart. One of the main differences between the photos is the time in which they were taken.

Fig. 19.1 was taken after sunset, and fig. 19.2 was taken just before sunrise.

This tip consists primarily of suggested assignments. Depending on the subject matter, you might want to refer to other tips in the book. A few of the things I photograph on a consistent basis are my family (see fig. 19.3 and fig. 19.4), a statue that's just outside my front door and an annual Fourth of July fireworks show not far from my home. I also often take group photos of my family and friends when we eat at restaurants or go to interesting places. I know they will mean even more to me in the future.

Fig. 19.1 (left) Camera: Canon EOS 20D; Lens: 11.0-18mm @ 11mm; F-stop: f/6.3; Exposure: 1 Sec.; ISO: 200

Fig. 19.2 (below) Camera: Canon EOS Rebel T4i; Lens: EF 28-135mm f/3.5-5.6 IS USM @ 30mm; F-stop: f/8; Exposure: 1/60 Sec.; ISO: 800

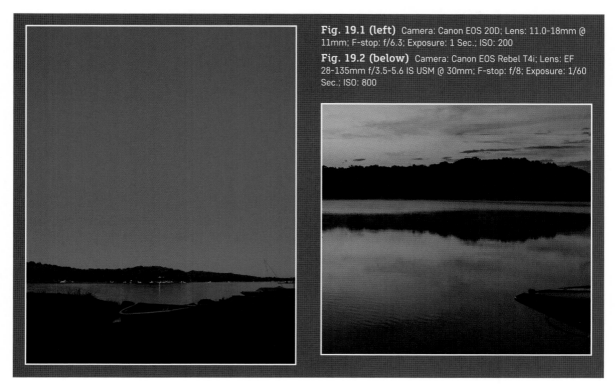

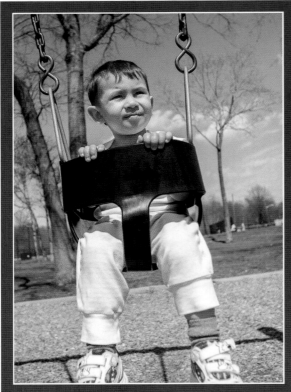

Fig. 19.3 I took this photo of my son when he was just two-and-a-half years old.

Camera: Canon EOS D60; Lens: EF 16-35mm f/2.8L @ 16mm; F-stop: f/2.8; Exposure: 1/1500 Sec.; ISO: 100

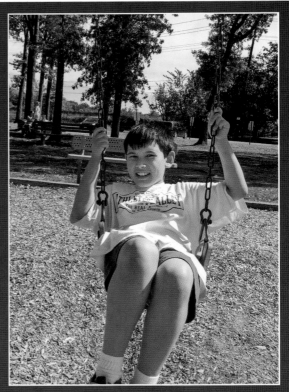

Fig. 19.4 Fast-forward eight years. It's amazing to see how much my son has changed over time. I highly recommend doing similar photo sessions with your family and friends.

Camera: iPhone 5S; Lens: Built-In @ 4.15mm f/2.2 @ 4.15mm; F-stop: f/2.2; Exposure: 1/2400 Sec.; ISO: 32

THE POWER OF REPETITION

1. Find an object within 200 feet of your home (for example, a tree, statue or other structure), and over the course of about six months to a year, photograph it at least 20 different times. Use the same lens, at the same focal length, and from a very similar angle.

2. Photograph one or more friends or family members on or around the same day each year in the same location. I think you will treasure these photographs over the years, and the quality of the photographs will probably improve as well.

3. Look through your library of photographs and choose 10 that you'd like to photograph again in a different way, or with a new lens, camera or other piece of equipment. Then schedule some time to photograph the same subjects or places again, or make a to-do list of photos you'd like to take and check them off as you complete them.

4. Take a photograph of yourself in a mirror at least one day each year with the camera under your chin so that you can be seen clearly. Then make prints cropped in a similar way (any size, from 4 x 6 to 16 x 20), and place them side by side in chronological order. You might even want to frame them that way!

Shopping Smart
How to Choose and Use Gear Effectively

One of the most confusing and time-consuming (yet fun!) activities related to digital photography is deciding what gear to purchase, whether new or used. The best overall advice I can give is to read reviews in magazines and online, watch video reviews, speak with others about their experiences, and try to test as many cameras and lenses as possible before making a decision.

Renting equipment can be especially helpful once you have an idea what you'd like to purchase, and some camera stores and online rental companies will allow you to apply some or all of your rental fee toward the item's purchase. For example, a large camera store in my area, Unique Photo (www.uniquephoto.com), offers a 50 percent credit of the amount you already paid for a rental toward the purchase of a new (or used, if available) item of the same make and model, as long as your purchase is within 90 days of when you rented the item.

Also, don't overlook factory-refurbished gear. It is generally equal to or even better than brand-new gear since refurbished items are usually looked over carefully so that they can be labeled as refurbished. Refurbished items also almost always have the same warranty as new items.

TIP 20

FINDING THE RIGHT LENSES

There is no substitute for doing your own lens testing (search "How to test a lens" on www .lensrentals.com for some excellent step-by-step advice). That being said, it's very difficult to properly test a lot of lenses. Technologies such as Image Stabilization (IS), which allows you to get sharp images at shutter speeds slower than the norm, are constantly improving, and on some cameras, the IS happens inside the camera body, allowing all lenses to be stabilized. The best sources I've found for unbiased reviews of lenses are magazines and online sites (you'll find many listed in this tip) that write about and review lenses. But before you head to your computer, here are some things to keep in mind.

UPGRADES—Some lenses may be upgraded by their manufacturer, but may keep the same or very similar name. For example, Sigma has created at least four generations of their 120–300mm f/2.8 lens, and the only way to quickly see which lens you are looking at is via the string of two- to three-letter abbreviations that follow the product name. I've noticed that Canon and Tamron will usually add a Roman numeral to the end of their lens names if a lens with the same basic specs is updated. Some companies also designate a higher-end group of lenses with one or more letters, such as Canon's L series of lenses (see fig. 20.1).

CROP SENSORS AND NON-FULL-FRAME DSLRS—Many lenses are made specifically for crop-sensor or non-full-frame DSLRs. Canon's line of DSLR

Fig. 20.1 A collection of Canon L lenses and converters at a photo trade show. L glass is Canon's highest quality lens line.

crop-sensor lenses are designated with the term EF-S, as opposed to its EF line. The EF line will work properly when mounted on either a full- or crop-sensor camera body, but the EF-S line will not mount on the EF line of full-frame Canon bodies.

Nikon's DSLR crop-sensor lenses are called "DX." The DX lenses can be used with its DX DSLR camera bodies, as well as its full-frame FX line of DSLRs. However, Nikon FX DSLRs will use the

camera's DX crop mode, which does not use the full area of the camera's sensor. This is very important to know before purchasing lenses (especially if you own a Canon DSLR). If your camera comes bundled with one or more lenses made for a crop-sensor camera, you can always sell them while they are brand new and invest those funds in lenses made for full-frame cameras.

LENS WEIGHT—The differences in weight between lenses can be staggering, even for lenses with similar specs. This should be considered because if you are planning to travel the world, you may not want to lug 40 pounds of gear around. Another important point about crop sensor lenses is that they tend to be much lighter than their full-frame DSLR counterparts because the lenses only need to cover a smaller sensor area. This can be seen with the Micro Four Thirds system, which is defined primarily by its sensor size (like the term full-frame or APS-C). Cameras built around the Micro Four Thirds system have a 2x crop factor, resulting in lenses that are often one-third to half the weight of full-frame lenses (when comparing lenses with similar focal lengths and maximum apertures). When I want to scale down for traveling and still get great image quality, I often choose my Olympus OM-D E-M5 and Olympus 14–42mm f/3.5–f/5.6 lens. The lens weighs just under 4 ounces (about 100 grams) and the body plus a battery weigh just over 15 ounces (425 grams).

Lenses with the same model number (even if brand new) may not all arrive to you in their best possible condition. Due to the fact that lenses are made from many different parts (including a lot of precision-cut glass), your experience with a specific lens may be very different from that of someone who tests a lens. In other words, you may just have a less-than-perfect copy if you are noticing extreme softness in one corner, or extreme vignetting or chromatic aberrations that you don't see in any other tests. That's why it is critical to do some lens testing soon after purchasing each of your lenses. If a lens is still under warranty, it is much easier to get it repaired or replaced by the manufacturer for no cost (except maybe shipping fees).

MICROADJUSTING THE AUTOFOCUS—One other major thing to keep in mind is that some lens and camera combinations may not autofocus on the exact spot your autofocus system "thinks" is the best plane of focus. Because of this, some higher-end cameras have the ability to microadjust the camera for specific lenses (the camera then remembers the adjustments you make).

Sigma stands out in this area, going much further by allowing you to attach some of their newer lenses to a USB dock, and the dock to a Mac or Windows computer. You can then update lenses' firmware, adjust parameters like autofocus at different focal lengths, and in some cases, adjust the way in which the lenses' Optical Image Stabilization (IOS) performs. A search online for "lens microadjust tutorial" will bring up some excellent articles and videos on this overall topic. If your camera does not have a lens microadjust function, you may be able to have the manufacturer tune your lens to your camera body if it is not focusing properly.

One specific product I've used to help me determine whether my lenses need to be adjusted is the Datacolor SpyderLensCal focus calibration tool (see fig. 20.2). One particularly good article on the topic that includes a DIY option for checking and making microadjustments can be found on www.the-digital-picture.com (search for "AF Microadjustment Tips").

Fig. 20.2 Datacolor's SpyderLensCal focus calibration tool.

camera brand). Illustrated in fig. 20.3 is one of my favorite lens/teleconverter combinations. The image quality is very good to excellent, but not as good as most higher-end telephoto lenses without a teleconverter that can weigh two to three times more. I'm able to achieve a focal range of 105–450mm with this combo when using full-frame cameras, and together, they weigh only 26.1 ounces (740 grams). Kenko also makes 1.4x and 2x PRO model Teleplus teleconverters that get very good to excellent reviews. I'd also recommend looking at teleconverter options from your camera's manufacturer, but make sure they are compatible with the lens(es) you are planning to use. In some cases, they will work but will not allow autofocus, which makes them much more difficult to use (especially with DSLRs). For much more on this topic, search online for "teleconverter information."

Two other products worthy of mention that help with this process are LensAlign and FocusPyramid (www.focuspyramid.com). An excellent how-to article that covers LensAlign can be found here: http://photographylife.com/how-to-calibrate-lenses.

TELECONVERTERS/EXTENDERS—Teleconverters extend your lenses' reach by magnifying the image (like a magnifying glass). Depending on a number of factors, these can do amazing things. The most important factors are starting with a high-quality lens and then only using a very high-quality extender. I've found them most useful for wildlife photography (especially of birds) and for taking photos of the moon. Also note that not all extenders work with all lenses. All will reduce the amount of light coming into the camera, some won't allow autofocus, and some are not compatible at all (even when using a matching

Fig. 20.3 A Canon EF 70–300mm f/4–5.6 IS and Kenko DG 1.5x Teleplus MC Teleconverter.

IN-CAMERA LENS CORRECTIONS AND POST-PROCESSING—This is a complicated subject but important to cover. No lens is perfect. Many have inherent distortions, such as pincushion or barrel distortions, and many have vignetting (darkening of the corners and/or borders). When shooting in

Raw or JPEG mode, some cameras allow you to apply different lens corrections to your images as the photos are taken, such as reducing chromatic aberrations (an optical issue that shows up in the form of color "fringing," usually seen around high-contrast areas like tree branches). Unless you are not able to do any correction to your photos due to deadlines, or some other reason, I recommend turning off any in-camera corrections so that you can apply corrections afterward in a program like Photoshop, DxO Optics Pro, DxO ViewPoint and Lightroom (my preferred option because it fits very well into my Raw workflow). There is even a way (via an Import Preset and a Develop Setting) to set "auto chromatic aberration removal" for all of your photos immediately as they are imported into Lightroom so that you don't have to remember to do it later. Visit www.ask andrewd.com and search for "chromatic aberration removal" for a video tutorial.

LENS FILTERS—The subject of lens filters, usually made of glass or hard plastic, could encompass an entire book! And for good reason. Even with the advent of better quality lenses and amazing software to improve the look of our images, there are some things that can't easily be corrected, and there are some filters that every serious photographer should consider having in their bag. Two of those include a circular polarizer for darkening skies and controlling reflections in some situations, and a neutral-density, or ND, filter, which is useful for long exposure shots like waterfalls, especially on sunny days.

Some of the websites listed here, such as www .dpreview.com, have discussion boards where people talk about different filters, and many of the sites do hands-on reviews of different filters. The one headache often introduced by adding a filter is vignetting (due to the fact that their width can extend into the edges of the frame), and I have a solution for that, which is shown in fig. 20.4. I attached a step-up ring to my filter threads on my lens. I then added a circular polarizer. And to show that another filter can be stacked, I added a Tiffen filter ND filter to the front of the circular polarizer. In real-life use, the circular polarizer should be placed in front of any other filters so that you can more easily adjust it.

Fig. 20.4 Here I've attached a 58–77mm step-up ring to the 58mm filter threads on my Canon EF 70–300mm f/4-f/5.6 IS lens.

Camera: iPhone 5S; Lens: Built-In 4.15mm f/2.2 @ 4.15mm; F-stop: f/2.2; Exposure: 1/380 Sec.; ISO: 32

When using the circular polarizer, be sure to only turn it in the same direction from the way you attached it to the camera to avoid potentially unscrewing it by mistake (been there, done that!). Also consider the fact that any glass you add to a lens will degrade image quality in some way, which is why I don't normally use a UV or Skylight filter unless I will be taking photos near an ocean or dusty environment. Skylight filters add a slight color tint to the image, so if I were to suggest one over the other, I would recommend a UV filter instead. Roger Clark (www.clarkvision.com) has some excellent tests on his site that show that telephoto lenses can be especially prone to image softening when using filters (just search for "filter quality").

Super Tip: I can't take credit for this one (I saw the suggestion online), but if you are having a problem removing a filter from your camera, try attaching a rubber band snugly around the filter and giving it a turn. It's pretty amazing how well it can work!

I chose to show the picture in fig. 20.5 to demonstrate three features found on some higher-end lenses:

Fig. 20.5 Camera: Sony A7R II; Lens: Zeiss Batis 85mm; F-stop: f/1.8; Exposure: 1/100 Sec.; ISO: 2000

1. First, the selective depth of field you see was possible thanks to a maximum aperture of f/1.8. If the maximum aperture had been f/2.8 or f/4, there would have been more depth of field (the type on the menus would probably have been sharp). This is assuming that I focused on the same object in the scene (the head of the statue of the woman praying).

2. Second, there is a very bright reflection from the sun on the statue (camera left) but the contrast in the image is still excellent, and there are absolutely no chromatic aberrations.

3. Third, there is a creamy and very pleasing "bokeh," or out-of-focus area in the background of the image.

Below are some of the websites (in alphabetical order) that I rely on for lens information; many of them also review cameras and other photo-related products.

CAMERA LABS (CAMERALABS.COM)—An excellent online resource with recommendations of lenses that are well organized by the lens manufacturer. It includes many actual tests of lenses showing their center and corner image quality at different apertures (often comparing similar lenses on the same camera body, which is no easy feat!). They also have some easy-to-read lists of "best lenses" from different manufacturers.

DIGITAL PHOTOGRAPHY REVIEW (DPREVIEW.COM)—A very popular site known for its user forums, Digital Photography Review has a database of many lens reviews. They have also partnered with DxO Labs to provide DxOMark data, which allows readers to compare various lenses at different apertures in multiple areas, including sharpness, distortion, vignetting and chromatic aberration.

DXO LABS (DXOMARK.COM)—DxO Labs has thousands of lens tests on their site. Don't miss their well-written "Best Lenses" articles, which cover lenses for specific cameras. You can find the articles by doing a search for "Best Lenses" on the site.

EPHOTOZINE (EPHOTOZINE.COM)—Another useful on-line resource with many lens tests and helpful real-life images (not just photos of test charts).

PHOTOZONE (PHOTOZONE.DE)—An excellent, well-cat-egorized resource with extensive testing (including a test of bokeh) and many outstanding real-life images. The site also has a nifty Sample Image Viewer that allows you to see a blown-up view of a small area instead of downloading an entire image.

POPULAR PHOTOGRAPHY (POPPHOTO.COM)—*Popular Photography* magazine has been doing lens tests for many decades, and their tests can be very useful in part because they are usually written by people who have had a lot of "on-camera" experience with lenses. The magazine also publishes very interesting lens-related articles like "21 Cool Lenses for Any Compact System," which can be found in the April 2014 issue.

SLR GEAR (SLRGEAR.COM)—This site combines re-views done by the editors of the site with recom-mendations in a few different categories from users of the lenses.

TIP 21

MAKING AND USING REFLECTORS

Reflectors (also called fill cards when they are in the form of boards or sheets), are extremely important in photography. In many cases, they can help avoid the need for any flash, even in situations you might think would require one. The main reason for using them is to reflect back light coming from different sources. That can soften contrasting light.

Some reflectors can also be used to soften light by being placed between the light and the subject. That usually produces a more flattering look on people's skin while increasing the size of the catchlights in their eyes. You can even turn reflectors into your main light source by setting up a white wall made of boards (or by just using an existing wall) and shining light or a flash on it that then reflects back on your subject(s).

Below are some inexpensive but effective fill card options. See Tip 22 (page 77) for information related to commercially available fill cards.

Fig. 21.2 Camera: Canon EOS Rebel T4i; Lens: Canon Macro EF 50mm f/2.5; F-stop: f/6.7; Exposure: 1/350 Sec.; ISO: 400

AUTO WINDSHIELD SUN SHADES—The sun shades often used to keep cars cool on sunny days can serve as excellent fill cards (see fig. 21.1). Some more expensive options even fold up nicely into a small circle. The Axius Basix Magic Shade is one product that I've used successfully, and I like the fact that one of their sun shades is matte silver on one side and black on the other. Shiny silver can reflect the sun back into someone's eyes, which can be

Fig. 21.1 An image of my assistant holding an auto windshield sun shade.

harmful. In fig. 21.2, the main lighting came solely from reflected light off of the matte silver surface of an auto windshield sun shade. The rest of the light came from natural daylight coming through the sides of a gazebo. The catchlights in her eyes are sparkling thanks to the reflector.

ALUMINUM FOIL—There are so many ways in which aluminum foil can be made into go-anywhere reflectors, from draping a roll of it over the side of a chair, ladder or light stand, to wrapping sheets of it around cardboard or foam board. In fact, you can create an entire metallic wall out of sheets of cardboard, rolls of aluminum foil and some tape. And, in most cases, one side of the foil will be a shiny silver color, and the other side will be matte silver, which allows for different lighting effects. Like with the auto sun shade, it's safer to use the duller side of the foil to reduce the intensity of reflections from the sun or strobes (flash). The lighting setup in fig. 21.3 shows how I lit the model for fig. 21.4 with a single softbox and a reflector made from aluminum foil wrapped around a piece of cardboard. I was able to adjust it by making a hole in the center of the cardboard and putting it on a tripod with a photo ballhead. The reflector creates a glow (some call it a "glamour" effect), and the reflector can be made in many different sizes.

SHEETS, TOWELS AND FABRICS—Bedsheets, pillow cases, plastic tablecloths, towels and fabrics can serve multiple purposes on location or in a studio. They can be great reflectors, backgrounds or surfaces on which subjects can be placed (or on which models can sit, stand or lie). They are also easy to fold up and can fit into many different types of bags. Many of these items can also be used to diffuse light. Plastic tablecloths are particularly good for this. Just hang a white plastic tablecloth so that the light shines through it, and you'll see some magic happen!

Fig. 21.3 Hair and Makeup: Pirri Hair Team

Fig. 21.4 Camera: Canon EOS Rebel T4i; Lens: EF 28-135mm F/3.5-5.6 IS @ 117mm; F-stop: f/11; Exposure: 1/60 Sec.; ISO: 200

PERSON WITH WHITE CLOTHING—Don't laugh, but when you see a great shooting opportunity and need a quick reflector, a good option is to have someone wearing white clothing (for example, a white T-shirt) stand within a foot or two of your subject. The "live reflector" can face the subject, or stand with his or her back toward the subject. Because of the way in which light can bounce and be reflected off of white surfaces, a person's clothing can have a significant effect on the overall look and feel of a photo.

Fig. 21.5 Camera: Canon EOS 5D; Lens: EF 28-135mm f/3.5-5.6 IS @ 135mm; F-stop: f/5.6; Exposure: 1/200 Sec.; ISO: 800

WINDOW AND SHOWER CURTAINS—Window and shower curtains are very versatile and widely available in a huge array of colors, sizes and styles. They can serve as effective reflectors, backdrops or surfaces upon which subjects can be placed. One of

the other advantages of curtains is that they are usually very lightweight, and they are also easy to hang on a rod or even a strong piece of string or rope. Shower curtains can be used to diffuse light, just like the plastic tablecloths mentioned earlier.

POSTERS AND SHEETS OF PAPER—Paper of all sizes and inexpensive wall posters can be found just about everywhere. They can act as excellent fill cards, and you can travel with them rolled up (just be sure to use some type of inner core inside so that the paper does not get damaged). An inexpensive "pool noodle" can work wonders as an inner core. They can be easily cut to any size and they are very light. For fig. 21.5, taken outdoors near Los Angeles, I asked the model to hold an 18 x 24-inch (45 x 60-centimeter) poster in front of her to reflect light back into her face and upper body. That gave the image the soft lighting effect you see, and it helped to give added life with a square-shaped catchlight on the bottom part of her eyes. This approach can be used with many different types of portraits.

PRO ASSIGNMENT

GET CREATIVE WITH FILL CARDS

1. Purchase an auto windshield sun shade (dull silver is best), and take a range of photos in different situations. Experiment by placing the shade on different sides of your subject, including under their chin (especially if you are going for a "beauty/glamour" look).

2. Make a fill card from an object or two described in this tip. I highly recommend the shower curtain approach because of how easy it is to find them, and for the beautiful light that can be created when using one.

3. Set up a "reflector wall" made from foam boards, paper, a tablecloth or a shower curtain, and shine light onto that surface using flash, artificial lighting or sunlight. That light should then be reflected back onto your subject to create a wall of light.

FINDING AND USING COMMERCIALLY AVAILABLE REFLECTORS

In the last tip, I covered many DIY/unconventional fill card options. However, there are a number of affordable, well-made reflector options on the market that can also be used to create better images, even in less-than-ideal lighting situations. A number of the tips throughout the book explain how to use reflectors, but this one is designed primarily to help you select the right reflector options for the types of photos you plan to create.

COLLAPSIBLE REFLECTORS

Few products are as useful and affordable as collapsible reflectors, found at virtually every photo store. There are also many useful and affordable 4-in-1, 5-in-1 or 6-in-1 (I'll call them X-in-1s) collapsible reflector sets on the market. They come in circular (see fig. 22.1), square or oval shapes from about 14–53 inches in size. Fig 22.2 was taken with the collapsible circular reflector pictured in fig. 22.1.

For a larger X-in-1 option, Adorama Camera (www.adorama.com) sells the Glow 5-in-1 40 x 60-inch Collapsible (Portable) Reflector for $50. The larger surface area of this rectangular reflector allows more light to be reflected back or shined through, which can be very useful (especially when photographing people). Like most X-in-1s, a translucent

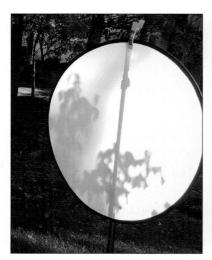

Fig. 22.1 A circular collapsible reflector.

Fig. 22.2 This photo was taken with the exact lighting setup shown in fig. 22.1.

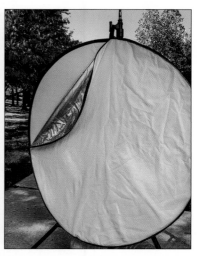

Fig. 22.3 A large collapsible reflector with cover partially unzipped, attached to the tightening knob of a light stand from a loop on its cover.

reflector is included (used to soften natural or artificial light). Another advantage of square or rectangular reflectors is that they are not likely to roll around, as circular ones can do if not clamped or otherwise held in place with something.

Depending on the manufacturer, translucent reflectors can also be purchased on their own or in sets. With products such as the one pictured in fig. 22.3, you can quickly change from a white opaque panel for use as a reflector to a shiny gold reflector to a translucent white reflector just by unzipping it and revealing the gold side. The 6-in-1 reflector kits from Westcott cost about $100 and have the advantage of two diffusion panels: the first blocks one stop of light and the other blocks twice as much light, or two stops. There is also a sunlight slip cover, which is considerably less gold in color compared with standard gold reflectors because it is made from a weave

This before and after shot from one of my workshops shows the power of placing a translucent reflector between the sun and a subject. In the photo on the left, I was in direct sun. In the photo on the right, with the help of a collapsible reflector held by an assistant camera right (meaning on the right side if you are looking from the camera's perspective) and angled to block the sun's direct rays, sunlight was controlled and diffused, producing an image with far less contrast. It also helped me to not have to squint as much, which allowed me to concentrate on my supermodel pose!

TRIFLIP KITS

Lastolite makes a number of innovative reflectors called TriFlip kits. There are many situations when this product can come in handy, especially outdoors.

- The Lastolite TriFlip 8 in 1 Grip Reflector Kit (approximately $115) is similar in some ways to the many 5-in-1 circular reflectors on the market. The TriFlip is 30 inches long, and the Mini TriFlip (sold in a similar 8 in 1 kit) is 18 inches long. Both have a handle designed for someone (or a photo clamp) to hold, and both fold down to about a third of their size.

- The TriFlip 8 in 1 Grip Reflector Kit comes with soft gold and silver covers, which are less strong compared with a bright gold reflector, and safer for the eyes when photographing them under bright sunlight or using powerful flash units.

Lastolite also sells the Joe McNally 24" Uplite Reflector Kit, which is a unique way of holding two reflectors in a clamshell configuration. Use the product as a reflector, or bounce a flash into the reflective part and have that light flow through the diffusion panel toward your subject. Visit www.lastoliteschoolofphotography.com for good information on how to effectively use their products.

of the silver and gold material. However, unlike most X-in-1 reflector sets, there is no white panel on the outside cover when you zip it up, though you can use two of the translucent panels together to create a pretty effective white reflector.

One of the best values I've found for a set of two high-quality reflectors is the Westcott Basics 40-inch 5-in-1 Collapsible Reflector (2-pack), available at Unique Photo (www.uniquephoto .com) for about $50. Westcott also makes a collapsible product that can be used as a reflector or for transmitting light, called the Illuminator Reflector Panel 48 x 72-inch White Diffuser (about $90).

The smaller collapsible reflector sets are particularly nice for flower and insect photography. They help control light, and at the same time, they can reduce or sometimes completely block the wind when you want to keep things in the shot still.

WHITE UMBRELLAS AND OTHER REFLECTORS

White umbrellas are very popular, available in many sizes and can also be found at most camera stores. They serve as good reflectors to bounce light back onto a subject, as in fig. 22.6, but are even better when used to diffuse light (especially from the sun). All white umbrellas with black coverings on the outside help to focus a lot more light toward the subject compared with pure white umbrellas, and some white umbrellas come with removable black covers, making them dual-purpose.

Just be careful of wind if you are outside with the umbrella on a stand. (See Tip 31 for tips on using sandbags.)

A specific umbrella that stands out in many regards is the Westcott 7-foot White Diffusion Parabolic Umbrella (fig. 22.7). It is 71 inches in diameter and costs about $100, a fraction of the price of many of their parabolic umbrellas. One of the great things about the product is that it can be used for reflecting light back toward a subject

TWO WAYS TO QUICKLY AND SECURELY CLAMP A REFLECTOR TO A LIGHT STAND

Fig. 22.4 In this image and the close-up of the top section, I show how easy it is to attach a reflector or board to a light stand using inexpensive A clamps. This is a much more stable option than the one in fig. 22.1.

Being able to quickly and securely attach a reflector gives you a lot of control, and it's quite simple once you see how to do it.

1. As shown in fig. 22.4, one option just requires four clamps arranged in the manner demonstrated. I recommend A clamps because they are super strong and very inexpensive (about $2 each at home improvement stores). I added a black super clamp just above where the bottom clamp attaches to the reflector to give it more stability. You could instead use a smaller clamp with the rubber protector covers facing toward the reflector in that location if you don't have a super clamp.

2. Another, more traditional option is to use a purpose-built reflector holder arm. It attaches to the stud found on the top of most light stands, as you can see in fig. 22.5. One negative

with this approach is that it can make the stand less stable, so sandbags become even more important. That being said, sandbags or other weights should be used almost any time you are using light stands (especially when outdoors). I cover how to find and make your own sandbags in Tip 31.

Fig. 22.5 A purpose-built reflector holder arm attached to a traditional light stand. For many different options, search online for "reflector holder."

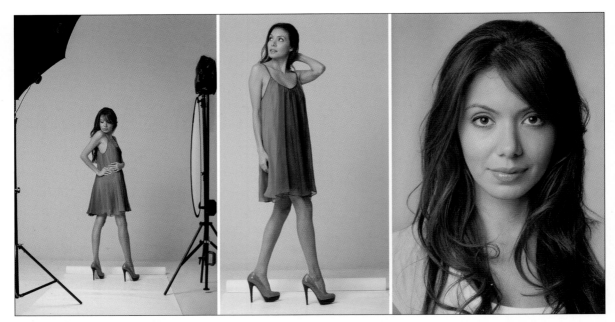

Fig. 22.6 For these photos, I used a large circular white translucent reflector placed camera right to bounce back light from an umbrella/flash combo placed camera left (shown in the left photo). The umbrella is 46 inches wide and made by Photek.

Center photo: Camera: Canon EOS Rebel T4i; Lens: EF 28-135mm f/3.5-5.6 IS @ 47mm; F-stop: f/10; Exposure: 1/200 Sec.; ISO: 200

Right photo: Camera: Canon EOS Rebel T4i; Lens: EF 28-135mm f/3.5-5.6 IS @ 135mm; F-stop: f/10; Exposure: 1/200 Sec.; ISO: 200

(like a traditional umbrella, but with quite a bit of light lost due to it "spilling" out the back). It can also be used to diffuse light from the sun or a lighting unit as it shines through it from above, such as the flash unit shown in fig. 22.7. Used outside, it is truly powerful in bright sunlight (especially in the middle of the day). Used inside, the light comes back toward the subject, creating a soft lighting effect. The company also makes silver and white/black 7-foot parabolic umbrellas. Those two are primarily only for reflecting light directly back to a subject as you would with a traditional flash inside an umbrella, but you could use them for reflectors instead. The white/black umbrella, pictured in fig. 22.8, won't allow light to spill out the back, unlike the White Diffusion Parabolic Umbrella. Westcott's silver umbrella (fig. 22.9) makes reflected light more concentrated and results in images with more contrast

(see fig. 22.10 as an example). However, the distance at which you place the umbrella to your subject will have a lot to do with the overall look.

WESTCOTT—With help from photographer Larry Peters, Westcott also created a unique reflector called the Eyelighter that's intended to be placed under a subject's face. It was designed to produce more pleasing catchlights compared with flat reflectors. It costs approximately $300.

A 30- to 60-inch reflector (white, silver, gold or a mix of silver and gold) under your subject's face can also give your subject's eyes and face a nice look (you can make one easily out of cardboard and aluminum foil), so I recommend trying that first before investing in a specialized product.

Fig. 22.7 Westcott 7-foot White Diffusion Parabolic Umbrella.

Fig. 22.8 Westcott 7-foot White/ Black Parabolic Umbrella.

Fig. 22.9 Westcott 7-foot Silver Parabolic Umbrella.

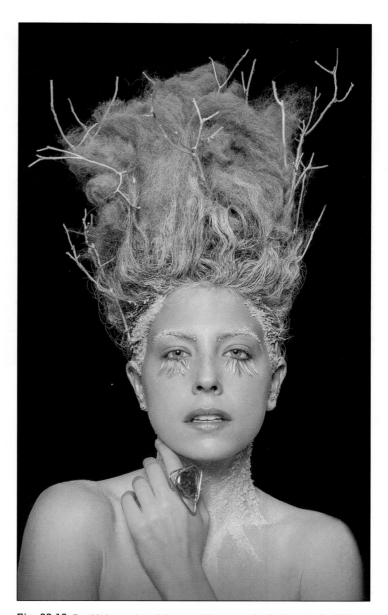

Fig. 22.10 For this image, I used the same Westcott umbrella shown in fig. 22.9, with a strobe light. It was placed behind me, about 10 feet from the model, raised high up and pointed down at an angle toward her.

Model: Heather Dorian; Hair and Makeup: Pirri Hair Team.

Camera: Canon EOS 6D; Lens: EF 28-135mm f/3.5-5.6 IS @ 56mm; F-stop: f/6.3; Exposure: 1/100 Sec.; ISO: 400

USING COMMERCIALLY AVAILABLE REFLECTORS

1. If one of the reflector options listed above (or a similar set of reflectors) seems like a good investment to you, purchase one and take at least 10 photos using each of the X-in-1 options as a reflector. Use diffused daylight coming through a window as your main light source and set your white balance to Daylight or Cloudy to begin. Your reflector will go on the opposite side of the light coming through the window.

2. If you use flash or bright sunlight as your main light, just keep in mind that reflecting very bright light of a highly reflective (shiny) silver and/or gold reflector can be really uncomfortable, or even damage the eyes of your subjects if they are looking directly at the reflective surface. Because of that issue, I recommend telling your subjects not to look directly into shiny reflectors in those situations, or you can use white, matte/soft silver or matte/soft gold instead when you are using direct sun or a powerful flash. On cloudy days, or when the sun is not directly shining on the reflectors, the more reflective options can produce great results because they create a lighting effect that simulates morning or afternoon sun coming through trees.

3. Place a white, silver, gold or combination gold/silver reflector under your subject's face or at their feet angled up (use caution as described above) and take at least five photos with the reflector at different distances and angles to see if your images look good that way. Matte silver is a particularly good choice for under the eyes. Gold can also work well, depending on how strong it affects the color of the final images, but using a mix of silver and gold, like the "sunlite" reflectors from Lastolite, will generally be better because it is not as yellow as a full gold reflector.

4. Take a few "before and after" photos outside with and without a white translucent reflector diffusing the sun (like the side-by-side photos of me on page 78).

CHOOSING AND USING A MONOPOD

A monopod can come to the rescue in many situations. It's important to know that in many locations, tripods are not permitted, but monopods are. Also, monopods are almost always easier to attach to the side of a backpack or pack in luggage, provided that the monopod you choose is not too long. I like using a monopod connected to a camera, which is then connected to my photo vest, as in fig. 23.1. (Note: Always use caution when attaching any item to your clothing or body, especially if you are traveling.) When I plan to walk around a lot, this can hang from my side while I stabilize the monopod with my right hand. This combination can't offer the same stability or long exposure capabilities that a tripod can provide, but you may find a monopod with legs that can do some of what a tripod can do. Good-quality monopods without heads are lightweight and very affordable at about $15–$100, so I highly recommend having at least one, in addition to a sturdy tripod. The materials used for monopods are not as important as with tripods because monopods have fewer parts. In general, I would save money and purchase a good-quality aluminum monopod instead of one made from carbon fiber (a strong but relatively lightweight material used in some monopods and many tripods). That being said, when weight is a big concern, carbon fiber monopods really shine.

With monopods, you'll be supporting the weight of your camera, but it's important to find a monopod that won't buckle if you apply a lot of downward pressure on it. Check the monopod's

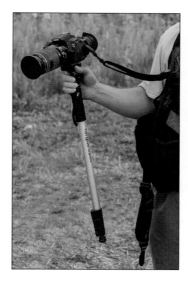

Fig. 23.1 Me holding a monopod connected to a DSLR and LCD loupe. My camera is connected to my photo vest via a PeakDesign Anchor and Peak Design Slide Camera Strap. Photo © Denis McGrath

load capacity. It should be about two times the weight of your heaviest lens and camera because of the extra pressure that may be applied to it when panning, tracking, etc. Also, be sure to check the maximum height with all leg segments extended. If you have a monopod that can extend higher than your eye level, along with a camera that has an articulating screen that can tilt down, you can create stable images from a position well above your eye level. This is particularly useful at trade shows and other events when you want to give the viewer a bird's-eye view over the crowd. A wired or wireless cable release also comes in very handy in these situations. Another rarely used but great feature of a monopod is getting very low to the ground without having to crawl. Just turn your camera upside down and use a wired or wireless cable release to get the shot or

video clip. See Tip 24 (page 86) and Tip 50 (page 190) for more on cable releases.

Some monopods also come with flip-lock legs (see page 90), which gives you some of the stability of a tripod. Most of these types of monopods allow you to tilt and twist the camera from the base, so you won't want to let go of your camera unless you are using appropriate sandbags or even a backpack/photo bag for stability (even then, test it well before letting go!). You may be able to insert an object (similar to a plug) at the bottom of the legs that's about three quarters of an inch (20mm) long and half an inch (12mm) in diameter to stabilize it. Just be sure to have a way to remove the object if you want to move the monopod freely! A search for "monopods for video" on YouTube will bring up a very good video review by B&H Photo of a number of monopods with flip-lock legs. Another excellent video review with good tips is entitled "Top 5 Monopods Reviewed" by DSLR Video Shooter. One product I use is a ProMaster MPV 432 Monopod, pictured in fig. 23.2 and fig. 23.3.

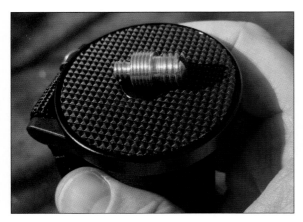

Fig. 23.2 This is the top of my ProMaster Professional MPV432 Monopod.

One very lightweight (under 2 pounds), inexpensive (about $15) and well-made 70-inch monopod

Fig. 23.3 My ProMaster Professional MPV432 Monopod standing on its own via its three retractable and removable legs. It actually can't stand by itself very easily, and there is no built-in locking mechanism.

that I use a lot with all of my cameras is the Targus 69" Monopod (Model #TG-MP7010). It's sold in most Target stores and online at other retailers. Another recommended light monopod that has been discontinued but is often available online is the TrekPod Go! PRO, pictured in fig. 23.4.

Fig. 23.4 The TrekPod Go! PRO monopod is super light and has an innovative and very "stealth" way of extending its legs so that you hardly know it's there. It also comes with a pretty amazing magnetic QR camera mounting system called the MagMount PRO.

If you are more interested in still photography than video, I would just purchase the bottom part of the monopod (with or without the flip-lock legs, but without a head), then add a ball head, like one of the many options from Manfrotto (check the load capacity before you buy).

Giottos makes a compact and inexpensive ball head called the MH1004-320 (about $12) that is great for camera/lens combos up to about 3 pounds. I personally use the Manfrotto RC2 QR system, so it would make sense for me to buy a ball head with a built-in RC2 plate, or to add an RC2 QR set (adapter and plate) to the top of a ball head that's strong enough to support it well (as shown in fig. 7.2 on page 28). Some monopods, such as the one in fig. 23.2, come with a reversible screw that can be inserted into the top of the monopod in either direction. You can then use just about any QR plate or photo head (such as a ball head) with it.

On that note, I don't recommend having different QR plates for different monopods and tripods. If you standardize, you can move from one to the other very quickly.

You might ask, "Why add a ball head when you can just attach a monopod directly to the bottom of your camera?" Think about what will happen in that case if you want to turn your camera to take a vertical photo (unless you have a tripod collar mount on your lens, which allows you to turn your camera body from horizontal to vertical). Your monopod will stick out sideways in the air like a light saber, potentially causing harm to anything in your path (not a good look, and not good at all for stability!).

CHOOSING AND USING A TRIPOD AND WIRED/WIRELESS SHUTTER RELEASE

Now that I've covered monopods, what about the wonderful world of tripods? In addition to increasing our odds of getting sharp images and level horizons (due to not having to hand hold the camera), tripods allow us to create incredible images that our eyes cannot see, such as light trails of moving vehicles, star trails and silky smooth, flowing water. Here are some things to consider when shopping for a tripod, and some tips for using them effectively. Though very important, maximum load (how much weight the legs can take) is pretty self-explanatory, so I won't add anything about it. And don't forget a wired or wireless shutter release (or two!). They are extremely important to employ when using a tripod.

SIZE MATTERS (WHEN FOLDED)

If you can't fit a tripod into your luggage or attach it securely to a backpack, you may have to leave it home, so definitely consider this first, and be sure to include the camera head you plan to use in your calculations since that will add some height and weight. Some tripods are specifically made to be as compact as possible, and they are often labeled as travel tripods, such as the Benro MeFOTO A0350Q Travel Tripod Kit with Ball Head (about $150) pictured in fig. 24.1 and fig. 24.2. You can find a review I did of this product on www .imagingbuffet.com. I was very impressed by how compact it was when folded down (just 12.6

inches/32 centimeters), despite its maximum height with the included head (51.2 inches/130 centimeters).

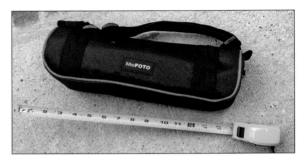

Fig. 24.1 This very compact tripod bag for the Benro MeFOTO A0350Q is only about 13 inches long (33 centimeters), which makes it easy to pack in many different travel bags.

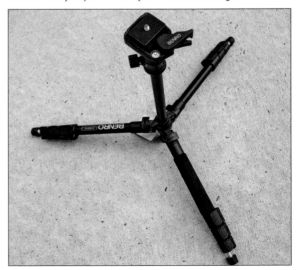

Fig. 24.2 This method of extending a tripod's legs very low to the ground (in this case, with the Benro MeFOTO A0350Q) offers excellent stability. You can often even lower the center column so it touches the ground for added stability.

If you like that tripod's overall look and feel, Benro also makes a slightly larger model, called the Benro MeFOTO A1350Q1 Tripod Kit (about $190). That tripod and head combination weighs 3.6 pounds, compared with 2.6 pounds for the A0350Q. Its maximum height with the included head is 61.6 inches (156 centimeters), and it folds down to just 15.4 inches (39.1 centimeters). It also includes a built-in monopod, which can be useful when traveling, but I recommend just bringing a separate monopod along and possibly sharing a head, which is easy to move from one to the other. Benro also makes a line of tripods called Travel Flat that are pretty amazing because they fold flat, unlike most other tripods.

HEAD OR NO HEAD?

INTEGRATED HEAD—I highly caution against purchasing a tripod with an integrated head that cannot be removed, unless it is just an extra lightweight and inexpensive tripod for holding a small flash or reflector. The reason is that if your tripod and head are separate, you can mix and match different tripod heads whenever you want. A common reason would be to use a lighter head to reduce weight for a trip, hike, etc. Also, if a tripod head breaks, you can just replace it instead of buying a new tripod.

MANFROTTO RC2 SYSTEM—As I mentioned in the previous tip, I have a few tripods and monopods with the Manfrotto RC2 QR plate and adapter, so for me, it would make most sense to either buy a tripod with a head that has the RC2 QR system, or just the tripod legs, to which I can then add a Manfrotto head with the RC2 QR system. I can also purchase another manufacturer's tripod head and attach an RC2 plate and adapter to the ¼-inch screw on the top, turning it into a QR tripod.

If you purchase just tripod legs (no removeable or integrated tripod head included), keep in mind that most have ⅜-inch screws, but some have smaller ¼-inch screws at the top for attaching to tripod heads. Most heads are made for ⅜-inch screws because they are stronger than ¼-inch screws, and many come with spring-loaded bushings that allow you to attach them to tripods

MACRO FOCUSING RAIL SLIDER

For macro work, a 2-way or 4-way macro focusing rail slider can be very useful, especially when you want to have very precise framing or do focus stacking, a technique in which you capture images at different planes of focus (for example, capturing the front of a flower in focus, then, by moving the camera, capturing the back of the image in focus instead of touching the camera lens). The images can then be combined using software like Helicon Focus (www.heliconsoft.com) or Photoshop to produce an image with extreme sharpness across its entirety. I use a 4-way macro focusing rail slider sometimes for flower photography, but it can also be useful for capturing artwork because the movements are very precise. The Flashpoint Budget Macro Focusing Rail (about $50) does the job well for many camera/lens combinations.

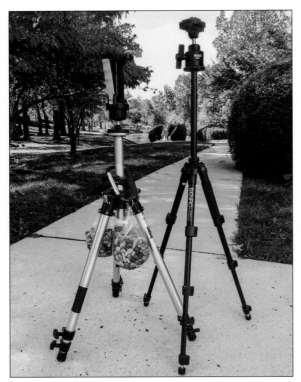

Fig. 24.3 Two of my tripods set up outdoors with two different heads. The one on the left has a trigger grip head and the one on the right has a ball head.

with ⅜- or ¼-inch screws. If the tripod head only has a ⅜-inch socket, you can purchase a ⅜- to ¼-inch-20 tripod reducer bushing. Just screw the bushing into the ⅜-inch tripod head socket and then screw the tripod head onto the tripod legs.

DOLICA—Dolica makes a high-quality and affordable head called the G100 Pistol Grip Head (about $70).

- One advantage of that head is that it adds almost 9 inches of height to your tripod, but it will also add almost 2 pounds of weight.

- I like the grip ball head design because it avoids the need to screw and unscrew small knobs (especially useful if you are wearing

gloves). A ball head tripod is shown on the right in fig. 24.3.

- You may find it a bit tiring to use because you need to squeeze the trigger every time you want to move the head (unlike most ball heads with a tension control system that allows you to move the camera smoothly with some resistance, then tighten the screw for when you want it to be rock solid and let go of the camera).

ARCA-SWISS—If you have a tripod with an Arca-Swiss compatible QR system (probably the most popular QR option), you might follow the same path as I would, but with products that are Arca-Swiss compatible. I prefer the Manfrotto RC2 system because I don't have to tighten any knobs when securing the camera to the tripod head (the camera just clicks securely into place). A small pull of a metal lever is all that's needed to release the camera, and there is a safety lock if I want to engage it.

GEARED HEAD OR 3-WAY HEAD—For times when you want more precise control over the movements of your tripod head, such as when doing still life or macro/close-up work or using panoramic mode, consider a geared head, like the Manfrotto 410 Junior Geared Head (about $260). Most geared heads work by turning knobs to make adjustments, which means that adjustments can be very accurate, but slow.

A similar (but faster) option is a 3-way head, which moves on the x- and y-axis via two levers. Manfrotto's X-PRO 3-Way Head (about $140) is a very good option in this class. It is compact (due in part to its retractable handles), has three bubble levels, weighs just 2.2 pounds and can support about 18 pounds. A 3-way head can also be useful

when doing video because you can pan slowly and follow a subject.

GIMBAL TRIPOD HEAD—Primarily designed to shift the center of gravity of a camera and large lens, gimbal tripod heads result in better control and better safety since when calibrated (placed properly on the head), the camera and lens can just "float" in the air supported by the head. Gimbal heads can also be used with non-telephoto lenses and are made by many companies, including Induro, Jobu Design, Nest and Wimberley.

Some excellent video reviews on YouTube include demonstrations of gimbal heads and tips for using them. A search for "Wimberley Gimbal Head Tutorial" brings up an excellent review by spikyhead 180. I own a Jobu Design Gimbal Head and absolutely love it.

DURABILITY VS. PORTABILITY

Construction: plastic, aluminum or carbon fiber? The question of what your tripod is made from is an important consideration. However, many variables contribute to a sturdy tripod, apart from the materials used, including the stability of the center column (some have a very thin diameter and often can't be reliably used for long exposures). You can easily add stability to just about any tripod by attaching weight to the center column hook (shown in fig. 24.4), or with two or more bags of rocks via the jumbo aluminum hooks shown in fig. 24.3 (see Tip 31 on page 114 for more details on where to find the rocks and hooks). If you use the bags of rocks, simple metal snap rings (like the silver ring shown supporting the front rock bag) make it much easier to hang and remove the bags.

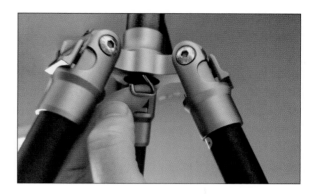

Fig. 24.4 Here I'm showing how to access the tripod hook on the Benro MeFOTO A0350Q.

In general, tripods made primarily of aluminum or carbon fiber will be stronger than those made from plastic, and carbon fiber tripods will almost always be lighter than aluminum tripods with a

REVERSIBLE CENTER COLUMNS

Some tripods have a center column that can be reversed, allowing the camera to be placed very close to the ground. This is a tripod feature that I like a lot. And here's a quick tip: if your tripod allows the center column to be reversed, you should be able to keep your tripod head attached, which saves some space while keeping it protected, because the tripod legs will be covering the head.

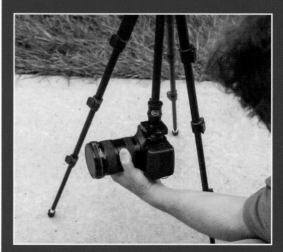

Here I'm demonstrating how I've reversed the column on the Benro MeFOTO A0350Q.

similar maximum height and load. Carbon fiber tripods are also highly regarded for "settling down" faster than similarly built aluminum tripods (leading to fewer issues with vibration and image blur). There are some tests and discussions of this topic online (search for "carbon fiber tripod dampening"). Just keep in mind that carbon fiber tripods are usually 50 to 100 percent more expensive than their aluminum counterparts.

Plastic tripods can do a good job (with a proper head and by hanging some weight on the center column), but they often can't take the same amount of wear and tear as products made from the other two materials, and their legs are usually not nearly as stable as the others. That being said, an inexpensive plastic tripod can serve you well when you really need to keep the weight down, and it's a good idea to just leave one in your car if you drive so that it's there if you need it.

TWIST OR FLIP?

Tripods and monopods have a few different mechanisms by which their leg extensions lock and unlock:

FLIP-LOCK LEGS—Just flip a piece of metal or plastic to release the tension, then flip it back after making the adjustment. I like how quickly I can open and lock this type down. Flip-lock legs are also usually easier to close than twist-lock legs when it is very cold or wet outside, or if your hands are wet.

T-TYPE, TWIST-LOCK LEGS—Just twist the T to release, then adjust and re-tighten. Twist-lock legs tend to need more adjustments compared with flip-lock legs over time, in my experience, but the tightening adjustments are usually easy to do.

TWIST-LOCK LEGS WITH RUBBERIZED LOCKING GRIPS—Just grab up to four of the grips with your hand and all can be released at once. Closing them takes more time, but if you unlock them all then turn the tripod over so that the legs all collapse, you can lock them just like you open them. I show this technique in my review for the Benro MeFOTO A0350Q on YouTube (search for imagingbuffet and Benro).

All three work well, but each has advantages and disadvantages, and the overall quality over time will depend on use and how well the leg locks are built.

SPIRIT LEVELS

Does the tripod or head have one or more spirit/bubble levels? These are often integrated into tripod legs, QR plates and/or tripod heads. They help to level the camera and/or tripod legs and are especially useful when on uneven ground, photographing artwork, taking panoramic photos or taking photos that include a horizon. Just keep in mind that tripod heads and legs are usually not in sync because of all the adjustments that your tripod head allows, so both should be leveled independently.

Fig. 24.5 A hot shoe bubble level.

You can also add a spirit level to the hot shoe of your camera (see fig. 24.5). Search for "hot shoe bubble level" for many options. However, the hot shoe is premium real estate which a radio transmitter or microphone may be occupying, so you should first try to use your camera's built-in electronic level if it has one, or you can use one of the following if they are not built into your tripod head and/or legs:

SPIRIT LEVEL PLATFORM (A.K.A. LEVELING PLATE)—A spirit level platform, like the Desmond Offset Bubble Level (about $20), is placed between your tripod legs and head. This helps to level the legs of your tripod, but not the head.

LEVELING BASE—A leveling base is sturdier and more expensive than a leveling plate, but offers a significant advantage. It fits between your tripod and tripod head, and usually includes a ⅜-inch male tripod thread. This thread looks like the top of a flat-top screw, and it pairs with a female thread from a photo ball head. The product allows you to tilt the base to compensate for tripod legs that are not completely level. A few examples include the Sunwayfoto DYH-66i Leveling Base (about $100) and the Acratech Leveling Base (about $150).

MANFROTTO 032SPL AUTOPOLE SPIRIT LEVEL—This is meant for photo poles like those described on page 142. However, you can attach it instead to the bottom of your tripod's center column to help level the tripod, as long as it is between about 1–2.4 inches. The advantage is that it is usually easier to see as you are making adjustments to the legs.

PANNING BASE

Does the tripod have a rotator/panning base? This is an important feature if you plan to do panoramic photography or just want to rotate your camera smoothly. Many tripod heads that have panning bases also have tick marks to help you work more efficiently. If your tripod head does not have a panning base, you can also purchase specialized panning bases that go between your tripod and head, such as the Feisol PB-70 Panning Base (about $40). An added bonus is that they add a few inches of height to your setup.

A tripod dolly with locking wheels can also be a lifesaver if you want to move a tripod around without constantly picking it up. Many can be found for under $50.

For an excellent overview and to research many specific models, I recommend searching on shutterbug.com for "tripod head buyer's guide." Also, for a closer look at many different product options, search YouTube by typing in a head type or specific product with the word "review." This will often bring up excellent hands-on video demonstrations of the products.

KEEPING THINGS STILL: WIRED/ WIRELESS SHUTTER RELEASE TIPS

Now that you've gone through the effort of purchasing and using a tripod, it's very important to use a wired or wireless remote shutter release to trigger the camera's shutter. The reason is because even if you are very careful when pressing the shutter button on your camera, you will almost surely introduce some camera shake into your photos.

There are many wired or wireless shutter releases on the market, and most are priced in the $10–$50 range, such as the Canon Remote Control RC-6 Wireless Infrared Remote Control Transmitter pictured in fig. 24.6. I like the idea of having an infrared transmitter as a backup for radio

transmitters, which are generally more robust and work from much longer distances. Infrared remotes work like TV remote controls and require a line of sight. In many cases, wired or wireless remotes can be set up to take time-lapse photos, which can produce some amazing results. Time-lapse photos look like movies, but are made from multiple photographs exposed over a period of time, and usually taken using a tripod or other camera support.

Fig. 24.6 The Canon Remote Control RC-6 Wireless Infrared Remote Control Transmitter. The RC-6 can be used with many Canon cameras and has a range of about 16 feet (5 m). It's very small, lightweight and inexpensive (about $20).

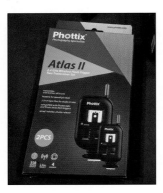

Fig. 24.7 Two Phottix Atlas II wireless flash transceivers.

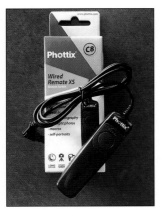

Fig. 24.8 Phottix Wired Remote XS

At about $20, the simple, affordable Phottix Wired Remote XS (fig. 24.8) is a well-made remote that has a 1-meter (about a 3-foot) shutter release with different models depending on your camera.

In some cases, shutter releases can do double duty and be set up to fire flash units as well as cameras. PocketWizard and Phottix brand radio remotes are well known for this capability, such as the Phottix Atlas II wireless flash transceivers shown in fig. 24.7. Either unit can be used as a transmitter or receiver, using radio signals. They allow users to attach one flash unit (set to receiver mode) to remotely receive signals from another transceiver mounted on a camera (set to transmitter mode). Or, the same unit can be used on a camera (set to transmitter mode) to trigger either shoe-mount or studio flash units (set to receiver mode) from up to about 1,100 feet. The transceiver (set to transmitter mode) can also be used to trigger a camera (set to receiver mode) to focus and fire from up to about 600 feet away. I've also used Yongnuo RF-603s for this purpose on my Canon DSLRs.

So what do you do if you don't have a wired or wireless shutter release? One trick is to set your camera's timer to a few seconds or even 10–20 seconds. That will allow the camera to "settle down" after you press the shutter. On many cameras, you can also choose to have the camera take multiple photos when it reaches the time to fire the shutter. Some wired or wireless shutter releases such as the RC-6 also allow for a 2-second delay, which is great when you want to take self-portraits or group shots and hide the remote at the last second.

On some cameras, you can download an app on your smartphone that will allow you to control your camera remotely. See Tip 50 for more options.

FINDING AND TESTING TRIPODS

1. If you are in the market for a tripod, determine what's best for you based on the above criteria, and consider purchasing two different sets of legs with one sturdy tripod head. Just make sure that you can carry it (see the next tip for more on that). A trip to a well-stocked camera store or a photo show like the PDN PhotoPlus International Conference + Expo in New York City (www.photoplusexpo .com) is the best way to do an actual head/tripod test, or you can purchase online from a store that allows returns for any reason without a restocking fee.

2. Test your head and tripod combination in the following ways:

- First, level your tripod legs without the camera placed on the tripod. The key with tripod legs is stability, and if you are very close to being level based on using a spirit level, that is usually sufficient since you will be able to make finer adjustments with the head.

- Place the camera on the tripod and level the tripod head. Then start with your shortest lens, such as a 50mm lens, and focus on an indoor poster or an outdoor sign with a lot of type. You can also tape a magazine page to the wall. Just be sure that your camera is on the same plane as your sign. Imagine a pair of perfectly aligned bookends with their two "walls" that hold the books. They are on the same exact plane.

- Activate the live view on your camera and use manual focus with the zoom function to focus as accurately as possible. Do your tests using a wired or wireless shutter release, as described earlier in this tip.

- Set your camera to Manual mode and take pictures at 1/320, 1/200, 1/80, 1/30, 1/8, 1/4 and 1 second (aim for an aperture of between f/8 and f/11) to see how stable the camera is at different shutter speeds. Also do a test with and without the mirror lockup engaged if your camera has the feature. Mirror lockup is a feature on most DSLR cameras that allows you to flip the mirror up before one or more exposures to reduce vibrations inside the camera that might cause camera shake and blurred images, especially when using telephoto lenses on tripods that are not very sturdy.

- Change to your other lenses and repeat the procedure. Critically examine the photos to see if the images are sharp.

- Do some testing in Shutter Priority mode in which you track a subject as it moves, like a bird or person running, to test how well you can follow the action with the tripod as you look through the viewfinder. Use 1/1000, 1/500 and 1/250 second as the shutter speeds. You may have to bump up your ISO to 800, 1600 or higher to achieve these speeds, depending on your camera and the amount of light available in the scene.

CARRYING A TRIPOD AND/OR MONOPOD

Many photographers, regardless of their skill level, have a love-hate relationship with tripods (and to a lesser extent, monopods). Tripods and monopods can be extremely useful, but they can also be cumbersome to carry, especially if you will be doing a lot of walking/hiking. These quick tips should help you carry your sticks (as the pros call their tripods) with much less effort.

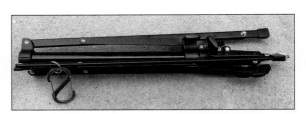

Fig. 25.2 The same light stand and Nite Ize S-Biner shown in Fig. 25.1.

THE S-BINER BELT METHOD

After lugging them around for years, I've discovered that I can more easily carry monopods and some tripods just by attaching an S-biner carabiner to my belt, then attaching a monopod or tripod to that directly, or to another S-biner on the monopod or tripod. Figures 25.1, 25.2, and 25.3 illustrate both how I attach the biners and how they look when attached to my belt. The main disadvantage with this setup is that depending on your height, a long monopod or tripod may hit the ground as you are walking.

THE PEAK DESIGN ANCHOR LINKS METHOD

I use a number of products from Peak Design that come with their innovative anchors. They give you extra anchors with most if not all of their products, so I use them at times instead of an S-biner, primarily because they are so light and small. Plus, I can leave the anchors on my belt all day because they are basically invisible (see fig. 25.3). In 2015 the company introduced new anchors made from Dyneema fiber, which are more durable than the original anchors. In addition, they have a built-in color indicator system to help you determine if they need to be replaced.

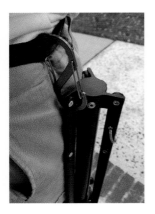

Fig. 25.1 One way to carry a tripod or light stand. In this case, I've attached one Nite Ize S-Biner (Size #4) directly to my belt, and attached the other side to the stand.

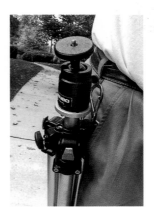

Fig. 25.3 Here's another photo of me carrying a tripod/head combo weighing just over 4 pounds, attached via a Peak Design Anchor.

ATTACH TO THE SIDE OF A BACKPACK

Many backpacks made for photographers and videographers have an open pocket and/or series of straps on the side to secure a tripod or monopod. An S-biner can help make the process of unhooking a tripod or monopod easier.

WORKING ON THE CHAIN GANG

Using different chains (available in home improvement stores like Home Depot) can be very useful for carrying and also storing your gear.

An assortment of chains and an excellent bolt cutter (Kobalt 8-inch Bolt Cutter) that makes it easy to customize any chain for carrying gear more easily. All chains have a weight capacity, and to be safe, I would multiply the weight you plan to carry times five and use that as a guide for choosing a chain (if your tripod and head is 10 pounds, choose a chain with a weight capacity of at least 50 pounds). Also, try to avoid chains with sharp edges.

With a chain and strong snap ring, any tripod is ready to be carried.

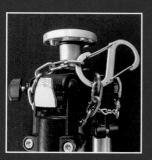

The chain shown here is super strong for heavier tripods and works well in conjunction with a Nite Ize S-Biner (Size #4). It's important to attach your chain in a way that allows you to take photos without having to remove it from the tripod (just your belt or bag).

ATTACH TO THE BACK OF A VEST OR JACKET

Though not the easiest method for retrieving a tripod or monopod, some vests, like those from www.thevestguy.com, have sturdy D-rings that can be used to attach an S-biner with a tripod or monopod, as pictured in fig. 25.4. This is a great option because the tripod or monopod is better protected compared with the belt method. I recommend using two S-biners (one attached to the D-ring and the other interlocked into the first one) for easier access and removal.

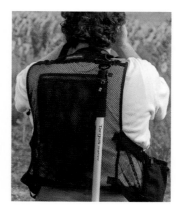

Fig. 25.4 I can still take photos while carrying a lightweight Targus monopod attached to a D-ring using an S-biner on the back of my photo vest. Photo credit: Denis McGrath

PRO ASSIGNMENT

TRIPOD TREKKING

Test as many of the approaches above that you think might fit your needs, and keep in mind that in some cases, you can keep your camera attached to the tripod or monopod while you are walking around. The best way to test these methods prior to a big trip is to spend at least an hour with whichever setup you choose, and simulate some of the activities you are planning to do, such as getting in and out of buses and trains, using restrooms, etc. When nature calls, you want to be able to take care of business without fighting with your gear!

TIP 26

ORGANIZING YOUR GEAR AND ACCESSORIES

If you own more than one camera, you probably also have a confusing assortment of cables, chargers, batteries, media cards, card readers, etc. If your cameras each take a different removable battery and/or media card type, then the fun really begins! It can be very frustrating working with so many components, and as someone with five different cameras, from an iPhone to a full-frame DSLR, I've had to deal with this issue for quite a long time. In this tip I will share some suggestions to organize your accessories and be able to quickly find what you need, whether you are taking photos at a nearby park or spending a month traveling around the world.

SMALL ZIPPER BAGS

I used to fight with tangled cords a lot (like those in fig. 26.1), especially when traveling. I then realized I could avoid the problem completely by using small zipper bags for each item, as shown in fig. 26.2. I like using the snack and sandwich bag sizes. The Ziploc brand bags seem to consist of heavier plastic and seal better than most store brand bags I've used, and they cost just a few cents per bag for most sizes. In some cases I also use twist ties, like those in fig. 26.3, to keep cords neater.

Fig. 26.1 Does this look familiar? Many of my wires used to look like this (actually worse) until I started using clear zip-top bags to organize them. See fig. 26.2 for the "after" photo!

Fig. 26.3 These twist ties are inexpensive and available in roll form with a built-in cutter.

Fig. 26.2 The same wires from fig. 26.1, but this time, they are placed individually in clear slider bags with desiccant bags and twist ties.

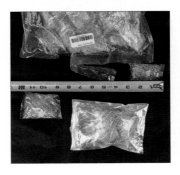

Fig. 26.4 Dry-Packs silica gel packets.

Since the bags are airtight, I'd recommend adding a small desiccant packet with any bag that will be stored in or brought to a less-than-ideal environment (especially humid environments). That being said, with a cost of about 20–40 cents per desiccant package, it's probably best to just use one in every bag since they will help avoid mold and mildew growth, as well as the tarnishing of metals (all electronics, including cables, contain metals that can get damaged in certain environments). You can purchase them online (just search for desiccant packs).

One particular desiccant product I like because it contains no cobalt chloride (a possible carcinogen) and because I can see when the gel needs to be changed, is called Dry-Packs 1gm Moisture Absorbing Silica Gel Indicating Packet (fig. 26.4). Each packet measures about 1 x 1½ inches (22 x 38 millimeters) in size. A package containing 20 dry-packs costs about $7 on Amazon. The zipper-lock package in which the product ships seals tight, but be sure to keep it in a relatively cool and dry place. I like the smaller size because I can use multiple dry-packs for my cameras and lenses, and single dry-pack for small items.

Once you have your accessories in bags, you can label them easily by writing down their contents on the outside of each bag with a standard Sharpie. The standard and original Sharpie ink dries instantly, and the ink is water-resistant. You can even use different color Sharpie markers for different types of items, or a certain color for accessories that go with a specific camera. You can also use adhesive-backed labels, such as those sold by Avery, and adhere them to the bags.

STORAGE CASES

There are many protective cases on the market, from lightweight smartphone cases to heavy-duty metal cases. After years of searching for just the right cases, I found many sturdy options available at Harbor Freight Tools (www.harborfreight.com). I use them to organize a lot of my gear, including flash units, batteries, small ball heads, radio transmitters and much more. These storage boxes are relatively strong, have see-through windows, come in sizes that are ideal for traveling and are very affordable. As with the sealed zipper bags, desiccant packs offer protection from moisture when placed inside these cases.

For considerably stronger (and in some cases waterproof) protective cases, try those manufactured by Pelican (www.pelican.com), SKB (www.skbcases.com), Seahorse Cases (www.seahorsecases.com), Road Cases USA (www.roadcasesusa.com) and Ape Case (www.apecase.com). They can cost many times more than comparably sized cases from Harbor Freight Tools, but they are usually worth the investment. Harbor Freight Tools cases should work very well for many uses if you stabilize the items inside the case and use them primarily for storage and organization (generally not for shipping).

Once you've filled or configured your cases, I recommend taking photos of how you've organized them. That way, if you change around the contents of your cases a lot, you will have a few photos as a reference for where things go. You can even paste a photo of the contents to the inside and/or outside of the case. Placing the photo inside is generally a better idea so that you can see what you are doing as you return items to their proper locations. If you attach the photos to the boxes using clear photo sleeves, you can easily change the photos later. You can find sleeves for 4 x 6-inch and 5 x 7-inch prints by searching for "Easy Mounts Clear Acid-Free Archival Photo Sleeves."

Dealing with various batteries used in cameras to flash units to microphone units can be a bit confusing, so I've created a special tip that covers those types of batteries, as well as how to configure battery boxes (See Tip 27, page 101).

STABILIZING ITEMS

Once you have one or more cases, it's important to keep the contents from moving around too much, especially if you will be traveling. Many cases contain small removable boxes, and depending upon what you put inside, the contents may move around if not stabilized. Here are a few tips to help.

TRY OUT THE BOXES—Mix and match boxes between cases as long as they fit, and take out any boxes to allow for larger items to fit.

SECURE THE BOXES—Hook-and-loop adhesive tape, such as the kind made by Velcro, can be useful for securing boxes to the bottom of the case, especially if you've taken any boxes out, causing them to be loose inside the case. Just be sure to always use the same side (hook or loop) on the bottom of the case so you can mix and match between cases.

3M makes a few very strong interlocking products under the brand name 3M DualLock Reclosable Fasteners. I've tested three of them:

- The TB3551/TB3552 400/170 Mated Strips are very strong, but each side is slightly different.

- The TB3500/TB3500 250/250 Mated Strips are also very strong, with no difference between both sides.

- The 3M DualLock TB4570 Low Profile Mated Strips also have no difference between both sides. However, the TB4570 is much

thinner and weaker than the other DualLock Reclosable Fasteners with regard to the bond between both sides. However, that weaker bond may be perfect for you if you'd prefer to have the boxes or other items release with less effort.

Also, a little goes a long way, so there's no need to cover the entire surface or most items (especially with the first two DualLock Fasteners listed here).

> ## PACKING FOAM
>
> Packing foam is ideal for cutting and inserting anywhere you need a sturdy type of cushioning. White closed cell foam is more easily chipped and damaged, so it's better for use as a box liner.

CUSHION YOUR PRODUCTS—Cushioned foam is another popular product, as seen in fig. 26.8. Customize it by cutting out sections carefully with a long knife or blade, such as an Olfa Pistol Grip Ratchet-Lock Utility Knife (L-1). Here are some cushioned foam options I recommend:

Pick N Pluck foam options: These avoid the need for cutting. Just trace the item lightly with some white chalk over the area where you want to insert it, pull out the foam pieces that are in that area and insert the item. Use multiple blocks of the foam to fill a case, or a portion of a case. I'd recommend the Pelican 1062 Pick N Pluck Foam Insert (made for the Pelican 1060 Micro Case, but you can purchase just the insert and use it for other cases).

Online Fabric Store (www.onlinefabricstore.net) sells Pick N Pluck foam in both 1- and 2-inch thicknesses for about $4 and $7, respectively.

Egg crates: For even more protection and to simulate the padding in many heavy-duty cases, add egg crate foam (or the ¼-inch closed cell foam) to the top of your items by attaching the foam to the lid, which will also help keep the items from moving around. I recommend the 1½ x 36 x 75-inch sheets of egg crate foam, which cost about $25 each, also from www.onlinefabricstore.net.

Another question that may come up is, "How do I get the foam to fit inside of my case?" If the case is just a simple square or rectangle, measure it, draw the dimensions on the foam, and cut it with a ruler and a sharp knife. If it is a more complex shape, use easy-release masking/painter's tape to carefully fill the bottom of a case, overlapping the tape a bit as you go. (Cut the tape with scissors for more accurate edges.) Pull the tape up and transfer it to the top of the foam, then cut the foam along the edges of the tape.

A SELECTION OF VERY USEFUL, YET AFFORDABLE CASES

I use Harbor Freight's item #93929, pictured in fig. 26.5 and 26.6, to hold many of my lighting accessories, including hot shoe adapters for mounting flash units on tripods, brackets for mounting multiple flash units on tripods or stands, umbrella brackets, quick-release plates and more. However, it is still small enough for me to take almost anywhere.

I use this same case to hold many of my wireless flash transmitters and receivers. I also store the batteries I will need for them in the same box. See the next tip for information on how you can easily test batteries, which is essential when using gear like wireless transmitters and wireless Lavalier mic packs that usually take 9-volt batteries.

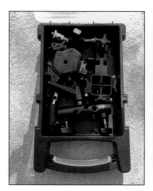
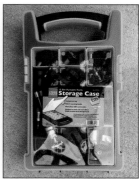

Fig. 26.5 and Fig. 26.6 Harbor Freight case (Item #93929).

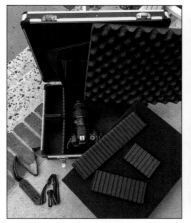

Fig. 26.7 (left) Harbor Freight 18 x 6 x 13-inch Black Aluminum Case (Item #69318)

Fig. 26.8 (right) Two different types of protective foam products are shown here. 1 x 24 x 108-inch charcoal packing foam (left) and 1/4 x 60 x 72-inch closed cell foam (right).

The Harbor Freight case shown in fig. 26.7 is relatively large and quite strong, with many potential uses. It can also be configured in several ways, and comes with protective foam on the top and bottom. I was even able to close it with a camera and body sandwiched between the top and bottom foam sections shown in fig. 26.8, without having to cut any foam. The bottom foam is Pick N Pluck foam, and the top foam is egg crate foam. Because the metal latches are not very rugged, I highly recommend using a luggage strap or other

strap around the outside of the case for added security when on the road.

Harbor Freight's Item #93928 (not shown) is quite large and can hold at least five shoe-mount flashes plus many accessories, though you should check the width of your flash units to make sure they will fit. I think it's the ideal travel case to carry shoe-mount flashes and accessories, AA and AAA batteries, wireless transceivers like PocketWizards or other 4- or 16-channel transmitters and receivers, umbrella brackets, and a few on-camera reflectors that can fold flat. Some of the yellow boxes that come with it are also ideal for holding camera battery chargers.

Harbor Freight's item #93927 (fig. 26.9) has the same width and length as Item #93928 but is twice as deep, so it can hold even more flash units and/or accessories securely. It can even be used to store camera bodies with attached lenses (depending on the size of the lenses). As I mentioned before with regard to bags, I highly recommend adding desiccant packs to the case if you store cameras in them.

Harbor Freight's item #95807 (fig. 26.10) is long and narrow, and relatively strong. I find it to be ideal for camera chargers and batteries. The sections can be customized in many different ways, which allows for a relatively tight fit without the need for much extra cushioning, though you may want to add some if you are traveling long distances. I recommend placing smaller batteries in bags with desiccant packs as shown in fig. 26.10 to easily sort them and to give them a bit more protection.

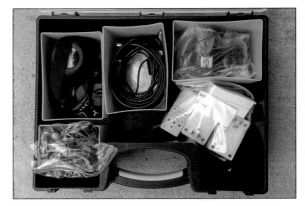

Fig. 26.9 Harbor Freight case (Item #93927).

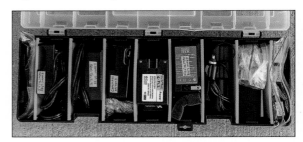

Fig. 26.10 Harbor Freight case (Item #95807).

PRO ASSIGNMENT

ORGANIZE YOUR EQUIPMENT (TRUST ME: YOU'LL BE HAPPY YOU DID!)

1. Gather all of your gear (or make a list of it) and think about which cases may be appropriate for your cameras, lenses, etc. Keep in mind that you can have main cases for storing many items, and smaller, empty travel cases just for when you are on the go. Then follow the suggestions in this tip for filling them up.

2. Create a custom foam bed for your gear using the products mentioned in this tip. You can use the foam that you pluck from Pick N Pluck foam sheets for inserting into other spaces that need it, especially if you use a knife with a long blade that extends to carefully remove it.

UTILIZING AND ORGANIZING RECHARGEABLE BATTERIES

As mentioned before, AA, AAA and 9-volt batteries (C and D batteries to a lesser extent) deserve their own discussion because they are used for so many photo and non-photo-related purposes. A common question that photographers often ask me is, "Should I use rechargeable batteries, and if so, which ones?" For flash units and wireless photo accessories, I highly recommend nickel metal hydride (NiMH) low self-discharge (LSD) rechargeable batteries for a few reasons:

- For battery-powered flash units, LED lights or cameras that use AAs, they perform much better than alkaline batteries, providing faster recycle times and a much longer service life during a photo session.

- They can be recharged for about five cents' worth of electricity each.

- Compared with non-LSD batteries that can lose much of their charge in a few months, good-quality LSD batteries can maintain about 75 percent of their charge, even after two years of nonuse.

The AA/AAA LSD battery brands I use successfully are:

- Sanyo Eneloop (now Panasonic), pictured in fig. 27.1. These batteries are my favorite because they are built well and perform extremely well in flash units. (I would not spend the extra money for the Eneloop XX batteries).

- Tenergy. Tenergy batteries can usually be purchased for about 20–30 percent less than the Sanyo Eneloops, and they work well, so they should definitely be considered, especially if you have a charger that can individually charge and run discharge/refresh cycles on NiMH batteries.

I have used and highly recommend the La Crosse BC-700 Alpha Power Battery Charger (about $50). If you must also charge batteries via a car battery or other 12-volt source, the La Crosse BC-500 charger is a good option, but not as good or easy to use as the BC-700.

For 9-volt NiMH batteries, I recommend the Powerex Imedion 9.6V 230 mAh batteries (about $10 each) with a 4-Bank Powerex Two-Hour Compact 9-volt charger (about $30).

Fig. 27.1 A very popular Eneloop Super Power Pack (Model # K-KJ17MC124A), shown open and closed. A newer version of the case is branded with the Panasonic name, has batteries that can be recharged 2,100 times versus 1,500 and comes with a better quality battery charger.

It also helps to have a battery tester to know the voltage of your batteries (especially non-rechargeable ones). Digital multimeters are inexpensive and do an excellent job. Harbor Freight sells one for under $10 (Item #98025).

BUILDING BATTERY BOXES

To quickly organize a pile of batteries in your home, office or studio, use a multimeter and box like the one shown in fig. 27.2. I recommend writing voltage levels along the left side in this manner: 1.2–1.29 V, 1.3–1.39 V, 1.4–1.49 V and 1.5+ V. Then just place the batteries in the proper row. For 9-volt batteries, as shown in the right side of the photo, you can create a similar voltage scale, from about 7.5–9.5 V, with the highest voltage batteries in the front section.

Harbor Freight's item #93929, seen in fig. 27.3, contains a few products mentioned in this and the previous tip. A piece of 1/4 x 60 x 72-inch closed cell foam from www.onlinefabricstore.net was cut to size and placed at the bottom of the box for extra protection.

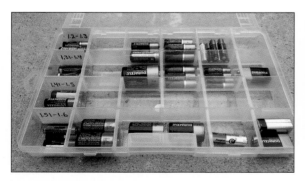

Fig. 27.2 This Harbor Freight case (Item #94458) makes it easy to collect and sort any size battery up to D.

CHECKING AND TRANSPORTING YOUR BATTERIES

For much faster battery testing, you can actually put alkaline and zinc chloride (Rayovac's Heavy-Duty batteries fall into this category) batteries into a charger like the La Crosse BC-700 for only a few seconds (you could damage the battery if you leave them in for much longer periods), which will give you a digital readout of the current voltage without starting any charging cycle. If you get a null reading for any battery, the voltage is very low, and you should recycle them. Some stores and municipalities will take and recycle different types of batteries for no fee. An excellent website that can help you find places in your area to recycle batteries and other items is www.earth911.com.

If you get a full reading, the battery is probably at or near 1.5 volts. Just be sure NEVER to recharge alkaline or any other batteries that are not meant to be recharged. The reason to test battery levels is because very often, alkaline batteries that don't have enough voltage to use for fast flash recycling (most alkaline batteries will stop working well in flashes when they reach about 1.3 volts) may still work perfectly fine for clocks, wireless mice, wireless keyboards and remote controls until they reach about 1 volt.

I also recommend four- or eight-slot AA/AAA plastic battery trays (search online for "AA battery case" for many sources), since the yellow boxes that come with most of the Harbor Freight cases have no tops. You can easily take out a set of batteries in a battery tray from a case and keep them in a jacket or camera bag so that they can be swapped out with a depleted set at any time. Just be sure to purchase cases that securely close if you plan to keep them loose in a pocket or bag.

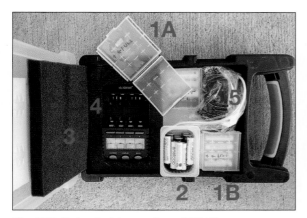

Fig. 27.3 Harbor Freight case (Item #93929)

1A Empty AA/AAA plastic battery case (I mark them to indicate that facing the positive tip of the batteries to the left means they are charged).

1B Full battery case.

2 Small Gerber baby food container (cleaned of course!) can hold many loose batteries.

3 1062 Pelican Pick N Pluck foam insert for the Pelican 1060 Micro Case was traced out and the foam plucked out so it could be used to cushion a La Crosse BC-700 charger.

4 La Crosse BC-700 charger.

5 Power supply for the La Crosse charger.

Studio Mastery

How to Get the Most from Your Home or Outside Photo Studio

Creating an in-home studio today is quite simple, but getting started can be overwhelming at first. A window with a couch or chair beside it is probably already waiting for you to make it a special place to capture moments in time of your family, friends or paying customers. A few lighting tools, like those described in this section, can make all the difference and help you produce images that you've always dreamed of creating.

In this section, I cover the nuts and bolts of lighting, choosing backgrounds, clothing choices for your subjects and even how to speak with anyone who is in front of the camera to make them more at ease. A photo studio is a blank canvas. Learn about the many options contained in the next group of tips, and I know you'll soon be creating some masterpieces!

SETTING UP CONTINUOUS LIGHTING FOR PHOTOGRAPHY

About a decade ago, the only way to produce affordable bright light was to use fluorescent tube lighting or incandescent lighting. Incandescent lighting comes in different forms and has different names, including halogen and tungsten, and all use a lot of energy and produce a lot of heat. Now, after much R&D and competition, there are many inexpensive CFLs and LEDs on the market—these require about five to eight times less electricity per lumen (a measure of brightness) and do not radiate nearly as much heat compared to their counterparts (though the base of CFL and LED bulbs can get very hot).

After testing many different bulbs over the last 10 years or so, I highly recommend screw-in A19/E26/E27 LED bulbs over CFLs because LED lights have come down dramatically in price over the last few years, require virtually no start-up time and contain no mercury (unlike CFL bulbs).

All bulbs have a specific color temperature. 5,000–6,500 Kelvin (K) bulbs are considered to be daylight, because they simulate the cool white light you often find during the day in most places. 3,000–4000 K bulbs are usually called "warmwhite" and simulate early or late-afternoon light, which is more pleasing and similar to the color of light you see with traditional incandescent/tungsten household bulbs.

Regarding wattage and brightness, the most popular LED bulbs are rated at a 40- to 75-watt equivalent, which equals about 450–1000 lumens. When compared with traditional incandescent lightbulbs, LEDs use only about 5–13 watts of electricity for that 450–1000 lumen output range.

So, which should you choose? I recommend choosing daylight LEDs if you want to closely match the natural light coming through windows during the day. You can then set your camera's white balance as though you are outdoors during the middle of the day. Choose warmer LEDs if you want to come close to matching the warm light in a home, office, etc. You can also mix the two and do some testing with different combinations depending on the situation.

The color temperature you set on your camera (or later in software, especially if you shoot in your camera's Raw format) is another very important part of the equation. See Tip 9 (page 36) for more on that.

A FEW COMPACT BATTERY-POWERED LED LIGHTS

There are many compact battery-powered LED options. Virtually all of them are natively close in color temperature to daylight (about 5500 K), and almost all of them come with a hot shoe and/or ¼- to 20-inch socket attachment for easy placement on a camera or light stand.

One that I own and that has impressed me due to its brightness, compactness and easy conversion to a tungsten-balanced light via a snap-on filter is the Flashpoint Reporter Super Compact 150 LED (about $50).

Another option that's very compact and high-tech is the Lume Cube (www.lumecube.com), a cube-shaped LED lighting product that's only a little larger than the size of a golf ball, but that packs a lot of lighting power. Plus, it's waterproof, with a depth rating of 100 feet, and it can be controlled by a smartphone to act like a wireless flash via Bluetooth. It can even be set to go off when it senses another flash via a built-in optical sensor. Plus, it can be powered via a USB battery pack.

You can find many more compact LED lighting options on the market in the $30–$100 range that take six AA batteries, such as the one pictured in fig. 28.1. Just search for "LED video light." They are considerably larger and heavier than the Flashpoint Reporter, but they can run much

Fig. 28.1 In this photo, I'm holding a rig I use for recording video at trade shows. I also use it for still images (on and off camera). It includes a 126 LED light with a hot shoe mount, powered by six AA batteries. Photo © Whitey Warner

longer if you change the batteries because they don't have built-in batteries. Ikan is just one company that makes some very high-quality battery-powered compact LED lights.

MEDIUM- AND LARGE-SIZE LED LIGHT PANELS

One of the most exciting product segments in the world of LED lighting is medium- to

CRI AND THE QUALITY OF COLOR

One thing that can make lighting more complicated with color photography is the quality of light that's produced by certain lights. With strobe (flash) and most incandescent bulbs, the color of light would usually simulate nature, either during the day (daylight) or early/late in the day (incandescent/tungsten). However, with fluorescent and LED lighting, that's not always the case. Think about the greenish light you may have noticed in a high-school gym or supermarket. That's similar to fluorescent lighting, and it's not always easy to make your color photos look as though you were outside during the day with just a quick white balance adjustment in your camera or in a program like Adobe Lightroom.

Color rendering index (CRI) is a measurement that helps to compare different light sources, like bulbs, with each other. One hundred is the highest value a light source can achieve, and a score over 90 means that colors should look very similar to those you would see with natural daylight. It's not a perfect measurement, but it can definitely help you choose between different lighting products. The problem is that many manufacturers don't publish a CRI for their bulbs (probably because they are usually in the 75–85 range). In those cases, it's best to read reviews and do your own tests.

Philips makes a SlimStyle A19 60-watt equivalent, dimmable soft white LED bulb that has a CRI of 90. I've used the SlimStyle Daylight LEDs and think they are fantastic because, in my experience, they reproduce color that looks very close to that captured with daylight. I could not find a CRI published for the Philips Daylight LEDs, but I'm sold regardless, and at about $7 per bulb, they are a great value.

large-size high-end LED light panels. There are many different options available that range in price from about $400–$2,500. Some just have daylight-balanced LEDs and some have a combination of daylight and tungsten-balanced LEDs, known as "bi-color LED lights." Others have slide-in color filters to convert some or all of the LEDs from daylight- to tungsten-balanced light. Many also include neutral-colored frosted filters to help diffuse the light. Virtually all of these can be dimmed to allow for a large range of brightness, and the advantage of the bi-color LED units is that you can dial in your color temperature to an exact Kelvin setting every time.

The Dracast LED500 Pro Bi-Color LED Light (about $700) is a good example of a highly rated bi-color LED light that can work with AC power or a portable battery. Another high-quality bi-color option is the Ikan IB508-v2 (about $550; under $500 each when purchased in a bundle of three). A less powerful but much more affordable (about $110) battery-powered option is the Savage LED204 Luminous Pro On-Camera Bi-Color LED Light.

CHOOSING LED BULBS MADE FOR LIGHT FIXTURES

Not all LED bulbs perform the same (even with very similar specs). The main negative with LEDs is that they are not as bright as many high-wattage CFL bulbs. That means you'll often need to use multiple bulbs to get enough brightness. You can mix different bulbs to get just the right color temperature for photography or for a specific space, as in fig. 28.2. In most cases, you can also use the same fixtures to illuminate any space. Be sure to check the life expectancy of the LEDs you buy, especially if you plan to use them for your home, office, studio, etc.; 10,000–50,000

hours is common, but I've seen some in the 2,000-hour range. Some only show a number of years based on a specific numbers of hours per day, which forces you to do some math to figure out the life expectancy.

Fig. 28.2 In this photo of a ceiling fan fixture in my kitchen, you can clearly see how different LED bulbs give off different colors of light. The warmer bulbs are warm white, and the cooler one is a 12-watt daylight bulb.

Keep your receipts and write the date you purchased the bulbs on the packaging to help you track them in case you need to exchange or return any before the warranty expires. One of my favorite daylight-balanced bulbs is the SlimStyle A19 60-watt equivalent, dimmable soft white LED bulb. It has a rated life of 25,000 hours, is lightweight, is quite resistant to breakage due to its design, and in my tests, the color quality is surprisingly close to daylight.

HOW TO FIND LIGHTBULB FIXTURES AND ACCESSORIES

There are many affordable AC-powered (plug-in) fixture options on the market, including:

- Socket adapters. These allow you to multiply the number of light sockets, as seen in fig. 28.3 and fig. 28.4. Multiple LED or CFL bulbs with socket adapters can be plugged into a power outlet multiplier. Quirky (www.quirky.com) sells a range of flexible power strips that can

be used in similar ways. Two other examples include the Westcott Four Socket Fluorescent Adapter, available for about $12 from B&H Photo, and the two-socket Leviton 660-Watt Keyless Twin-Socket Lamp Holder Adapter, available at a number of retailers for under $3. Westcott (www.fjwestcott.com) also makes many other continuous lighting fixtures and accessories worth exploring. I especially like their Rapid Box Octa products because they are built well and allow you to quickly set up and break down your lighting setups.

Fig. 28.3 (left) A warm white LED bulb is plugged into a Project Source 660-Watt Ivory Medium Light Socket Adapter from www.lowes.com (about $3).

Fig. 28.4 (right) The warm white LED bulb and light socket adapter from fig. 28.3 is shown here plugged into a Power Outlet Multiplier.

- Simple torch-style lamps. These take standard A19/E26/E27 bulbs and are sold just about everywhere (just remember to use sandbags with them to keep them from tipping over!). Some fixtures, such as the one pictured in fig. 28.5, have four to five adjustable, octopus-like arms that allow you to focus multiple LED or CFL lights on a subject and highlight specific areas of many different types of scenes.

Fig. 28.5 This five-head, 66-inch floor lamp is from Home Depot. You can find similar products at many other stores.

- Clamp-on fixtures. These have metal reflectors and can be found in most home improvement stores (search for "incandescent clamp light").

- Light sockets. These have a hole for an umbrella, as well as a standard ⅝-inch light stand adapter (search for "AC light socket umbrella" for many options). As with most electronics, reviews can be very helpful when making a purchase. One particular model that stands out for its features and price is the Flashpoint Cool Light 5 Socket Light Unit from Adorama (about $17). It has five sockets and five switches on the back to control each light. Impact (www.impactstudiolighting.com) also has a number of products worth a look, such as item #VA903 (pictured in fig. 28.6). It costs about $150. It comes with five daylight-balanced CFL bulbs, and the bulbs can be turned on and off via switches on the back. Another product I like due to its outstanding flexibility is called the Adorama Socket with

Light Stand Adapter & 20" Flex Rod, pictured in fig. 27. It is very versatile, with the ability to be adjusted in many ways. The six-socket adapter shown in fig. 28.8 converts a single E26/E27 light fixture into a six-bulb unit.

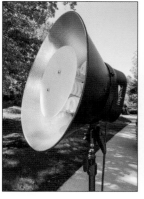

Fig. 28.6 This is the front and back of a well-made plug-in lighting unit from Impact (Item #VA903).

Fig. 28.7 The Adorama Socket with Light Stand Adapter & 20" Flex Rod.

Fig. 28.8 Always note the maximum wattage that can be used with your fixture, as well as the sum of the wattage of bulbs that can be used in the adapter.

PRO ASSIGNMENT

PLAYING WITH CONTINUOUS LIGHT SOURCES

1. Think about what type of photography you currently do or would like to do that can benefit from plug-in continuous LED lights. Then purchase a combination of fixtures and bulbs (or use what you currently have), keeping in mind the color temperature of the bulbs.

2. Do a photo session (still life or portrait) using LED or CFL lights. Take at least 10 photos with the lights bare bulb (nothing in front of them) from 3, 6 and 9 feet away, and then place some diffusion material in front of them (see Tips 22 and 32). Also, use some type of reflector (covered in Tips 21 and 22) to fill in the light. You can also use another LED or CFL light as a reflector (usually set to about a quarter of the power of the main light).

3. Mixing light types and settings can be very interesting. For example, try doing a portrait session using a warm white LED light (about 3500 K) on the subject, with your white balance set to Daylight and with daylight coming into your home, office or studio for the background. Your subjects will look warmer than normal, but as long as the LEDs are not too warm, they'll probably look like they are being bathed in warm sunlight! People generally like the look that this combination will provide, and because it's pretty easy to find daylight streaming into a home from direct or indirect sunlight, you can create beautiful portraits almost any time.

WIRELESSLY CONTROLLING LIGHTING UNITS

Remote controls, from TV remotes to wireless camera shutter releases, have certainly made life easier. But what if you could remotely turn on and off your continuous lights with the press of a button, allowing you to control the amount of light, color of light, and whether the lights are on or off, even if they are high up in the air or on the other side of the room? Another big plus is the ability to turn off lights in between photo sessions, thus saving energy. Here are a few steps for setting up one or more lights so that you can wirelessly control them.

PURCHASE A WIRELESS REMOTE CONTROL TRANSMITTER—I highly recommend the Woods Plug-In Digital Wireless Remote (Model #13569), pictured in fig. 29.1 and fig. 29.2. It costs about $20 for a 3-pack. It has a relatively small remote that you can attach to a tripod via hook and loop closure, or to a camera's hot shoe by securely gluing a flash shoe to the bottom of the remote. A flash shoe looks like the bottom of a shoe-mount flash and allows you to insert an object into the hot shoe on the top of many DSLR and mirrorless cameras. One product that works well for this is the Revo Hot Shoe to ¼- to 20-inch Male Post Adapter (about $7 at www.bhphoto.com).

Just unscrew the top thumb screw until it is flush with the top of the screw and use glue or a strong hook and loop product like the very strong 3M DualLock products mentioned on page 98 in Tip 26 to attach it.

Fig. 29.1 Top: The box for the Woods Plug-In Digital Wireless Remote. Bottom: The product items shown outside their box.

PLUG IT IN—Plug a light fixture into one of the three receivers (see Tip 28 for a number of light fixture options), then plug the receiver into a wall outlet

or power strip (the best option). Then repeat that step with the next two (if you have more fixtures). The fixture can contain one or more lights, and you can use light socket adapters as described in Tip 28 (page 105) and shown in fig. 28.8 as long as you don't exceed the maximum wattage for the fixture. (Exceeding maximum wattage is difficult to do with LEDs or CFLs since most bulbs are under 10 watts each, and most fixtures can accept at least a 60-watt bulb or equivalent, which would be six bulbs.)

Fig. 29.2 Demonstrating the Woods Plug-In Digital Wireless Remote.

LABEL YOUR LIGHT FIXTURES—Label each fixture or light stand with a one, two or three to help you identify which is which. I have seen many examples of people writing directly on or near bulbs with original Sharpies, so you could label the bulbs, but I would avoid it if possible. Most remotes are all labeled with corresponding numbers, but some, like the Woods Model #13569 unit, is not, so I would use a standard, original black Sharpie to label both the remote and its corresponding receiver.

A note about Smart Lighting: There are many lighting options available today that can be controlled over the Internet or via Bluetooth. One major advantage is the ability to change the color of the light. A search for "Smart Home" or "Smart LED Lighting" will bring up many links and a lot of information. For the cost and convenience, you still can't beat the plug and play digital wireless system I recommended in this tip.

PRO ASSIGNMENT

ADJUST YOUR LIGHTING REMOTELY

1. Set up your lights as desired with the same settings you would normally use for continuous light shooting. Use the remote control with one or more bulbs per outlet to increase the overall amount of light and to adjust the color temperature of your lighting. For portraits and many other situations, if you set up a group of main lights controlled by two remotes, and a fill light with a third remote, you will have a lot of creative options. Then just adjust your ISO, shutter speed and aperture as needed.

2. Add an accent light in a hard-to-reach place, like in a corner, in the background or on a light stand above the scene. This can have a dramatic effect. Consider adding a color gel in front of your lights for even more control. See Tip 32 for more on using color gels.

3. Use different bulbs in different fixtures for added control. For example, you can place daylight bulbs (5000–5500K) in Fixture #1 and the same wattage of warm white bulbs (2500–4000K) in Fixture #2. That will allow you to change the color temperature with the push of a button. Pressing both buttons allows you to have both sets of lights on at the same time, which will create a color temperature that's between daylight and warm white (approximately 4000K).

TIP 30

CREATING A "GRID SYSTEM" FOR UNDER $300

In this tip, I'm going to explain how you can create a very useful and affordable grid lighting system. These lighting setups are useful in keeping the shooting area very clean and open because they allow you to mount your flash units and reflectors to the crossbar (support bar) normally used for hanging backdrops. Let's assume that you already have your main background set up.

STEP 1—Set up two camera stands with a crossbar about 7 feet above the floor, approximately in the spot where you want your main light to be (in this case, the main light is to the right of the camera). You can use a crossbar made for photo backgrounds or you can use a painter's pole like the one I'm adjusting in fig. 30.1 or the ones seen in fig. 37.1 on page 139.

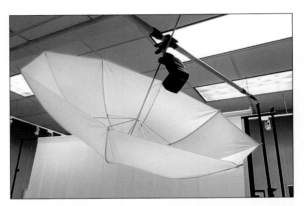

Fig. 30.2 The right side of our grid system, with a shoe-mount flash and an umbrella.

STEP 2—Hang your main light upside down (camera right), as shown in fig. 30.2. Here are a couple of ways to do this:

- Use a sturdy clamp with ball head attached. There are many on the market and the strength needed will be determined by your light and umbrella.

- Use a U-shaped clamp to both hang and attach the light. I recommend the Manfrotto 039 U-Hook Cross Bar Holders (sold in a set of two) or the Kupo Hex J Hook because they will all fit well into Manfrotto's 035 Super Clamp or some other clamps you can find named "super clamp."

- Use the more versatile and affordable Manfrotto 175 Spring Clamp. This clamp has

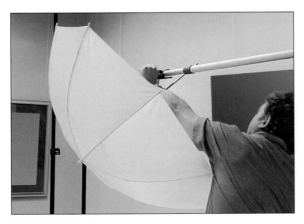

Fig. 30.1 A background stand and crossbar made from a retractable painter's pole.

an extra stud that can support softboxes and umbrellas, and the clamp can hold reflectors and other items.

STEP 3—Add one or two more background stands on the opposite side, creating a U-shaped grid. On this side, you will usually hang one or more reflectors, like the large circular one shown in fig. 30.3.

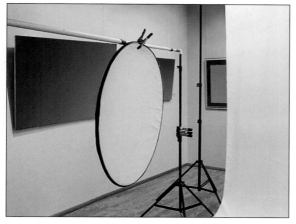

Fig. 30.3 The left side of our grid system.

STEP 4—Add additional lights or reflectors to use as fill lights, hair lights, etc. The grid system can even be used to construct a makeshift hair/makeup/dressing room, and any of the crossbars can hold an over-the-door mirror.

This system can also be used outside, with or without flash. On a sunny day, instead of using flash, reflectors or lightweight white fabric can be used to either reflect light back onto a subject or to allow the sun's rays through (acting like a big window with translucent drapes in front). This is especially useful midday. See Tip 21 (page 74) and Tip 22 (page 77) for some specific examples.

See Tip 31 for information on how to make and use sandbags.

TIP 31

MAKING AND USING SANDBAGS

There are many sandbags and beanbags on the market, and for good reason. They serve the basic but very important role of stabilizing cameras, tripods, light stands and other equipment. I'll even go as far as saying that they can save lives, and not using them in some cases can be extremely dangerous. Without them, there is a much greater chance of a light stand or tripod tipping over, especially if you are outside with a light stand that has a reflector or background attached to it in some way, such as via an extension arm. Similar to a ship's sail, just a light to medium breeze can quickly tip a light stand over. One specific reflector holder that has a built-in, threaded counterweight to help offset the weight of reflectors, lights, etc., is the Impact Telescopic Collapsible Reflector Holder. Even with that, I would recommend using a sandbag or two on the bottom of each stand.

In Suggested Equipment: Beanbags on page 163 I discuss and recommend a few beanbags for stabilizing cameras. You can purchase prefilled sandbags, at photo retailers, make your own sandbags, or buy empty sandbags and fill them yourself. The last two options are usually more versatile and less expensive than commercially available products.

I've found that about 15 pounds is enough weight to give extra support to an average 6- to 10-foot light stand, but you will need to do your own testing based on what you are doing. Two sandbags

(one on each side of the bottom of a light stand), are usually better than one.

SANDBAG OPTIONS

EMPTY SANDBAGS—I've found inexpensive, good-quality, empty sandbags on Amazon and B&H Photo (www.bhphotovideo.com). Just search for "empty sandbag." I like bright-colored sandbags so that they can be more easily seen in a dark room or when placed on a dark floor. The Impact Empty Saddle Sandbag, pictured in fig. 31.1, is a great choice. It is available in multiple colors and sizes from B&H Photo (sizes are listed as the estimated weight of the bags when filled).

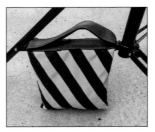

Fig. 31.1 An example of how I use a commercially available sandbag filled with clean rocks from either a dollar store or pet store.

SADDLE SANDBAGS—These are often best because they drape nicely over the rods that support the bottom of most light stands.

You can also try the following options:

- Hang them from a retractable hook that can often be found just under the center column of a tripod (unlike stands, most tripods have no support bars on the bottom of their legs).

- Wrap the saddle bags around one or more of the tripod legs, but that's not very secure (especially if you move the tripod). Plus, the ground may be dirty.

- If your tripod has no hook, drape two lightweight, 3- to 5-pound sandbags across from each other over the tripod head (placed just above the legs) before attaching your camera.

- Use a 5-inch Jumbo Aluminum Hook to hold two sandbags on either side of the tripod's support column (it looks like a large carabiner), as pictured in fig. 31.2. The hook is available at Harbor Freight Tools for about $3.

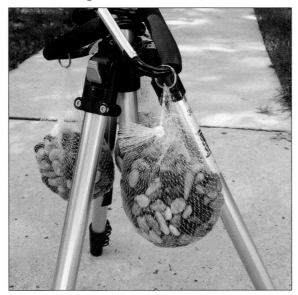

Fig. 31.2 This technique of hanging bags of rocks via jumbo aluminum hooks can really help steady your shots, especially when using lighter tripods.

- If you prefer sandbags with single holes to hang them instead of a handle made from strapping material, Adorama sells empty small Flashpoint Weight Sand Bags by the pair. Most of the companies that sell empty sandbags also sell filled ones, but shipping costs can be higher, and if they are sealed, you can't transport them empty and fill them when on location.

PLASTIC BOTTLES—Instead of bags, another option is to use plastic bottles, such as 500-milliliter water bottles, and fill them with sand. If you plan to do this, be sure to use bottles made from heavy plastic. A funnel will help a lot to minimize spillage, and wider-mouth bottles will make filling and emptying easier. The main negative with water bottles is that they are not nearly as formfitting as the other options discussed here. You may ask: "Why not just use water to fill the bottles?" Even with multiple bags protecting the bottles, I just don't feel like it's worth it to take a chance with water because a spill can be messy and dangerous, especially if there are lighting units and/or wires on the ground. Freezing temperatures will also make the water in the bottles freeze and expand.

PLASTIC ZIPPER BAGS—You can also purchase gallon-size plastic zipper bags and just drape them over the support rods of your light stands, but the empty sandbags are much more durable, plus they have a handle that allows them to be

DOUBLE BAGGING

Prior to placing it in the empty sandbags, I recommend double or triple bagging your sand using high-quality zipper bags with slide closures, such as Ziploc Slider Storage Bags, available in gallon or quart sizes. Put about 3 to 10 pounds of sand in one bag, and then place that bag in another bag. That gives extra protection in case the first bag leaks and allows you to customize the weight of each sandbag. The gallon bags should be used when you want to simulate the look and feel of a filled sandbag, and the smaller, quart-size bags should be used when you want to have more options. For example, compared to when taking photos in your own home or studio, you may prefer to use half as much weight in each sandbag when traveling.

hung from a tripod hook, or placed over a tripod head and draped over the legs of the tripod as described above.

TRADITIONAL SANDBAGS—Another option is to buy no-frills, traditional sandbags. I've prepared some step-by-step directions below with photos showing how I use them. The specific sandbags shown are the 14 x 26-inch OD Sand Bags from www.campingsurvival.com. These are much lighter and less expensive than the other commercially available sandbags I mention in this tip. That makes them ideal for when you want to dispose of them after use, and they come with simple pull-strings instead of zipper closures. If you can't find the sandbags there, you can find similar bags at www.sandbagstore.com.

HOW TO FILL YOUR SANDBAGS

SAND—I recommend using bulk play sand from a home improvement store, but not all are created equal so read the reviews before purchasing. Play sand is generally clean, sifted so that it is free of rocks and best at conforming to the shape of the items you drape it across. Quikrete 50-pound Play Sand, available at Lowes (www.lowes.com) for less than $5, gets very good reviews.

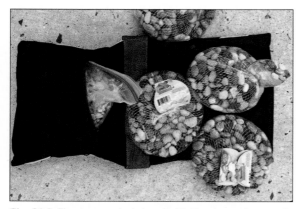

Fig. 31.3 These are rocks I place inside the zippered compartments of empty sandbags.

SMALL ROCKS—I sometimes like using small rocks instead of sand. One approach that I've used successfully is to buy small bags of aquarium/decorative rocks from a dollar store, as pictured in fig. 31.3. The ones I've purchased are small and smooth and cost $1 for a 2½-pound bag. The main reason I like them is that I can stuff as many of the small bags as I want (up to the bag's capacity) into an empty sandbag, and I can easily take them out when I'm done, without any concern about puncturing a plastic bag full of sand. If I'm traveling by air, weight is a real concern. I can just bring the empty sandbags with me and purchase 10–20 bags of the rocks when I get to my location (as long as a store can be found), depending on how much equipment I need to support.

A less expensive rock option is to purchase a ½-cubic-foot bag of rocks (weighing about 40–50 pounds) from a home improvement store like Lowes or Home Depot, then following the directions for bagging rocks in Make Your Own Sandbags on page 117. There are many different rocks available in various sizes and shapes. For maximum conformability, I would recommend pea gravel, which costs about $4 per ½-cubic-foot bag. One negative with this product is that the bag will also contain a lot of fine particles that you will not find with the dollar store bags of rocks. Aquarium gravel from a pet store is another product that should work well, though it will cost about 5 to 10 times more than the rocks sold at a home improvement store.

MAKE YOUR OWN SANDBAGS

1. Decide how many light stands, tripods or other equipment need supporting. Then purchase a few more sandbags than you think you will need so that you will always have them ready. (You will need a minimum of three bags of the dollar store rocks I mention on page 116 for each side of a saddle sandbag to give a light stand or tripod decent support.)

2. Determine whether you want to use sand or rocks, and purchase the amount you need to fill the plastic bags before placing them into the empty sandbags. Then, test them out before using them for an important job or project to make sure that they help stabilize your equipment.

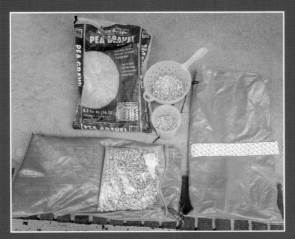

Fig. 31.4 Here are the items I suggest to make your own sandbags: A bag of pea gravel with a plastic strainer, a plastic soup container, clear slider bags and two 14 x 26-inch orange sandbags.

1. To make your own sandbags, fill a gallon clear slider bag with pea gravel or other rocks (double or triple bagging is recommended). If desired, strain the rocks through a plastic strainer to reduce the amount of sand in the bag, which can leak out in the form of dust if you use clear slider bags like the one shown in fig. 31.4. A leftovers container also works will for scooping rocks into clear slider bags.

2. Place the filled bag into the bottom of the sandbag.

3. Place a 2-inch (5-centimeter) strip of hook and loop material the same length of the bag inside the bag and across the center. In fig. 31.4 the hook and loop material is shown on top of the right bag before I placed it inside just below where it is now (I used 2-inch Velcro brand Industrial Strength Tape). This allows the clear bag with the rocks to stay on one side, and it serves as a good hinge for placing on light stands and other locations, as seen in fig. 31.5. Alternatively, you can use double stick tape, or you could even just create a series of tape loops and line them up side by side across the length of the seam.

4. Place another filled bag into the top of the sandbag, tie it up and start protecting your gear and loved ones!

5. Alternatively, you can follow the same process, but use the dollar store bags of rocks or aquarium rocks, which will avoid the dust issue.

Fig. 31.5 Above left: Here's a look at the sandbag in use, securing a light stand. You can see how the 2-inch wide Velcro brand hook and loop material is acting like a hinge between the two sides of the bag. Above right: Side view of sandbag in use.

TIP 32

CREATING WINDOWLESS "WINDOW-LIGHT" PORTRAITS AND STILL LIFES

There's something magical about the softness that light filtering through a window can create, and photographers have been capturing images using window light for about as long as there have been photographic processes. But what can you do when natural light is not available, or when you'd like to create a specific look no matter the time of day? These tips will help you to create window light portraits and still life photos without any real windows.

One thing to consider is that the light output (number of lumens) of most continuous lighting sources is much lower than most strobes (even shoe-mount flash units). That means you will need quite a bit of continuous light (sometimes multiple fixtures) to get enough light to capture a moving subject without blur. Luckily, continuous daylight-balanced fluorescent and LED lighting are generally very affordable. Also, the power requirements are just a fraction of what's needed for the same output when compared with halogen or incandescent lights and fixtures, and the heat generated by fluorescent and LED lighting is dramatically less than that of halogen or incandescent lighting. This makes light modification, such as placing colored gels or even some fabrics in front of the lighting units, much easier, though you should always use caution when placing potentially flammable materials in front of any light source.

Fig. 32.1 This little lady was a real "ham" for the camera.
Camera: Canon EOS 5D Mark II; Lens: EF 24-105mm f/4L IS @ 85mm; F-stop: f/5.6; Exposure: 1/80 Sec.; ISO: 1000

Fig. 32.2 These two dogs were lit by the continuous lighting setup shown in fig. 32.3.
Camera: Canon EOS 5D Mark II; Lens: EF 24-105mm f/4L IS @ 58mm; F-stop: f/7.1; Exposure: 1/60 Sec.; ISO: 1000

Here are some tips to consider when setting up your lighting:

CONSIDER THE PLACEMENT OF YOUR LIGHTS AND THEIR MOBILITY ON SET—The placement of your main lights is what determines so much of the look of your portraits. Wheeled light stands are one way to help make quick modifications (especially if the lighting unit you are using is heavy). For the photos shown in fig. 32.1 and fig. 32.2, all three of the lighting units were placed on Avenger A430 light stands, as shown in fig. 32.3. They are camera right, about 7–10 feet away from the pig and the dogs, who needed some extra room to move around the set. As you move the lights farther away from the subject(s), you lose light intensity, and the quality of the light will change, often leading to harder shadows. I also kept the lights very directional (placed at about 4 o'clock if the subject was at 12 o'clock), so that the lighting would look flattering and more dramatic than a front-lit image. For the height of the light, I basically centered the softboxes with the subject's face. Softboxes are the lighting units you can see on the right side that hold the light fixtures and serve to soften the light in different ways depending on their size and the diffusion materials used in front of the lights.

CHOOSE AND SET UP YOUR DIFFUSION, FILL LIGHTING AND OTHER LIGHTING—Diffusion of the main light is very important because it can greatly affect the overall look of images, including how harsh the light appears and the look of the shadows (contrast). For all of the photos shown here, only an internal baffle was used to diffuse the light for the left and center softbox. The baffles are basically clip-on diffusion sheets that attach to the inside of the units, and they do a great job of diffusing light while retaining good brightness. For the softbox on the right in fig. 32.3, two

12 x 12-inch sheets of Manfrotto Filter Diffusion Pack (similar to the Pro Gel Diffusion Filter Pack, available at www.bhphotovideo.com) were taped together and clipped onto the top of the softbox. I chose this approach because I like the way that the combination of medium-diffused light from the left and center softboxes mixes with the less diffused (harder) light provided by the softbox on the right. Another bonus of this setup is that the multiple lights produce a very interesting catch-light pattern in the dogs' eyes (similar to a room with multiple windows).

Fig. 32.3 The continuous lighting setup described in the text.

PREPARE YOUR FILL LIGHT— Fill light is another essential part of any portrait, and it's used to lessen the contrast in a photograph. For the portraits in figs. 32.1 and 32.2, I used a Larson 42 x 72-inch Reflectasol Super Silver and a Larson 42 x 72-inch Reflectasol Soft White, both placed camera left. The Super Silver reflector is closer to the camera.

CONSIDER YOUR BACKGROUND LIGHTING—For the portraits in fig. 32.1 and fig. 32.2, I placed a small fixture camera right (just out of the frame) with a 50-watt halogen bulb (similar to a standard lightbulb you might buy at a hardware store) to illuminate a portion of the background from about 4 feet away. Because the color temperature of the light was about 3500 Kelvin and my camera was balanced for about 5500 Kelvin, the

light created a nice warm glow on the neutral gray backdrop. I could have also placed a warm color gel over a daylight-balanced light to create a similar warming effect. See below for more on color gels. I photographed fig. 32.3 in a photo studio with a few continuous lights. The background light was created by the modeling light from a studio strobe unit. A projection attachment was added to the light to create the oval shape of light on the wall. A flashlight was used to create the lighting on the pepper and the column.

COLOR GELS—Color gels add many interesting creative lighting options. They are usually sold as thin plastic sheets (but they can be heavy plastic or even glass), and they come in a range of colors and sizes. Search online for "Roscolux Swatchbook" to find very inexpensive sample books with a rainbow of small gels that can be used as is in front of your lights (especially shoe-mount flash units), or you can use them to find just the right color you want so that you can order larger sheets. And always be careful! Some lights and/or fixtures can burn the gels and potentially cause a dangerous situation.

Fig. 32.3 "Dancing Pepper."
Camera: Sinar P2 with a Leaf Digital Camera Back; Lens: Sinaron Digital 60mm; F-stop: f/5.6; Exposure: 1/2 Sec.; ISO: 50

USING ON-CAMERA TTL FLASH FOR PORTRAITS AND EVENT PHOTOS

Throughout this book I've talked about the beauty of light coming from one side. However, if you glance through just about any wedding album or magazine that shows professionally shot party photos taken indoors, you will almost always see the type of lighting that is most popular for that kind of photography—on-camera flash. Everyone's face is usually lit evenly, with no strong shadows on either side (unless there was other light in the room or coming in through windows). That's because it's not usually feasible to roll a light stand around or have an assistant follow you around everywhere holding a flash on a pole in the air so that your light can simulate the afternoon sun.

TTL stands for through-the-lens flash metering and it works by firing a "pre-flash" just before the main flash. That information helps the camera determine the proper flash exposure automatically, even if the distance from camera to subject changes from shot to shot. For example, you might photograph a bouquet of flowers from 3 feet away, followed by a portrait of 10 people 10 feet away. There are different variations of TTL depending on the camera brand and technology that's used, and they have abbreviations like E-TTL, A-TTL, iTTL, etc. My goal in this tip is to help you make well-exposed photos quickly with a camera and TTL flash by following a step-by-step process.

Fig. 33.1 My Canon EOS 6D camera with a hot shoe–mounted Yongnuo YN-468 II flash. Many of the flash's adjustments can be made directly from the camera's flash menu, which can save a lot of time compared with navigating through menus on the flash.

STEP 1: PLACE A SHOE-MOUNT FLASH ON YOUR CAMERA OR A PHOTO BRACKET

There are quite a few TTL flash options for most cameras that have a hot shoe (especially Canon and Nikon DSLRs), from models made by the camera manufacturer to those from third-party manufacturers. Flash units made by the same manufacturer as your camera are generally a good choice, though they can cost two to six times more than third-party options (often with very similar features). Either way, I would highly recommend purchasing a recently made TTL flash versus one that's a few years old because camera technology keeps advancing. A very good third-party flash is the Yongnuo YN-468 II. Fig. 33.1 shows the one I own for the Canon system, and I think it is outstanding for basic, on-camera TTL photography as well as manual flash. That being said, in late 2015, Canon released the Speedlite

430EX III-RT, and it is packed with features for about $250.

For more control when on the go, including the ability to create lighting effects closer to those you might achieve in a studio, you can move the flash to a hand-holdable bracket or light stand. You can also put the flash on a small ball head on the bracket. That's especially useful for lining up the focus-assist light (a built-in light that helps the camera focus) so it's pointing in the proper direction. There are too many wireless options to discuss here, but five excellent websites to explore reviews and tutorials are: flashhavoc.com, pixsylated.com, speedlights.net, Strobist.com and YouTube.com (search for David Carrico's channel for a few excellent reviews and tutorials on the Yongnuo YN-622N, which is a camera-mounted wireless flash trigger that can control a number of different Yongnuo flash units).

A FEW NOTES ON USING BUILT-IN FLASH

Using a built-in camera flash such as a pop-up flash found on many DSLRs is much better than nothing in low-light situations, but also problematic for the following reasons:

- First, the size of the flash is generally very small, which leads to very small catchlights in the eyes as well as contrasty, dark shadows behind your subjects if they are near a wall.

- Second, most on-camera flash units, when used with a wide-angle lens or zoom lens at a relatively wide setting, can result in a noticeable shadow toward the bottom of the frame because the flash is not high enough to clear the lens.

- Third, a built-in flash shares battery power with your camera, causing more frequent

battery changing than if you were to use an on-camera flash with a separate battery.

That being said, if you plan to use your built-in flash, just select the Flash Exposure Compensation (FEC) option in your camera's menu to make adjustments to the flash's power, as I show in fig. 33.2.

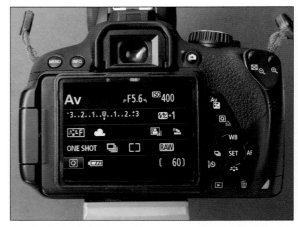

Fig. 33.2 The Quick Control Screen of my Canon EOS Rebel T4i (accessed via the "Q" button on the back of the camera). The built-in flash is up and the Flash Exposure Compensation (FEC), located just under the ISO, is set to +1.

STEP 2: SET YOUR FLASH FOR TTL

Every TTL-compatible flash has a TTL and Manual mode (most have a Stroboscopic mode as well, which allows you to fire multiple flashes quickly in a specified time period). Set your flash to TTL mode and start with no plus or minus FEC. Then try -2, -1, 0, +.5 and +1 to see the effect each has on your subject(s). Minus 1 and -2 often work best when you are outdoors and want to create "fill flash," which fills in shadows without a strong indication that flash was used. When indoors, start with 0 and then try +.5 and +1. As you move up in the numbers, the effect of the flash will become more pronounced on the subject(s) compared with other lighting in the room.

STEP 3: SET YOUR ISO, SHUTTER SPEED AND APERTURE

This is where flash photography can get a bit confusing. You can get good flash exposures with a TTL flash using Program, Aperture Priority (as in fig. 33.3), Shutter Priority or Manual modes, but I strongly feel that manual is best because it allows you to set everything based on your situation. Regarding ISO, I recommend using the highest ISO you can use without introducing much noise (usually that will be ISO 200–1000, depending on the camera), especially if you are taking most of your photos indoors. That will cause your flash not to work any harder than it has to, and your recycle times will then be faster.

Fig. 33.3 For this image, I used my built-in flash and had my camera mode set to Aperture Priority. Because of that, the camera read the ambient light and chose an exposure of 1/6 second, resulting in the glowing light on the kids' faces.
Camera: Canon EOS D60; Lens: Canon Macro EF 50mm f/2.5; F-stop: f/2.8; Exposure: 1/6 Sec.; ISO: 400

Now on to aperture: If you are photographing groups of people (especially if they are standing in multiple rows), f/11 is a good starting point for full-frame 35mm DSLRs, and f/8– f/11 is a good starting point for cameras with smaller sensors, like the APS-C or APS-H size sensors used on most Canon Rebels and most Nikon DSLRs. If you want a more shallow depth of field, use smaller f-stops, like f/2.8 or f/5.6. You can also change any time you want throughout the event or photo session.

Fig. 33.4 In this image of my wife and her parents, niece and nephew, I used a similar approach as with fig. 33.3. However, there was more light in the room, so the exposure was faster.
Camera: Canon EOS D60; Lens: EF 16-35mm f/2.8 @ 22mm; F-stop: f/2.8; Exposure: 1/90 Sec.; ISO: 400

Regarding shutter speed, start with your camera's fastest sync speed (usually 1/180–1/250). In many cases, with those settings, all of the light in your photos will come from your flash (little to none from the lighting in the room). You can check if that's the case by turning off the flash with those settings to see if you can see anything. Anything you see will be adding to the flash exposure, since every flash exposure is essentially two exposures in one (the available light exposure plus the flash exposure). When there is more light in a room, you can use a faster exposure, as in fig. 33.4. In darker cases, you will want to use shutter speeds closer to 1/125 or 1/60 to allow some of the light in the room to show. Just be aware that if your shutter speeds are too slow, your images will probably start to show blur and ghosting

(when you can see through an object or person due to a long exposure), either in the background or the foreground. On many digital cameras, you can use Aperture Priority and limit the shutter speed to 1/60 second or sometimes the fastest sync speed, such as 1/200 second. That allows the camera to use the flash but avoid things like ghosting of different areas in case someone moves during a slow exposure.

STEP 4: ADD A FLASH MODIFIER

This is a very important step because even with an on-camera flash, the light that comes from most flash units is still too contrasty, creating harsh shadows and small catchlights in your subjects' eyes. When you turn your camera, the shadow also ends up in an unnatural location.

My favorite lightweight, versatile and easy-to-use modifier is the Rogue FlashBender. The latest model is the Rogue FlashBender 2 (Large Reflector). I own the original FlashBender Large Light Modifier, as pictured in fig. 33.5, as well as the Small Reflector and Softbox kit, which are similar to the current models, but the company has made a few improvements, including making them 20 to 30 percent lighter. The product softens your light source while allowing you to focus light toward your subjects in different ways

Fig. 33.5 Here I am holding a shoe-mount flash with a wireless flash trigger (Yongnuo RF-603) at the bottom, and a Rogue FlashBender Large Light Modifier attached to the top. The image is so bright because it was captured just as the flash went off thanks to the radio trigger unit that was in the camera's hot shoe.

Fig. 33.6 For this image I used an external shoe-mount flash mounted on a bracket just above my lens, along with a Rogue FlashBender Large Light Modifier.

Camera: Canon EOS Rebel T4i; Lens: EF-S 18-135mm f/3.5-5.6 IS STM @ 50mm; F-stop: f/5; Exposure: 1/160 Sec.; ISO: 400

via flexible metal "fingers" that are embedded behind the panel. I used one in fig. 33.6 to create a softer light and large catchlights in the eyes, compared with what I would have achieved with only a shoe-mount flash aimed directly at my subjects. You can include light bouncing off of a ceiling if you want by aiming your flash up, allowing it to "see" the ceiling, or you can bend the top of the reflector to avoid most of the reflected ceiling light from reaching your subjects. You can also add a diffusion panel to the front of the FlashBender 2 Reflectors. When sold together, the product is called the Rogue FlashBender 2

(Large Soft Box Kit), and costs about $60. A small softbox kit is also available for about $35. The company also sells FlashBenders made from soft silver, which is designed to give more "punch" compared with their white fabric. I use them both on and off camera, and I really like how easy they are to attach to my shoe-mount flash units.

- Gary Fong makes a number of good products for modifying flash, including the Lightsphere Collapsible (garyfong.com).

- Honl Photo is another company known for their flash diffusers (www.honlphoto.com).

- And another good option that uses magnets to hold the flash modifiers is MagMod (www .magnetmod.com).

STEP 5: SET YOUR FLASH EXPOSURE COMPENSATION

This is where the magic happens. On cameras with built-in flashes, you should set Flash Exposure Compensation (FEC) as an option as long as you are not on full Auto mode (a mode in which the camera takes over just about all the controls, including in most cases choosing a specific JPEG mode instead of Raw). Regardless of the camera, in most cases where you want the subject to be well-illuminated, keep the FEC set with no plus or minus setting. Then, like above, try -2, -1, +.5, +1 and +2 to see the effect each has on your subject(s). If there is a lot of available light and if you want the lighting from your flash to be subtle, use values like -2 and -1. Once you have the right number dialed in, you can keep using it until your lighting changes.

STEP 6: ADJUST SOME ON-FLASH PARAMETERS

Some of the other options commonly available on many flash units include an infrared focus assist light to help achieve focus even in very low light. Another common option is the ability to turn on and off an audible (beeping) flash-ready indicator (useful if you are in a quiet room, like a church or other house of worship). One more involves delaying or turning off the camera's sleep function, which can be useful if you'd prefer not to press a button to wake it up every so often.

PRO ASSIGNMENT
SHOOTING WITH TTL FLASH

1. Choose a TTL shoe-mount flash and start by using it directly on your camera. First, take a few photos with no flash modifier in both horizontal and vertical orientation to see the look you can achieve. Then, add a flash modifier as described in Step 4 and take photos of people and objects from a few feet away as well as about 10 feet away to see how well the flash covers each situation. Use as high an ISO as you are comfortable (I often use ISO 400–800 with my full-frame Canon EOS 6D and Sony A7R) so that your flash doesn't have to work as hard.

2. Now move your camera to a bracket and add a TTL cord or other wireless option that retains TTL. Angle the flash using a small ball head for extra control and repeat the same assignment.

USING PORTABLE FLASH UNITS OFF CAMERA WIRELESSLY

As I mentioned in the last tip with regard to on-camera TTL flash photography, the most natural and pleasing light usually comes from a light source that simulates the early morning or late-afternoon sun. Apart from using window lighting, there's no easier way to re-create that natural lighting effect than with one or more off-camera, battery-powered compact flash units. To keep things simple, I will focus on using a single flash in Manual mode to begin.

On a side note, off-camera, wireless TTL metering can also be achieved with most TTL-capable flash units (sometimes with additional hardware needed). That means the flash can be adjusted automatically from shot to shot just by changing the distance between your subject(s) and the flash. And virtually all flash units that have TTL flash also have a manual option.

Here's a step-by-step approach that should help you start making great flash photos in no time (once you have the gear...and fully charged batteries!).

STEP 1: SELECT YOUR GEAR

You will need a radio/infrared transmitter and receiver, a flash unit, a tripod and a stand clamp, or something to prop the flash up.

RADIO/INFRARED TRANSMITTERS AND RECEIVERS—There are many options for transmitters and receivers,

and your choice will depend to some extent on your camera and brand of flash. PocketWizard (www.pocketwizard.com) radio transmitters have been the industry standard for many years, and for good reason: they are well built, with impressive features, and they start at about $170 for two 10-channel PocketWizard PlusX Transceivers. The more channels a system has, the more options you have to change a channel if you experience any interference. This is primarily a concern where multiple photographers are working, such as in a large rental studio, or at a trade show.

Fig. 34.1 This four-channel radio receiver with a built-in umbrella holder is ideal for holding a lightweight shoot-through umbrella, and you can use a clamp with a ball head (also shown here) to either hold it or attach it to a pole or other object.

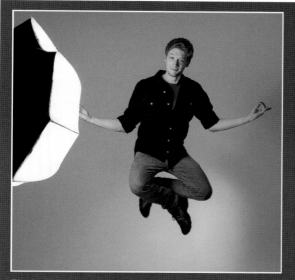
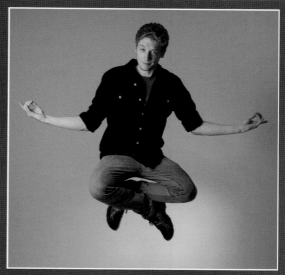

Fig 34.2 These two images were taken just a few seconds apart. On the left side is the main light, which is a Yongnuo YN-560 III Speedlite inside a 40 inch White/Black brolly box. It is being triggered by a Yongnuo radio transmitter sitting in my camera's hot shoe. On the right (outside the frame) is a large piece of foam board to reflect some light back onto the subject. The warm light behind my subject is a single warm white (about 3500 K) incandescent light bulb. I darkened the room for this shot and used a flash sync speed of 1/125 sec. Doing both made it easier to "freeze" him in mid-air and avoided almost all motion blur.

Camera: Canon EOS Rebel T4i; Lens: EF 28-135mm f/3.5-5.6 IS @ 28mm; F-stop: f/5.6; Exposure: 1/125 Sec.; ISO: 400

You can purchase four-channel radio transmitter/receiver sets with or without built-in umbrella sockets for as little as $20 per set (just search Amazon for "wireless flash triggers" for many options). In general, I recommend using a separate umbrella bracket instead of the ones with built-in umbrella sockets because that approach is much stronger (however, it can work well with a lightweight umbrella, as shown in fig. 34.1). I've used the four-channel triggers for years and like them a lot, primarily because the set can be used with just about any camera with a hot shoe, the transmitter is small and lightweight, and I can buy multiple sets of them very inexpensively so that I have backups in case anything breaks or stops working.

Four negatives to this product are they are not very durable; they have only four channels (however, a very similar 16-channel option can also be found on Amazon); they use a battery for the transmitter that's not AAA or AA (and it's not always available in stores that sell other batteries); and accessing the transmitter's battery requires a tiny screwdriver (luckily, it can run for over a year on a new battery with light use without having to be changed). On that note, I highly recommend testing your batteries. If your receiver uses a 12-volt battery, I would replace it if it reads under 11 volts. Label and keep the batteries that read 10–11 volts around in case of emergency.

A step up in build quality that uses much more popular AAA batteries for the transmitter and receiver is the Yongnuo RF-603 Wireless Transceiver Kit (about $25). There are multiple adaptations of this product for different Nikon and Canon DSLRs. An added bonus with this product (and the reason for the different models),

is that it can also be used as a wireless shutter release. That can be very useful if you want to do self-portraits or place the camera in a specific location (for example, above a basketball hoop or at the finish line at a race) while taking photos from another location.

FLASH UNITS—Regarding which flash unit(s) to consider, there are many options. Almost any shoe-mount flash with manual power controls going back 30 years or more is capable of doing a fine job. However, I prefer a system that allows me to wirelessly control the power settings of any compatible flash units I'm using from my camera. That means the flash can be inside a softbox or high up in the air on a stand, and I can still control its power. One third-party flash unit that I own and that stands out in my mind because it can do that and more is the Yongnuo YN-560 III used in the photos in fig. 34.2 and pictured in fig. 34.3. Unlike most other flash units, this flash has a built-in radio receiver, so any camera with a Yongnuo transmitter on it (or plugged into its side) can fire the flash. But that's not all. In order to control the power of one or more Yongnuo YN-560 III flash units, I use the Yongnuo YN560-TX (about $60). It serves as a transmitter and has a digital screen that makes adjustments easy. This flash is manual only, and the transmitter can control a number of different flashes and adjust their power from the camera, which is a fantastic feature.

TRIPOD, MONOPOD, CLAMP—You will want to place your flash on a tripod, stand or clamp, as in fig. 34.1, depending on your equipment, space and the effects you want to achieve. Even though you can use a sync cord to fire a flash unit, doing it wirelessly is safer (less chances for someone to trip over a cord). Having no wires also makes it easier to move your camera and flash around. I discussed different tripods and clamps in Tip 24 on page 86 (all can be configured to hold small shoe-mount flashes).

Fig. 34.3 A Yongnuo YN-560 III flash unit and a Yongnuo YN560-TX transmitter.

Fig. 34.4 This rig uses a wireless shoe-mount flash, a Godox S-Type Bracket Holder with Bowens mount and a white umbrella.

Fig. 34.5 I took this photo with a lighting setup similar to the one in fig. 34.3. The main difference is that the umbrella I used for the photo was slightly smaller (about 30 inches/76 cm).

Camera: Canon EOS Rebel T4i; Lens: Canon Macro EF 50mm f/2.5; F-stop: f/11; Exposure: 1/250 Sec.; ISO: 400

SETTING UP YOUR FLASH UNIT, STEP-BY-STEP

The rig in fig 34.4 is composed of a wireless shoe-mount flash mounted to a Godox S-Type Bracket Holder with Bowens Mount. I then added a white umbrella and set it up to shoot through the umbrella, which produces a contrasty look, with more prominent shadows, as seen in fig. 34.5. It's very sturdy and easy to use either hand-held or mounted onto a lightstand. For softer shadows and less contrast, you can reflect light from an umbrella onto your subject, you can use

a card-like reflector like the Rogue FlashBender products shown in fig. 34.6, or you can use a setup similar to the one shown in fig. 34.1.

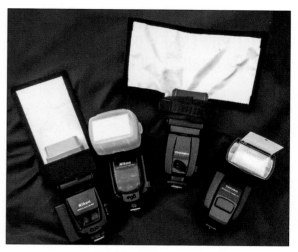

Fig. 34.6 The electronic flash units shown here use Rogue FlashBender Reflectors.

With regard to radio (RF) or optical/infrared wireless flash operation, let's begin with the option that often requires no extra hardware: optical/infrared wireless.

A number of Nikon, Canon, Sony and other cameras have the ability to send a signal wirelessly to trigger compatible flash units. The system usually requires a pop-up flash or another flash on camera to trigger the other flash. In addition, this setup is usually less reliable than using radio triggers, which means you can miss shots, especially if there is a long distance between your camera and flash, a lot of sunlight, or if your flash unit is hiding behind an umbrella or softbox. That being said, if you already have the gear, I recommend testing it out (especially in bright sunlight if that's one of the settings you plan to take pictures in) because it may work just fine for your needs.

If you are very serious about off-camera flash, if you want more consistency in more situations,

or if you can't use the built-in option, I highly recommend using wireless radio flash triggers on your camera and flash unit.

STEP 1: SET YOUR FLASH TO A MANUAL POWER SETTING AND NOTE THE AMBIENT LIGHT

Power levels on flashes that have manual settings usually range from 1/128 power to full power (1/1). The advantage of having many power options is that very small adjustments can be made (instead of jumping from 1/2 to full power with no steps in between). I like to keep my flash setting from between 1/4–1/2 power (or even lower if possible). Here's a super tip: Use multiple flash units so you keep recycle time short, battery life longer and hopefully avoid overheating, which is always a concern with shoe-mount flashes.

The ambient light during a flash exposure is very important to consider, whether it's super bright or pitch black. The important thing to understand is that every flash exposure is essentially two exposures combined into one. The ambient light portion (the part without the flash), and the part that uses the flash. Thus, it's a good idea to first take a photo without your flash on so that you can see what the ambient lighting looks like.

STEP 2: SET YOUR ISO, SHUTTER SPEED AND APERTURE

This step is exactly the same as Step 3 in the previous tip. Use Manual mode and set your ISO, aperture and shutter speed based on the suggestions in that tip. The only difference is that you will now control the power of the flash. If, after taking an exposure, your subject is too dark, then either increase your flash power (for example,

from 1/8–1/4 power) or choose a smaller f-stop value on your camera or increase your ISO.

STEP 3: ADD A FLASH MODIFIER

Because your flash is now off-camera, you have a lot more flash modifier options. As mentioned before, the Rogue FlashBender Large Reflector is an excellent product that provides fast, on-the-go diffused lighting, and I use it quite a lot. Fig. 34.6 features a range of electronic flash units with different diffusion options attached to each one. In most cases, I prefer the ones that look like cards compared with the plastic diffusion caps because they are made to reflect light from the flash pointed up to the sky, which produces a nice even light, without taking up much space. For softer lighting that creates larger catchlights in my subjects' eyes, I like placing a circular translucent white reflector in front of one or two shoe-mount flash units to create a softbox-like effect. Speaking of softboxes, there are many brolly boxes on the market (just search for the term) that open like umbrellas, but that provide light like a softbox (see fig. 34.2 for a photo that includes a brolly box). Some are shoot-through and others reflect light back toward a subject. One very versatile option that can be a brolly box as well as a shoot-through and reflected light umbrella is the Lastolite 8-in-1 Umbrella (about $130). I cover more reflector/umbrella options in Tip 22 (page 77).

A BIT ABOUT HIGH-SPEED SYNC

All cameras have a normal maximum sync speed (usually 1/160–1/250 second) when using flash. If you try to use a shutter speed that's faster than what your camera is capable of handling properly (known as the maximum flash sync speed), you will see some black bars, or darkened sections

in your images. High-speed sync is useful when you are outdoors and want to lessen the intensity of a bright sky while still being able to freeze your subject and/or use a lower f-stop, such as f/4 or f/5.6. Canon calls their implementation of it high-speed sync (HSS), and Nikon calls theirs Auto FP high-speed sync. One thing to keep in mind about HSS is that it generally needs a lot of flash power to light your subject properly, and more light is needed as you choose faster shutter speeds, so it's best to use as slow a shutter speed as possible.

A number of flash units can be used on or off camera for HSS, including the following:

- Canon Speedlite 600EX-RT (about $550)
- Nikon SB-910 Speedlight (about $550)
- Nikon SB-700 Speedlight (about $325)
- Yongnuo YN-568EX II Speedlite (about $100)

All of the above flash units can be triggered wirelessly, but extra hardware may be necessary, depending on the flash and your camera system. For example, Canon makes the Canon Speedlite Transmitter ST-E3-RT (about $300), which allows for wireless radio triggering of the Canon Speedlite 600EX-RT with or without HSS.

For a more affordable option, Yongnuo makes the YN-622C (for Canon) and YN-622N (for Nikon) that can be used with Yongnuo's YN-568EX or YN-568EX II flash units for HSS or non-HSS flash photography. One particular blog that covers the Yongnuo products very well is www.davidcarrico.blogspot.com, and for an excellent HSS tutorial for Canon using the Yongnuo products listed here, visit YouTube and search for "CamCrunch HSS." Most of the websites below also go into more detail about high-speed sync if you'd like to explore the topic more.

SOME ONLINE FLASH RESOURCES

WWW.FLASHHAVOC.COM—A wealth of information and reviews presented primarily in the form of product announcements and well-written Gear Guides with extensive product descriptions. The editor also does a great job of answering questions about what can be a very confusing topic.

WWW.JOEMCNALLY.COM—Joe McNally is a truly fantastic photographer who shares a lot of his lighting tips and opinions on his website. I also highly recommend his book, *The Hotshoe Diaries*.

WWW.PIXSYLATED.COM—An excellent resource for all things related to flash photography (especially the Canon system). The site is run by Syl Arena, photographer, educator and author of the outstanding book *Speedliter's Handbook*.

WWW.SPEEDLIGHTS.NET—This site features many reviews and common-sense overviews of products. One example is the review of the Nikon Speedlight SB-600, which is presented as being a very good alternative (as long as you know its limitations) to newer and more costly Nikon Speedlights like the SB-700 and SB-910.

WWW.STROBIST.COM—This website and its founder, David Hobby, have done an enormous service by helping to educate and inspire many to start using and refining how they use compact flash units.

WWW.THE-DIGITAL-PICTURE.COM—Another well-written site with many in-depth reviews of flash units and accessories.

WWW.YOUTUBE.COM—As I've noted before, YouTube is an incredible resource for learning about flash techniques and watching how-tos, like the excellent tutorial by Gary Fong of the Canon 600EX-RT Transmitter.

FINDING AND USING OFF-CAMERA FLASH

1. Choose one or more off-camera flash units by reading some of the product options in this tip and by checking some of the sites listed. If you have one or more flash units, learn more about them, as well as wireless radio and optical trigger options.

2. Follow the step-by-step approach for setting up your flash unit (keep your manual nearby!).

3. Follow the Pro Assignments in Tip 22, Tip 35 and Tip 36. The specific suggestions offered will help you create images, backgrounds and shooting situations that you may not have considered before. If I mention the sun in some of the tips, just substitute a flash unit.

4. Freeze your subject! Try the same approach and settings as I used for fig. 34.2 to capture someone jumping, someone juggling or a similar action shot. The key is to keep the room relatively dark and use a fast shutter speed during the flash exposure, such as 1/125 or 1/250.

SELECTING SOLID BACKGROUNDS

A photo background (a.k.a. backdrop), whether in the form of a pure white bedsheet or thousand-dollar hand-painted muslin (a popular smooth, cotton fabric), can play a huge role in the overall look of a photograph. On many movie sets, especially in the 1940s, '50s and '60s, painted backdrops were used to give the feeling of being outdoors, or in some other exotic setting.

The following are a few ideas for finding and creating different types of backgrounds for your images. See Tip 36 (page 136) for information on non-solid and digital backgrounds, and Tip 37 (page 139) for information on hanging backgrounds quickly, easily and safely.

Fig. 35.1 The model in this photo is standing on white seamless paper that's feeding from a roll system that holds multiple rolls of paper. The lights above are attached to an overhead track system.

SMALL BACKDROPS: SEAMLESS PAPER AND COLORED FABRIC

There are many solid-color backdrops available for shooting portraits and still lifes. One popular option, called seamless paper, comes on a paper core, and is usually hung from a background support bar that's supported by two light stands, like in fig. 35.1. The most popular paper widths are 53 and 107 inches. Another choice is to use solid-color fabric, available at fabric stores and from companies that specialize in selling backgrounds. The variety of color options is staggering, and some of my must-haves include white, black, medium gray and maroon. The main disadvantage to fabrics is that you can usually see folds

STEAM AWAY YOUR WRINKLES!

I would be remiss not to mention a couple of good portable steamers: The Jiffy Steamer ESTEAM (approximately 2-minute startup and 15-minute run time until it needs to be refilled), and the Salav TS-01 Travel Handheld Garment Steamer (approximately 2½-minute startup and 10-minute run time until it needs to be refilled). Regardless of which steamer you choose, I highly recommend using distilled water because it will keep the inside clean and free of mineral build-up.

Fig. 35.2 Here I demonstrate proper form when applying steam to a fabric background. Photo © Whitey Warner

and/or seams in the material. Also, fabric tends to be lighter than paper, which means that light can pass through and cause patterns and unwanted effects in some cases. The creases can be reduced or eliminated by steaming or ironing the fabric, as I'm doing in fig. 35.2 (or keeping it on a roll), but steaming can take a lot of time, so keep that in mind before choosing your backgrounds.

MEDIUM-SIZED BACKDROPS: LINEN TABLECLOTHS

Here's a little secret for finding affordable backdrops that are resistant to wrinkles: search for "linen tablecloth" online. You should find many high-quality solid-color options up to about 7 x 11 feet (84 x 132 inches). That size should work well for up to about four or five adults (assuming the photo is of the top portion of their bodies, and that they don't stand or sit more than about 8 feet from the background).

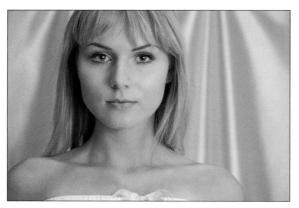

Fig. 35.3 I used a white satin fabric for the background in this image. I really like how it looks when it's bunched up a bit like an elegant theater backdrop.

Camera: Canon EOS 5D Mark II; EF28-135mm f/3.5-5.6 IS @ 135mm; F-stop: f/7.1; Exposure: 1/100 Sec.; ISO: 800

Other excellent household items that are inexpensive and that work well are shower curtains and window shades. IKEA is one particularly good source for those; their Vivan white curtains come

in a pair (each measuring 57 x 98½ inches). They allow light through but are not see-through, and they can also be used to diffuse natural or artificial light. IKEA also sells two mosquito nets named Solig and Bryne that offer many creative options for boudoir photography or other situations when you want to create a romantic look and feel. Silk-like fabrics are yet another affordable, machine-washable, wrinkle-resistant choice that photograph beautifully, as seen in fig. 35.3. Search for "satin fabrics" to find many options.

LARGE BACKDROPS: VINYL

Another option is to use heavyweight vinyl (also available in rolls and in many colors). High-quality vinyl photo backdrops are reusable, easy-to-clean and very smooth. They can be purchased in very large sizes (like 9 x 24 feet), and though not bulletproof, most vinyl backgrounds made for photography can withstand a lot of wear and tear over time. They can be set up as an infinity sweep, which reduces or eliminates the shadows often seen where a wall meets a floor. And the surface can be cleaned like a tile floor. Just be careful of high heels, light stands, sharp objects, etc. They can damage the material. White vinyl is especially popular because it's ideal for portraits when you want to blow out the background for a magazine cover look. "Blowing out" means making the background pure white, which is a very clean and popular look. Some vinyl backdrops have a glossy surface, which can produce a subtle reflection in front of a subject. Others are matte or semi-gloss, which reduces glare considerably.

INEXPENSIVE AND REPURPOSED OPTIONS

Another solid color option (especially if you don't have to take the background out of your home or studio) is to use a board or multiple boards. Foam

boards can work well, but they are easily damaged, so a stronger board, like the Thrifty White Hardboard Panel Board, available from Home Depot and other home improvement stores, is a better choice.

A few other options include using a portable projector screen, as seen in fig. 35.4, or retractable banner stand as a backdrop. These can be especially useful when you have limited space or time for setting up multiple stands. Even though projector screens are always white, you can usually attach very lightweight materials to them for virtually unlimited options. You can have your own artwork printed and incorporated into a retractable banner stand, and they are even available in two-sided versions, which I recommend over a one-sided stand if you plan to purchase one.

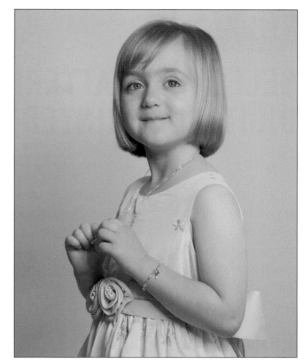

Fig. 35.4 I used a retractable projector screen for the background in this image.

Camera: Canon EOS 5D; Lens: EOS EF 24-105mm L @ 93 MM; F-stop: f/5.6; Exposure: 1/100 Sec.; ISO: 800

CREATIVE SHOOTING WITH SOLID BACKGROUNDS

1. Set up a solid-color background using paper that's at least 30 x 40 inches. If you don't have background stands, just tape the paper to a wall or use some of the techniques described in Tip 37. Easy-release masking/painter's tape is often a great choice for this, though depending on which product you choose, it may leave marks or remove paint from a wall, especially if you wait a few days to remove it. Experiment by having your subject(s) stand or sit 3, 6 and 9 feet from the background, and experiment with different apertures (f-stops) at each distance. You will notice a big change in the look of the background due to changes in the depth of field. This exercise can also be done with inanimate objects (still life setups).

2. Repeat the assignment above using a solid-color linen tablecloth, vinyl and/or curtain.

3. Lighting plays a big role, so experiment by adding no special lighting to the background (just let your other lighting illuminate the background). Then add one light from one side to create a gradient effect. Then use two lights, illuminating the background evenly at a 45-degree angle (this works especially well when you want to blow out a white background). Also try placing a light on the ground or on a small light stand behind your subject(s), aiming it up to create a sunrise/sunset-like glow.

4. Try lights with different color temperatures or add a color gel over the light to create some interesting effects (see page 120 for more on color gels). Further control the light by setting up a barrier (called a flag) between the light that's shining on the background and your lens to help avoid flare and to increase overall contrast.

SELECTING PATTERNED AND DIGITALLY PRINTED BACKGROUNDS

Once you've practiced and feel comfortable with solid backgrounds, try incorporating textured fabrics, digitally printed backgrounds and hand-painted scenic backgrounds into your photographs to offer virtually unlimited options for adding a dramatic look to your images. The options can be overwhelming, so here are some tips for finding appropriate products.

OLD MASTERS

One of my favorite types of non-solid backgrounds is known in the industry as an Old Masters style. These backgrounds are available from many companies and evoke the look of a Rembrandt or Vermeer painting. I prefer the ones that don't have a hot spot painted in (a slightly brighter area simulating a spotlight that's designed for the subject to stand or sit) because it limits the ways in which I can use it. Ten by twenty feet is a popular fabric background size that's generally affordable and just big enough to drape so that you can photograph your subjects sitting on a chair on top of the material (standing or sitting directly on it). It also fits in almost any washing machine. Did I mention you should *definitely* choose a machine-washable backdrop if you photograph pets (or if anyone will step on the material)? One specific 10 x 20-foot backdrop I've used for years is from the Interfit Italian Series (Milano Grey is the color, and it has an elegant, marble-like look, as seen in fig. 36.1).

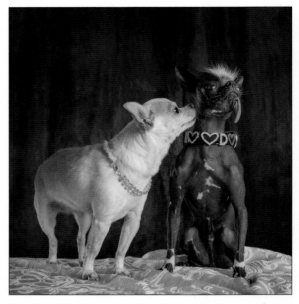

Fig. 36.1 This photo was taken at a fundraising event. It's the same background as the one shown in multiple photos in Tip 32 (page 118), and I find that it works extremely well for almost any person or pet.

Camera: Canon EOS Rebel T4i; Lens: Canon EF 28-135mm f/3.5-5.6 IS @ 28mm; F-stop: f/6.3; Exposure: 1/100 Sec.; ISO: 400

WALL PAPER? WALL PAPER!

Thinking out of the box, wallpaper offers an almost unlimited number of looks and styles. Consider adhering the wallpaper to a large 2 x 4-foot or 4 x 8-foot sheet of foam core (or even traditional background paper) to give it more support. An example of a wallpaper background is in fig. 36.2.

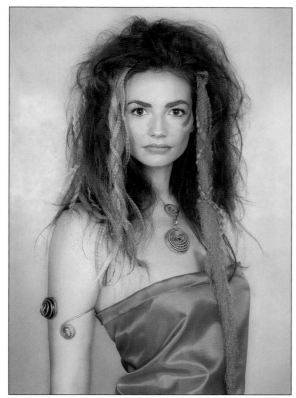

Fig. 36.2 For this photo, I used the wallpaper that was already on the walls of this beauty salon for the background.

Hair: Pirri Hair Team; Makeup: Giovanna.

Camera: Canon EOS 5D; Lens: EF 24-70mm f/2.8L @ 68mm; F-stop: f/10; Exposure: 1/160 Sec.; ISO: 250

WRINKLE-FREE AND WASHABLE

Searching for "wrinkle-free photo backgrounds" is a good way to find some amazing options that can make for quicker setups (especially when on location). One relatively new option is called Softeez Wrinkle Free. This background is machine washable and digitally printed onto a soft blanket-like material. One company that offers wrinkle-free backgrounds, as well as a wide range of related items and equipment, is Owen's Originals (www.owens-originals.com).

You can also make your own wrinkle-free backdrop by finding a company that produces custom photo blankets. The product that comes closest to the Softeez product is a fleece blanket, and there are companies online that will print a custom 50 x 60-inch fleece blanket for under $60 (just search for custom fleece blanket). Just upload a file with a pattern or a photograph, and usually within a week or two, you'll have a custom backdrop delivered to your door. Keep in mind that you can make the background as blurred as you want to mimic the look of shallow depth of field. In general, the more blur you build in, the further the background will look from your subject. Some companies even sell bokeh backdrops that emphasize the out-of-focus effect.

Fig. 36.3 The red satin fabric is truly incredible because of its bright color and distinctive look.

Camera: Canon EOS 6D; Lens: EF 28-135mm f/3.5-5.6 IS @ 28mm; F-stop: f/6.3; Exposure: 1/160 Sec.; ISO: 800

OTHER OPTIONS

Other good solid and non-solid background options to know about (especially for those who do a lot of location portraits) are collapsible, reversible backgrounds. One common size for these when expanded is 5 x 7 feet. They are made from a satin material that collapses down

to about a fourth of its expanded size, and they generally show minimal creasing. Adding some distance between the subject and background will help blur the background. One particularly impressive product in this category that's available in a few different solid colors is the Impact Super Collapsible Background, which is 8 x 16 feet.

For the photo of two Shih Tzu dogs in fig. 36.3, I used a product called Rosette Satin Fabric. It's made up of many soft, raised, rose-like blooms.

For a very modern and elegant look, a number of companies make patterned backgrounds from a range of materials. For example, Westcott makes an innovative portable backdrop system called the X-Drop Kit. It combines a 5 x 7-foot backdrop and drop stand that is under 3 pounds and has five points of contact to reduce wrinkles and maximize the area the background covers. Westcott also sells 9 x 12-foot matte velour backdrops under its Modern Vintage brand. The only downside is that the backdrops are not machine-washable. Three more companies with a wide range of high-quality and stylish backdrops are Drop It Modern (dropitmodern.com), Backdrop Outlet (backdropoutlet.com) and Denny Manufacturing Company (www.dennymfg.com).

SHOOTING WITH NON-SOLID AND DIGITALLY PRINTED BACKDROPS

1. Set up your patterned or digitally printed background using material that's at least 30 x 40 inches. If you don't have background stands, just tape the background to a wall or use some of the techniques described in Tip 37. Have your subject(s) stand or sit 3, 6 and 9 feet from the background, and experiment with different apertures (f-stops) at each distance. The amount of blur in the background is important with any background that is not completely solid in color, but it is especially important with backgrounds that portray a scene or other design.

2. Create an outdoor scene indoors using one or two backdrops. Some backdrops include a 3D effect that makes it look as though your subject is walking down a country road, or laying on a beach. The best way to achieve this is to use background stands to hold your backdrop, like those shown in Tip 37. If you use a different background for the floor, pay special attention to where the backgrounds meet at the back of the set. If the seam shows, you can usually retouch it fairly easily in Photoshop or other image editor.

HANGING BACKGROUNDS AND CREATING SETS QUICKLY AND EASILY

Once you've purchased one or more background options, how do you hang them or place them under your subject(s) so that they do the job well, and in a safe manner? Here are some tips for traveling with and setting up a number of different types of backgrounds.

BACKGROUND STANDS AND BACKGROUND SUPPORT BARS

Because so many photographers and videographers use backdrops, you will find many background systems available on the market. They generally consist of two heavy-duty stands, like 1 and 2 in fig. 37.1, and a support bar (a.k.a. crossbar), like 3 in fig. 37.1, that comes in three to four sections, with holes drilled on the extreme ends for placement on the tops of the stands. The stands have thin threaded rods at the top, which allow support bars with holes to be placed on them, followed by wingnuts to keep the support bar more secure. The main problem with those types of support bars is that the manufacturer assumes you will use all of the support bars and that you will place the stands a specific distance from each other (usually about 10 feet). There are a few solutions to this problem. One option is to drill holes through the support bars in multiple locations so that you can configure the bars in different ways for different locations. Two other options include purchasing or making a telescoping support bar, as described next.

IMPORTANT: For safety and stability, especially if you plan to create a sweep with the background paper or other material, be sure to use sandbags (Tip 31, page 114) on the legs of the background stands. A sweep is when you extend the background forward so that it becomes a surface that covers the floor. If done right, when photographed, you don't see any seam where the background curves. That's how "seamless paper" got its name.

USE A TELESCOPING SUPPORT BAR OR MAKE ONE—Some background systems are sold with a telescoping crossbar that allows for a wide range of different lengths. However, if you already have background

Fig. 37.1

1 and 2. Stands made specifically for holding backgrounds.

3. Three pieces of interlocking metal tubes that form a background support bar.

4A. A 16-foot telescoping painter's pole (described in this tip).

4B. Another telescoping painter's pole.

stands, telescoping painter's poles, like 4A and 4B in fig. 37.1, can be purchased from a number of retailers. They solve the problem of wanting to configure your support bars in different ways, but one thing to keep in mind is that they generally are going to be a bit longer than the carry bag designed for your background stands and support bar (especially if you need them to extend over 10 feet). The main advantage that telescoping bars or painter's poles have over the metal tubes, is that telescoping poles can be used across a wide range of distances between the support stands, as seen in fig. 37.2. The metal tubes have holes that make the distance options less flexible.

After I noticed how strong and affordable the telescoping painter's poles were, I purchased one, and then realized that I needed a way to make it fit across the tops of my stands, so I put my MacGyver hat on and found a small 90-degree plastic piece (Item #23935) for under 50 cents in the plumbing department at Lowe's that threaded perfectly onto the top, as seen in fig. 37.3. The other end of the pole had a large hole (designed for hanging on a hook), but it needed a little bit of drilling to fit snugly onto the stud of my light stand. You may or may not have to drill

them out, depending on the extension pole you choose. One of the advantages of these poles is that some can extend to 16 feet or more. The one I use and highly recommend was purchased at Lowe's for under $30 and is called the Ettore 4.8- to 16-foot Adjustable Metal Pole (Item #109411). Because this pole extends to 16 feet (5 meters), it is about 5 feet at its shortest. Ettore also makes a 3.6- to 8-foot and 4.7- to 11.9-foot pole (Item #108618). Just keep in mind that the most popular length of seamless paper is just under 9 feet.

Fig. 37.3 A 90-degree plastic threaded elbow piece is shown here attached to a painter's pole. It's a simple way to use a painter's pole as a backdrop support bar.

ATTACH FABRIC TO A PAPER CORE—Seamless paper comes wrapped around a paper core, which helps keep the surface free of creases. If you have a way to transport long rolls, or if you keep them in a studio, you can use the same paper cores they ship in to attach and then roll a fabric backdrop around the core. A strong tape like Gorilla Tape (gorillatough.com) can work well for attaching the fabric to the core. Then, you only need to steam the fabric once since it will stay crease-free as it comes off the roll (as long as it is not stepped on). Another option is to make a pole pocket in the top of the fabric (or purchase a backdrop that has the pocket sewn in). You can then insert a fixed or telescoping support pole through the pole pocket, and then roll the fabric up, as seen in fig. 37.4. The advantage to that scenario is that the support pole can be taken out of the pole pocket if you want to clean the fabric, or if you need to fold it up for travel.

Fig. 37.2 Two background stands with a painter's pole extended to about 10 feet.

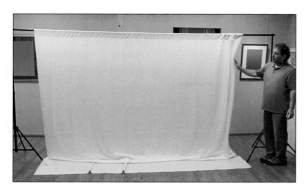

Fig. 37.4 In this photo, I'm demonstrating what a pole pocket looks like when used with a backdrop. Pole pockets often come pre-sewn into the top of photo backdrops, or you can make your own.

MAKE YOUR OWN POLE POCKET—You may not realize how easy it is to make a pole pocket from almost any paper or fabric. For paper, such as wallpaper, handmade paper, etc., just fold over the top of the paper about 6 inches down from the top. Then use strong tape like Gorilla Tape to make a pole pocket. For fabrics, a few companies make iron-on hemming tape; I've also seen peel-and-stick tape designed for fabrics that is much easier since it requires no sewing.

HOOK AND LOOP

Velcro's hook and loop products, as well as other hook and loop products, can be very useful when hanging paper or fabric. A few strips adhered to a background support bar and a few behind the top of a large paper sheet can make for a sturdy background without the need for clamps or a pole pocket. Search for "sewable hook and loop" for sewable options (usually the loop side is sewn to the fabric and the hook can be applied to a background support bar). Yet another option is to purchase Velcro Fabric Fusion Tape, which is designed to bond to fabric with a steam iron.

Hook and loop can also be very useful for keeping tablecloths and other fabrics in place on top of tables. Just attach some adhesive-backed hook to the top of the table near the corners. Then match them with the loop from the Fabric Fusion Tape or sewable loop that has been attached to the fabric.

SHOWER CURTAIN HOOKS

Shower curtain hooks come in a few basic forms. They are inexpensive and make hanging fabrics very easy, especially when you don't have a pole pocket across the top of your fabric or paper. Shower curtain rings are ideal for hanging backgrounds from grommets because they allow you to keep multiple fabrics on a rod without wrinkling them. One type assumes that you have a series of holes running along the top edge of your fabric (similar to the grommets or reinforcements used in tarps, vinyl signs and shower curtains). The most compact hooks I've seen are made from thin metal, have a pear shape and clip on via spring tension (see fig. 37.5 for an assortment of options). A search for "shower curtain rings" should bring them up, along with a similar product that has little ball bearings to help the fabric or vinyl move from side to side across the curtain rod or similar pole. Grommets, as pictured in fig. 37.6, can be very useful for hanging backgrounds. It's pretty easy to add grommets

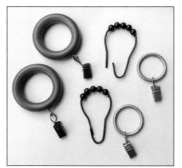

Fig. 37.5 A collection of three types of shower curtain rings. The only ones that open (avoiding the need to thread them onto the bar from the edge) are the ones in the center.

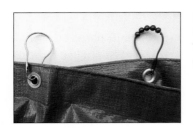

Fig. 37.6 Two shower curtain rings threaded through two grommets.

Fig. 37.8 This photo shows a heavy background being supported by a number of binder clips.

yourself with a grommet kit; every 3–4 inches is a good amount of spacing to use between them. Or, you can have grommets added to almost any fabric by a company that specializes in making signs.

Another popular curtain hook option has small alligator clips attached to plastic, metal or wood rings. They are very useful, but they can cause damage to fabrics, and in most cases, you will need to take the pole off the stands to insert the rings because they can't be opened like the wire shower curtain rings. A better option, in my opinion, is to use the shower curtain hooks with standard binder clips, as seen in figures 37.7, 37.8, and 37.9. They are super-strong, come in different sizes and are very inexpensive (you probably have a few already!).

The advantage of using curtain hooks is that if you have relatively thin fabric, you can keep multiple backgrounds stored in a relatively small amount of space, without the fabric getting too many folds in it. Just move a few of them over to

the side, just as you would a shower curtain that can be compressed and moved to one side of a curtain rod. Another advantage to the products I highlighted is that the fabric can be attached to and removed from a rod while it's still mounted.

USE A POLE SYSTEM TO INCREASE YOUR OPTIONS AND SAVE SPACE

A few companies, including Manfrotto and Impact, make sets of poles that can be placed between a floor and ceiling to create a stable and space-saving set of uprights on which poles can be hung (similar to a football goalpost). Manfrotto calls theirs Autopoles, shown in fig. 37.10. If you've visited a mall or department store like Macy's, you've probably seen these holding up signage. Many different clamps and background roll holders can be added to them, as seen in fig. 37.11, including manual and motorized systems that can hold multiple backgrounds at one

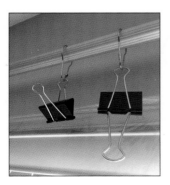

Fig. 37.7 This image illustrates a simple and strong way to hold backdrops: with binder clips! You can use them either way I've shown in the photograph.

Fig. 37.9 A close-up of one of the binder clips supporting the backdrop in fig. 37.8.

time. Just search for "photo pole background system." Manfrotto even makes bases for their Autopoles that turn them into sturdy stands. And here's a little tip I learned a long time ago—you can keep your ceilings clean by putting socks on the tops of the poles.

With all that said, I must caution you when using any pole system without bases. If the pole gets pushed away from where it's being supported, damage to people or property could result. Because of this, I would not recommend they be used near pets or young children. Also, I recommend not using them for sweeps in which paper or fabric is pulled down from the backdrop area and used under people's feet, because it adds to the stress that's put on the poles. Instead, I would just use them to hold backgrounds, reflectors and/or items to help control lighting, such as sheets of diffusion material.

USE A STUDIO TRACK SYSTEM

A studio track system can be invaluable because most if not all of your backdrops can be hung up at all times and ready to go. For some useful photos and products that can help you manage a few or many backgrounds, search for "track combo" on www.backdropoutlet.com and view the products and images that come up for any of their studio track products. Their innovative muslin clips and carriers make it easy to hang just about any fabric much like a shower curtain and access it at any time.

Fig. 37.10 Two Autopoles with a roll of paper supported on the painters' pole described earlier in this tip.

Fig. 37.11 (inset) A close-up of one of the sides of the Autopole with a super clamp and Manfrotto Spring Clamp.

PRO ASSIGNMENT

CREATE A SET WORTHY OF A BROADWAY STAGE

1. Create a pole pocket in a piece of paper or fabric that you'd like to hang as a backdrop. Then choose either light stands, a pole system or studio track system to hang the backdrop.

2. If you plan to work in multiple environments, or if you just like the flexibility that a telescoping painter's pole offers, use one as a background crossbar, following the instructions in this tip.

3. Purchase or find some material, such as remnants commonly sold at fabric stores that will work well for a background, then add grommets yourself or have them added for you. Most remnants are 40–60 inches (101–150 centimeters) wide, and the length varies a lot, but you will generally be able to purchase at least three yards (36 inches or 91 centimeters) of a particular material. Then use curtain rings to hang them securely. To reduce wrinkles or for added support, try clamping the bottom section of the material to the light stands you are using.

HOW TO DRESS YOUR PEOPLE AND PETS WITH STYLE

It's no secret that what you wear can have a huge impact on the way you are perceived by others. Whether you are taking photos of your own family or being hired for a photo session, it's helpful to know some clothing and accessory tips. These suggestions can come in especially handy if you have been given the honor and responsibility of taking group photos of your family, company or other group.

DRESS COMPLEMENTARY TO THE MEMBERS IN THE PHOTO—For family photos (with or without pets), multiple people in the same photo should wear complementary colors and be dressed in a similar style of clothing. However, that doesn't mean you have to look like a sports team! It just means that if there are three sons in a photo, two should not wear T-shirts while the other wears a button-down shirt with a tie. Pets generally don't need any clothing at all, but sometimes a stylish shirt, jacket, bandanna or other accessory can really add to the look of the image, as in fig. 38.1.

DRESS FOR EVENTS—As a rule of thumb, advise your family members or clients as follows: For formal family photos, people should look like they are going to a formal wedding, and for more casual family photos, they should dress as though they are going to a birthday party at a nice restaurant. No matter what, you want people to look natural, like in fig. 38.2.

Fig. 38.1 In this photo, my client took "dress like your pet" to a whole other level! I really like the fact that she's not matching her dog, but rather, they are complementing each other.

Camera: Canon EOS 5D Mark II; Lens: EF 24-105mm f/4L IS @ 70mm; F-stop: f/5.6; Exposure: 1/100 Sec.; ISO: 1250

Fig. 38.2 I could have asked the boy to put his jacket back on for this photo, but it looks much more natural and relaxed (yet still formal and a perfect complement to his sister) this way.

Camera: Canon EOS 5D; Lens: EF 24-105mm f/4L IS @ 105mm; F-stop: f/6.3; Exposure: 1/800 Sec.; ISO: 800

AVOID WEARING BRIGHT WHITE CLOTHING—White tends to blow out. This is because our cameras can only capture a certain dynamic range, or number of shades from highlight (bright areas) to shadows (dark areas). Instead of bright white shirts, jackets, etc., ask your subjects to wear off-white. If bright white is all you have to work with, you can make adjustments later. I recommend shooting in your camera's Raw mode and exposing your images so that the whites are not too blown out. You can then make corrections later by lightening the shadows and increasing exposure a bit while adjusting the highlights via a highlight recovery tool.

AVOID WEARING ANYTHING WITH A HERRINGBONE PATTERN—This can cause odd patterns (moiré) to appear in the clothing. This can be a major headache, so try to recognize in advance what patterns will create a moiré. If the session requires a specific type of clothing that produces moiré, there are ways to fix it in post-processing.

CHANGE OF CLOTHES—In an ideal world, people should have at least one change of clothes (for example, an extra shirt, jacket, etc.). That can do wonders for a photo, especially if someone's clothing just looks out of place. In fig. 38.3, I asked my clients to bring a specific piece of extra clothing for the photo shoot.

Fig. 38.3 For a hair salon photo shoot, after speaking with my client, I asked each model to bring at least one black shirt, and I really like how their expressions, body positions and wardrobe all complement each other.

Camera: Canon EOS Rebel T4i; Lens: EF 28-135mm f/3.5-5.6 IS @ 28mm; F-stop: f/9; Exposure: 1/125 Sec.; ISO: 200

DON'T FORGET THE SHOES AND SOCKS!—Assuming your subjects' feet are in the photo, if one person has old tennis shoes on and the rest are wearing their finest footwear, the photograph will probably not look its best. Also, white socks generally look awkward with dress shoes, so keep that in mind, as well. At least socks are easier than shoes to retouch if you have to deal with that issue!

KEEP THE ACCESSORIES TO A MINIMUM—Jewelry and other common accessories, like handbags in photographs, can enhance, as in fig. 38.4, or create distractions. Usually, less is more. Ask your subjects to keep jewelry and accessories to a minimum, unless that's their signature look. For example, you wouldn't ask Mr. T to come to a photo shoot without his full array of bling!

Fig. 38.4 For this portrait of a young girl lit mostly by a large window, I was very impressed by how nicely her beautiful shirt and jewelry came together to create an elegant look.

Camera: Canon EOS D60; Lens: EF 16-35mm @ 35mm; F-stop: f/2.8; Exposure: 1/30 Sec.; ISO: 400

WEAR IT WELL! WARDROBE EXPERIMENTATION

1. Photograph someone in the same lighting and with the same background, but ask them to change into at least three different outfits so that you can compare the look that you get from all three clothing changes. The background could be natural objects, such as a group of trees, or it could be a solid or patterned background indoors. To minimize the chances of people clashing with the background, consider using neutral backgrounds like a medium gray fabric or a white wall when doing your testing.

2. Photograph a family or group of friends three different ways: very casual (T-shirts, jeans and shorts), dressed well but not too formal, and very formal.

3. Photograph someone with no jewelry, a few pieces and then all decked out like an Egyptian Queen or King.

4. Photograph one or more people with or without sunglasses. I think you'll be amazed at the difference in the overall look and mood between the different images.

HOW TO TALK TO YOUR MODELS TO GET THE MOST NATURAL IMAGES

They say: "It's not what you say but what you do." Well, in portrait photography, I think that what you say to your subject is as important as what you do with your lighting, framing and camera settings. Knowing a few simple things can help your subjects relax, and at the same time help them to express themselves so that you can capture their emotions and not just a typical smiling face.

Fig. 39.1 I captured this image of my 2-month-old son and my dad at my home (time flies!). The lighting was entirely from a table lamp and a halogen torch lamp. Both of those lights had the same color temperature, so it was easy to balance them when I prepared the final image.

Camera: Fujifilm FinePix S3 Pro; Lens: Tamron 28-300mm XR DI f/3.5-6.3 @ 60mm; F-stop: f/4.8; Exposure: 1/250 Sec.; ISO: 200

TIPS FOR COMMON SITUATIONS

GETTING A NATURAL SMILE—That being said, being able to photograph one or more people smiling naturally with their eyes looking at the camera is a good start. To do that, I often use a tried-and-true method of saying, "Okay, on three: one, two, three!" and I take the photo when I say the number three. I don't know exactly why the "happy face magic" enters the atmosphere when the number three is said, but it is amazing how well it works! To break the frozen grin that can happen when people are waiting to be photographed, you can say, "Okay, now everyone count with me to three: one, two, three!" It just so happens that saying the number three will cause your mouth to be in a position very close to a smile, so it often works very well.

PHOTOGRAPHING BABIES—For babies who have not yet learned their numbers, words like "Who's a good baby?" with a tickle to a leg or arm (by a parent or with a parent's permission) using something like an artificial feather can work wonders. Singing songs that the baby likes can also do the trick. A parent or relative can also hold the child and do whatever they normally do to elicit a smile, such as tickling the child's stomach as you take some photographs, as in fig. 39.1. In this image, my father was singing to my son and making noises, which allowed this photo to be possible. You can also look for opportunities to

take photos when your subject is looking away. Those might include full profile images, which can elicit a pensive look regardless of age. You can also have someone hold a toy or puppet next to your lens as they make funny sounds.

Fig. 39.2 For this image, I used the technique of asking the pet's owner to keep looking at me, and after just a few seconds I got a classic "Blue Steel" pose from the Wheaton Terrier!
Camera: Canon EOS 20D; Lens: Tamron 18.0-200mm @ 149mm; F-stop: f/10; Exposure: 1/200 Sec.; ISO: 400

TAKING A GOOD GROUP PHOTO—A common challenge is with group photos that include a dog or young children. Let's say you are doing a family photo (yours or someone else's) with two adults, two teenage kids, one or two children between four and 10, a toddler and a large dog. The one, two, three method will probably work well for everyone but the toddler and the dog. I recommend first getting a few great photos using the one, two, three method. One key tip is to tell your subjects: "Look at me; I'll make sure the baby and dog look great." The reason is that all too often, parents or family members will be focusing on the baby or pet without focusing on looking at the camera. I used this technique in fig. 39.2 and fig. 39.3. Be sure to take more photos than you think you need, which should reduce all or most of the cloning that will be necessary later. Cloning in this case means selecting and copying just the baby and dog from one photo and pasting just that section into a photo in which everyone else looks great. If that approach doesn't work, you now just need some great images of the toddler and the dog.

Placing your camera on a tripod and using a wired or wireless cable/shutter release removes the need to press the shutter button (see Tip 24, page 86, and Tip 50, page 190, for more on that topic), and you can more easily clone in the baby and dog later. Use the tickle and singing techniques for babies/toddlers, and for pets, you can use treats or toys by holding them over the camera. Some pets will dart toward the camera when you do this, so that's another reason to use a tripod. If that happens, try again with the pet

Fig. 39.3 I asked my father-in-law to look at me as I counted 1,2,3, which also attracted the attention of the little boy. Who needs a smile when you can get those types of expressions!
Camera: Panasonic DMC-LX5; Lens: Built-In @ 7.5mm; F-stop: f/8; Exposure: 1/400 Sec.; ISO: 400

back in the location they were seated or standing before.

Another reason for using a tripod is that you can include yourself in the photo. Just leave a seat or place empty, and after taking some photos of the group, include yourself by using a wireless cable release or self-timer. Then, in post-processing, clone yourself in. Even smartphones these days have apps with self-timers. You may not need to do any cloning, but it's good to have those initial photos just in case.

TIPS FOR TALKING TO YOUNGER KIDS

For younger kids (about 3–10 years of age) who just won't crack a smile, or from whom you want to elicit a bit more emotion, here are some things you can say and do that should help:

ASK, "WHAT'S YOUR FAVORITE TV SHOW?"—When they answer, you can converse with them a bit if you are familiar with the show, or you can ask them to tell you something funny from one of the shows. You can also ask them to act like one of the characters in the show. Viewing a clip from the show on a smartphone (YouTube is usually the best place to find them) can really help them to perk up, and you might be surprised at the reactions you get.

DOWNLOAD AN APP ONTO YOUR SMARTPHONE WITH FUNNY SOUNDS—Sound Effects Free on Apple iOS is just one sample app that's fun and that you can have the child play for a few seconds. You can also ask them which funny sound button you should press so that you can get the shot without them having to hold the smartphone. Due to the content of some of the funny sound apps, I would ask a parent or guardian permission before doing this (if you are not the parent or guardian). Also, it usually costs a dollar or two to remove the ads,

which I highly recommend doing, especially if you find any of the apps useful. Otherwise, you may have to wait for video ads to play, and the moment may be lost forever!

ASK ABOUT A FAVORITE TOY—Ask a group of young siblings to get their favorite toy and show it to you like they were doing show and tell. To avoid getting photos of kids just holding the latest electronic gizmo, this can be modified to only include their favorite stuffed animal. You can then ask them each to hug their animal for a group hug. On this same note, it's often very cute to capture photos of pets hugging or playing with their favorite toys. You can also ask the kids to hug each other, which is a photo Mom and Dad generally love to have.

Fig. 39.4 I think the off-center crop and lovely spring background add to this photo's interest. The lighting was the fixture shown in fig. 28.6 and 28.7, placed slightly camera right about 5 feet from the kids.

Camera: Canon EOS 5D; Lens: EF 24-105mm f/4L IS @ 105mm; F-stop: f/5; Exposure: 1/640 Sec.; ISO: 800

GET THE KIDS AND PETS TOGETHER—Kids hugging, holding, sitting next to and/or petting their pets is another great photo opportunity that is seldom captured. You can say things like: "Whisper a secret in Fido's ear," or "Can you give Tabby a big hug?" In fig. 39.4, I was photographing a brother and sister and asked the boy if he would give his

sister a little hug. That resulted in some great images (after a few funny faces!). In fact, this was Mom's favorite photo from the entire session.

TIPS FOR WORKING WITH MODELS, REGARDLESS OF THEIR EXPERIENCE

When photographing individual male or female models at a workshop, or those who you hire for a photo session or paid assignment, there are many things you can say to get more natural-looking images (especially with those models who have little to no on-camera experience).

LOOK AT THE LIGHT—One of my favorite things to do is to ask the model to "look toward the main light and think about what you would like to eat for dinner." That will usually elicit a smile, but also a pensive look that does not look posed.

LOOK AWAY—I almost always will ask a model to "look away for a few seconds and then look at me and smile." That helps to unfreeze a frozen-looking smile. For a bigger smile, you can say, "Look away for a few seconds and then look at me and smile like you just won the lottery."

WAITING FOR THE BUS—This is something else I often say to models: "Act as though you are waiting for a bus or train." Just about everyone has done that, and I generally get some good images with that statement.

TURN BACK—"Turn toward the back wall and look to your left, then at me" is also a good phrase to use because it creates a different look and a few interesting angles.

Fig. 39.5 It took only a few exposures to get this jumping image. I describe the lighting for this image in fig. 34.2 on page 127, and I highly recommend experimenting with jumping and similar poses.
Camera: Canon EOS T4i; Lens: EF 28-135mm f/3.5-5.6 IS @ 28mm; F-stop: f/5.6; Exposure: 1/125 Sec.; ISO: 400

JUMP—Another great thing to try is to say: "If you feel up to it, can you jump for a photo (but please be careful!)." Then capture photos before, during and after the jump. Those photos can be really outstanding. In one case, a guy I photographed told me that he had a special jumping pose, and I was very happy with the resulting image (fig. 39.5).

TIPS FOR WORKING WITH COUPLES

When photographing a male and female model together (or a dating or married couple), there are many things you can say to increase your chances of getting interesting images. Here are a few things you can say (for demonstration purposes, let's say your models' names are John and Jane).

LONGTIME COUPLES—"John, please look at me, and Jane, look at John as though he is your longtime boyfriend who just asked you to marry him." (I would use that for models, but not for people who are dating.) A related statement for people who are married would be: "John, please look at me, and Jane, look at John as though he just took out the garbage without your having to ask him three times." That's sure to get an adoring look.

NEWER COUPLES—For those who are dating, you can just say, "John, please look at me, and Jane, look at John for exactly 20 seconds without blinking... Just kidding! You can blink now." Those little jokes can really make a difference because it helps people to relax.

ANOTHER OPTION—For another nice look and feel, you can also ask one subject to look at the other person, and the other person to look off into the distance, as shown in fig. 39.6. I asked the man to look into the woman's eyes, but I asked the woman to look out into space. You can help create a lot of emotion by using techniques like this.

Fig. 39.6 For this photo for a hair salon, lighting was natural daylight and a monopod-mounted umbrella with a single shoe-mount flash unit.

Camera: Canon EOS Rebel T4i; Lens: EF28-135mm f/3.5-5.6 IS @ 80mm; F-stop: f/5; Exposure: 1/100 Sec.; ISO: 200

TRY NOT TO LAUGH—"Please face each other, cross your arms, look deeply into each other's eyes and DON'T LAUGH!" If they laugh, make sure you capture it, then ask them to do it again, and you will probably get some nice expressions because they probably have relaxed a bit. For siblings or friends, you can just say: "Please look into each other's eyes and DON'T LAUGH!"

MAKE IT NATURAL—This statement might be okay with advance permission from your models, and it will almost surely help you produce a classic image for couples who are dating or married: "John, please hold Jane's right hand. Now, please close your eyes and kiss her hand for three seconds." Assuming all goes well with those photos, you can then add: "Jane, now react to that any way you'd like." Sometimes that's the best way to get wonderful expressions from people; let them do what they feel is best based on their true emotions.

OTHER TIPS—For many more related tips from working pros, watch live or recorded videos on websites like creativelive.com and photovisionvideo.com. Both are excellent resources, and CreativeLive has the advantage of providing their training for free while the courses are being streamed over the Internet. They also offer discounts to purchase courses while the courses are running, and they run special sales from time to time. PhotoVision allows you to purchase access to all of their content for about $20 per month, which is a great value. Also worth noting is that all members of the Professional Photographers of America (PPA, www.ppa.com) receive access to the PhotoVision collection of 800+ videos as part of their membership.

TIPS FOR TALKING ANIMALS INTO COOPERATING

For dogs and cats, here are some things you can say or do to get them to look at or near the camera:

BARK—I often get good reactions by growling a bit at the dog or even barking a bit (yes, I look and sound silly—the dogs think so, too!), but I've done it hundreds of times, so I have collected enough scientific evidence to know it works!

TOYS—A squeaky toy also works extremely well. Just hold it behind the camera and squeeze it when you are ready to take the photos. Some dogs will want to play with the squeaky, so you may want to hide it at first. For a cat, have someone dangle a cat toy by the string while the cat sits on their lap or plays on the floor. This is often a good way to get them to be animated and to look in a few different directions.

Fig. 39.7 Two of my favorite dogs, Jake Chug and Teekee.
Camera: Canon EOS Rebel T4i; Lens: EF 28-135mm f/3.5-5.6 IS @ 50mm; F-stop: f/7.1; Exposure: 1/125 Sec.; ISO: 200

VOICE COMMANDS—For dogs and cats who respond to their owners' voices and commands, you can often get funny or otherwise interesting expressions from statements like "Want a cookie; Talk; Lie down; Want to go for a walk?" and the like. I used this technique in fig. 39.7. Each dog was told by his or her "mom" things like "Where's Grandma?" and "Want a cookie?" as they waved their hands over my camera. All of those actions can work wonders! Just be sure the person is speaking to their dog or cat from just in front of the camera without getting in the shot.

> **PRO ASSIGNMENT**
>
> ## DIRECTING YOUR MODELS FOR THEIR CLOSE-UPS
>
> 1. Do a group photograph of a family with a baby or dog. Take at least 20 photos of the group using the tips I suggested (be sure someone is taking a video of you when you are barking and growling at the pets!).
>
> 2. Set up your camera on a tripod and include yourself in a family photo, or in a photo with at least one friend. Be sure to take some photos of your family or friend first so that you can clone yourself into another photo if necessary.
>
> 3. Photograph at least one model or family member (or family member who happens to be a professional or aspiring model). Take at least 10 photos using all or most of the five suggested things to say to individuals.
>
> 4. Photograph a married or dating couple, two models or two friends/siblings. Take at least 30 photos using whichever statements are appropriate for the subjects.

Shooting in the Field
Getting Better Photos Outdoors, On the Move and at Events

There's nothing like traveling to an exotic destination with camera in tow and capturing a special image that defines the trip. But for the vast majority of people, you don't have to get on a plane to create incredible images of wildlife, cultural festivals, and lakes, rivers or oceans. Many of these places and things are right in your backyard. In this section, I will cover specific tips and techniques for capturing images of people, places and things that you may not have thought about doing until now.

So charge up those batteries, bring extra media cards and get ready to explore our world!

MASTERING GROUND-LEVEL PHOTOS (WHILE STAYING CLEAN!)

Some of the most interesting photos I've seen, and some of my own favorites, are those that have been made with the camera close to or on the ground. Examples include landscapes that show the texture of the ground and/or the effect of peeking through blades of grass. To get these shots in the days when 35mm film was primarily used, it was very difficult to avoid having to crawl around on the ground to make sure that exposure, focus and composition were correct. Things are different now, but it's not always obvious how to get good low-vantage-point images in different situations. Here are some tips I recommend:

USE AN EVF OR ANGLE VIEWFINDER—If your camera has a flip-out screen that allows for live viewing and the review of images when viewed from above, definitely use it. Since you won't be looking through an eye-level viewfinder, use the camera's live view or an EVF that flips up to frame the image and check focus and exposure.

If your camera lacks a flip-out screen, you can use an angle viewfinder. The FlipBac Angle Viewfinder and LCD screen protector (fig. 40.1) is one product that will do the job. I personally would attach it to a glass screen protector instead of directly onto a camera's LCD due to potential damage from the adhesive. You can find the "stick-on" LCD screen protectors I use by searching online for "GGS Optical Glass LCD Screen Protector."

One great option for DSLR users is to use a Vello Snap-On LCD Screen Protector, which is about $28 and available for many Canon and Nikon cameras. I attached the FlipBac Angle Viewfinder to my Vello Snap-On LCD Screen Protector for my Canon 6D, as seen in figures 40.2, 40.3 and 40.4.

Fig. 40.1 The FlipBac Angle Viewfinder and LCD screen protector next to my Panasonic Lumix LX5.

Fig. 40.2 The FlipBac Angle Viewfinder comes with strong adhesive to allow it to attach to either an LCD screen or a screen protector.

Fig. 40.3 This is what the FlipBac Angle Viewfinder looks like after it has been attached to the Vello Snap-On LCD Screen Protector.

Fig. 40.4 And here's what the Vello Screen Protector and FlipBac Angle Viewfinder look like mounted to my Canon 6D.

You can purchase two of the Vello protectors and only attach a FlipBac to one of them, as shown in fig. 40.3. Then, when you want to use the FlipBac, attach the Vello with the FlipBac to your camera (fig. 40.4). The reason I recommend this is because the FlipBac can be distracting when you don't need it. One small negative with using this combination is that the image reflecting off of your LCD will be at a slightly different angle compared to the angle you would have if you had attached the FlipBac directly to your camera's LCD. That being said, it works fine. Another option is to use a glass "stick-on" screen protector for your camera LCD. Then, only use the Vello when you use the FlipBac. See Tip 8 (page 33) for more on this topic.

If your camera's LCD can articulate and point straight up toward the sky, you can use an LCD loupe. It will give you a magnified view, block any glare and help to steady the camera. To make this work, you may need to remove your optical viewfinder's eye cup if you have one and if it is in the way, and you may also have to adhere the LCD loupe in some way (e.g., magnets, hook and loop, special frame, etc.) to the LCD or an LCD protective cover to keep it steady.

Another option is to use a smartphone or other device, such as an external HDMI monitor, that allows you to view your LCD remotely. That works best when the camera is on a tripod, but you can also use a hot shoe smartphone mount if you'd prefer not to use a tripod.

USE A TRIPOD WITH A REVERSIBLE COLUMN—Some tripods have center columns that are reversible, allowing you to place the camera very close to the ground while giving you excellent stability, as I'm doing in fig. 40.5. This, in conjunction with

the other suggestions here, can be very useful. Keep in mind that it's easier in almost all cases to attach your camera to the tripod head before reversing the column.

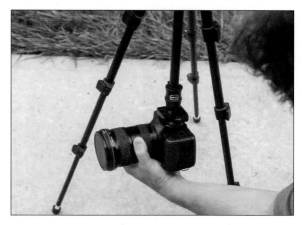

Fig. 40.5 In this image I'm demonstrating how I've reverse-mounted a camera on a Benro tripod by reversing the center column.

USE A MONOPOD AND JUST TURN THE CAMERA UPSIDE DOWN (BE CAREFUL OF COURSE!)—The advantage of this approach is the flexibility to move around. A wireless or wired cable release that removes the need to press the shutter button is invaluable in these situations.

USE A WATERPROOF CUSHION OR BAG TO KEEP YOUR KNEES AND BODY CLEAN—A simple plastic bag can be very useful, and it can easily be stored away. Another option is to kneel or lay on a product I helped develop called the GalleryPouch bag (www.GalleryPouch.com), as I'm doing in fig. 40.6. It's made from heavyweight laminated bubble material that is very difficult to pop. It rolls or folds up easily, and it offers waterproof cushioning in any size up to 52 x 156 inches. It kept me clean when I took fig. 40.7 and was in a position similar to how one might look while doing a push-up with knees on the ground.

Fig. 40.6 In this photo I'm using a GalleryPouch bubble bag to protect my knees during a photo shoot. *Photo © Whitey Warner*

Fig. 40.7 I got really low to the ground to capture this image of a wonderful little dog named Buddy.

Camera: Canon EOS 6D; Lens: EF 70-300mm f/4-5.6 IS @ 275mm; F-stop: f/5.6; Exposure: 1/2000 Sec.; ISO: 800

USE A SCREW-ON UV FILTER—If you are working with pets close-up and on their level, you should consider using a screw-on UV filter. That will protect the front of your lens from potential "wet kisses." Just watch for vignetting in the corners of your images. In most other cases, especially with telephoto lenses, I prefer not to use them because they can cause a loss of contrast, poor image quality and unwanted reflections that looks similar to flare from the sun. Ultra-thin UV filters are less likely to create a vignetting issue on many lenses.

PRE-FOCUS—You can also shoot without looking at the LCD or through the viewfinder. Take the shot by pre-focusing on a spot in manual focus, or by using autofocus, and then check the LCD. This is more of a hit-or-miss approach, but the results can be fantastic.

PHOTOGRAPHING MINIATURE WORLDS

Since I can remember, I've been fascinated by miniaturized worlds. It all started with a love of toy trains and grew from there. Not only do these shrunken landscapes allow you to challenge yourself as a photographer, but the combination of the miniature and life-size allows for compositions that are playful, artistic and at times nothing short of incredible.

Here are some tips to help you create gorgeous, shareable (and maybe even salable) images of your own miniature worlds.

USING FOCAL LENGTH TO CREATE DIFFERENT ILLUSIONS—Use a wide-angle to medium focal length (28–50mm) and photograph the scene from about a foot or two away to create dramatic vistas and an intimate feel. Conversely, try using telephoto focal lengths (75–300mm) for fine details or to compress the scene so that miniatures look closer to each other than they are in reality. Backgrounds will likely then go out of focus, like in fig. 41.1. I experimented with different angles and zoom levels and thought that this captured the feeling I wanted to achieve.

STABILIZE YOUR CAMERA FOR THE SHARPEST IMAGES— Because you are shooting such small details, a solid tripod (or at least a monopod) is highly recommended. These will help you get sharp and clean images without having to crank up your ISO, which could introduce too much noise (digital grain) into your photos. That's because a tripod allows you to make longer exposures, which lets more light into your lens, and allows

Fig. 41.1 A view camera being operated by some cute mice. You can see a full shot of the same camera in fig. 41.2.

Camera: Olympus E-M5; Lens: Olympus M 14-42mm f/3.5–5.6 II @ 17mm; F-stop: f/5.6; Exposure: 1/250 Sec.; ISO: 640

Fig. 41.2 This shows the entire camera to help compare it with the close-up image in fig. 41.1.

Camera: Olympus E-M5; Lens: Olympus M 14-42mm f/3.5–5.6 II @ 17mm; F-stop: f/7.1; Exposure: 1/1000 Sec.; ISO: 3200

you to choose higher apertures and lower ISO settings. If you have a DSLR, you may also want to use mirror lockup to help avoid internal camera vibrations.

SHOOTING WITHOUT A FLASH—Because flash on your camera can ruin the illusion of a miniature world, Aperture Priority or Manual are generally the best shooting option for photographing miniaturized worlds with existing light, or light that you add to the scene, as in fig. 41.3. In this photo, lighting came from strobe lights in softboxes with a lot of white reflectors to help increase the evenness of light and give the scene the feel of a winter's day. Lower f-stop numbers (f/2.8–f/5.6) will allow more light in, so start with the lowest f-stop possible for your lens. Shutter Priority can also work well, especially if you want to use a tracking technique or if you want a specific motion blur effect for things that move, like toy cars and trains. In fig. 41.4 I could have used Shutter Priority, but I used Aperture Priority instead.

If you are photographing still scenes and would like more of a cartoon effect, then higher f-numbers (f/8 or f/11) and wider lenses will help bring more things into focus, even if the characters are positioned in different locations (planes of focus) throughout the set.

SHOOT LOW AND HIGH—Get low! Lower perspectives will help make the objects, buildings, people and other miniatures in the scene look larger than life. Shooting from an overhead perspective can give viewers the feeling of being on a plane or blimp, much like the video footage we often see today from drones.

Fig. 41.3 I had fun creating this miniature world for a holiday card, and I named the guy with the broom "Smiley the Snowman." I used artificial snow and found the props at a store that sells a lot of holiday decorations. I placed the lens a bit higher than his head to allow the background to fade off into infinity. The only real retouching was removing a string in Photoshop that was holding Smiley up from his wrist.
Camera: Sinar P2 W/ A Leaf Digital Camera Back; Lens: Sinaron Digital 100mm; F-stop: f/5.6; Exposure: 1/60 Sec.; ISO: 50

Fig. 41.4 I waited for just the right moment to capture these two trains in motion (1/4 second worked very well in this case), and I included some foreground, middle ground and background to give the image more of a real-life, full-size train feeling.
Camera: Canon EOS 6D; Lens: EF 28-135mm f/3.5-5.6 IS @ 44mm; F-stop: f/22; Exposure: 1/4 Sec.; ISO: 800

GET CREATIVE WITH LIGHTING—Play with different lighting scenarios in order to create a natural appearance. Play around with sunlight, directional lighting, and even dark or night scenes where your miniature scene is illuminated from within, which can create very dramatic images such as fig. 41.5. Pinpoint (very narrow beam) or wider light sources from flashlights can be directly shined on areas of the scene, or even the ceiling if it is low enough to reflect light back on the track. Small color gels placed over the lights can add drama or be used to correct the light so that it looks completely natural.

Fig. 41.5 For this photo of a train set, a friend shined a bright flashlight on a white ceiling to give the darkened room a twilight look.

Camera: Canon EOS 6D; Lens: EF 28-135mm f/3.5-5.6 IS @ 135mm; F-stop: f/6.3; Exposure: 1/20 Sec.; ISO: 1600

PRO ASSIGNMENT

SHOOTING TRAINS AND OTHER MINIATURE SCENES

1. Photograph a train set. With the camera on a tripod, lock in on a particular area and wait for the train. By choosing a specific location, you can concentrate on the background and foreground, as well as the point of focus. If the train will be coming by often, use a continuous focus on the train to determine just the right point of focus (usually that's on the front of the train). Then switch to manual focus, or use the back button focus technique described in Tip 10. When the train enters the frame again, take about 10 photos using a Continuous Shooting (burst) mode.

2. If you are shooting handheld, have someone hold an item that you can focus on in the approximate place where the train will arrive (assuming that it is permitted to reach into the train area!). If not, you can always guess by pre-focusing on something to the left or the right of where the train will be traveling. You can also use a Continuous Autofocus mode during the shot, as described in Tips 10 and 11.

3. Include miniature statues of people or animals in the scene. Including one or more people or animals in a miniature scene can create the look of a 1950s B movie (watching the trailer for *Attack of the 50 Foot Woman* should give you some great ideas!). Take photos from a low perspective and shoot with a wide-angle lens to create added drama. For animals, you can put them in a variety of situations, like I did in my photo of the mice taking pictures with a view camera.

4. Play with lighting. Take at least 20 photos while someone shines a flashlight on the scene. Take some with just a bit of light strategically shining on an area, and some with a lot of light on the scene (or on an area like a ceiling that reflects light back on your scene).

5. Create a story with a few characters. Get creative and create a few photos with a group of characters in a comic book format. If your characters can "move," consider doing some stop-action movies, since you are probably all set up for it already. Boinx Software's iStopMotion is one affordable and very popular piece of software that can help you create your own masterpieces.

TIP 42

TAKING SAFARI-QUALITY PHOTOS AT THE ZOO

Zoos, wildlife parks and farms are some of my favorite places to recommend taking pictures, especially when you are looking to build your portfolio with a diverse subject matter. They offer many opportunities to learn how to photograph rare animals as well as teach you how to cope with challenging environments and locations, similar to what you would encounter if you were on safari on the savannahs of Tanzania or tracking tigers in the jungles of Borneo.

PHOTOGRAPH ANIMAL INTERACTION—Some of the most incredible opportunities in animal photography are in capturing the interactions at the zoo, whether it's between animals or an animal and zookeeper. It's always amazing to see how excited the animals can become when they play together or are fed, and how remarkably stunning these photos, such as fig. 42.1, can turn out. A zoom lens is very useful in these situations, allowing you to capture incredible detail from a long distance, as I did in fig. 42.2. I recommend practicing with something like a 28–200 millimeter lens because it allows for a wide range of different focal lengths without having to change lenses.

CAPTURE ANIMALS AND PEOPLE TOGETHER—One of my favorite photos to take at the zoo or aquarium is of an exciting interaction between the resident

Fig. 42.1 Who doesn't love penguins?! I can watch penguins for hours. By checking the feeding schedule at zoos and aquariums, you can capture action shots like this.

Camera: Canon EOS Rebel T4i; Lens: EF 70-300mm f/4-5.6 IS @ 115mm; F-stop: f/9; Exposure: 1/640 Sec.; ISO: 400

Fig. 42.2 I was touched when I saw this scene, and I'm always looking for moments like this. It helps to have a telephoto lens in these instances so that you can act quickly and zoom in without startling the animals.

Camera: Canon EOS Rebel T4i; Lens: EF 70-300mm f/4-5.6 IS @ 190mm; F-stop: f/9; Exposure: 1/250 Sec.; ISO: 400

animal and a visiting human. What could be more moving than a person's hand "touching" an animal's hand with just the glass between them? Without getting too much into the legalities of photography (I'm not a lawyer and can't offer legal advice), always consider people's privacy when posting and licensing/selling photos, especially if the people are recognizable in the photos.

Fig. 42.3 I took about 20 photos of this bird, and this was my favorite.
Camera: Canon EOS Rebel T4i; Lens: EF 70-300mm f/4-5.6 IS @ 70mm; F-stop: f/4; Exposure: 1/4000 Sec.; ISO: 1600

CREATE A WILD SCENE IN A CONTROLLED ENVIRONMENT— Whether you're photographing animals at the local zoo or while on safari, one of the most common challenges for any wildlife photographer is removing the human element from photographs, be it the shadow of your safari jeep or the chain-link fence of a zoo enclosure. For fig. 42.3, I used

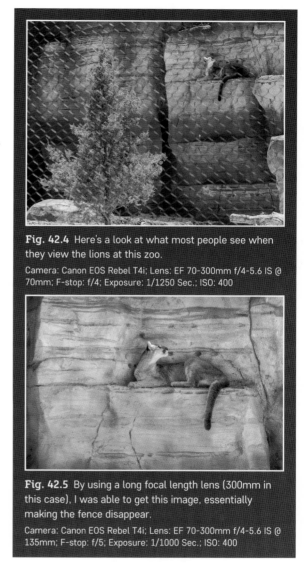

Fig. 42.4 Here's a look at what most people see when they view the lions at this zoo.
Camera: Canon EOS Rebel T4i; Lens: EF 70-300mm f/4-5.6 IS @ 70mm; F-stop: f/4; Exposure: 1/1250 Sec.; ISO: 400

Fig. 42.5 By using a long focal length lens (300mm in this case), I was able to get this image, essentially making the fence disappear.
Camera: Canon EOS Rebel T4i; Lens: EF 70-300mm f/4-5.6 IS @ 135mm; F-stop: f/5; Exposure: 1/1000 Sec.; ISO: 400

the "shooting through glass" techniques described in Tip 15 to reduce glare. Practicing at the zoo, you should try getting a fence to disappear, which can be done by getting very close to the fence and using a fixed focal length long lens, or a zoom lens that has a telephoto setting (over about 200mm in 35mm terms), as I show in figures 42.4, 42.5 and 42.6. It's best to set your lens to Aperture Priority, with as shallow a depth of

field as your lens will allow (for example, f/2.8–f/5.6). I've also found that this technique works best when your subject is at least 10 feet from the fence. If your autofocus system gets confused, you may need to focus manually.

Fig. 42.6 Just like with fig. 42.5, I was able to greatly reduce the effect of the fence in this image, but you can see a bit of the fence's patterns in the background if you look closely.

Camera: Canon EOS Rebel T4i; Lens: EF 70-300mm f/4-5.6 IS @ 300mm; F-stop: f/5.6; Exposure: 1/200 Sec.; ISO: 400

TAKE PICTURES AT WILDLIFE PARKS—If you've always dreamed of or are planning to take a big trip to do wildlife photography, wildlife parks offer by far the best chance to shoot in a simulated wild environment. In these situations, much like a safari in Africa or a wilderness expedition in Alaska, you are the one limited in movement while the animals roam free. Many of the same photography challenges you would face in the wild will present themselves on these easier expeditions. I was in the right place at the right time in fig. 42.7. That's a big part of the magic of photography—the unknown.

Also, it's a good idea to take photos of the signs and maps outside and inside the park as I've done in fig. 42.8. They can be very helpful for finding your way around, and they offer an interesting look at what's inside.

Fig. 42.7 I was very surprised and pleased to be able to capture the similarity in color between the woman and the peacock!

Camera: Canon EOS Rebel T4i; Lens: EF 70-300mm f/4-5.6 IS @ 160mm; F-stop: f/5; Exposure: 1/1600 Sec.; ISO: 800

Fig. 42.8 I found these signs to be quite magnificent, and the light was also fantastic that day.

Camera: Canon EOS Rebel T4i; Lens: EF 70-300mm f/4-5.6 IS @ 70mm; F-stop: f/4; Exposure: 1/1600 Sec.; ISO: 800

PHOTOGRAPH ANIMALS FROM A VEHICLE—If you are shooting from a car, stabilizing your camera becomes very important. Your primary source of stability when stopped should be the ledge of your window (preferably with the window all the way down, but some products are designed to be used with the window partially up). In order to reduce vibration, you should either purchase a beanbag or place a medium-sized towel or jacket beneath your lens and on top of the window ledge. You can use a beanbag that's designed for stabilizing light stands (see Tip 31, page 114), or you can choose a purpose-built beanbag made

SUGGESTED EQUIPMENT: BEANBAGS

Some of the best stabilizing beanbags you can get are: Gura Gear Sabi Sack, Gura Gear Super Sabi Sack, Gura Gear Anansi Weight Bag Sack and any of the beanbag camera supports from www.thevestguy.com. When you need some serious lens support when working from inside a car or different outdoor locations, a larger beanbag, like the Bean Bag Camera Support System from www.thevestguy.com is a great choice. The product comes in three sizes: small, large and extra large. For almost any size camera/lens combination, The Pod (www.thepod.ca) is a nicely designed line of camera beanbags that have a 1/4-20 screw at the center to help keep it balanced on car windows or window ledges (see fig. 42.9, fig. 42.10 and fig. 42.11). They even make a small accessory called The Cube that compensates for the added space created by camera battery grips.

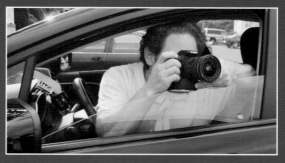

Fig. 42.9 The Pod works surprisingly well for DSLRs with small lenses, and the 1/4-20 screw at the center helps keep it balanced on car windows or window ledges.

Fig. 42.10 Another view of one of The Pod's beanbags. The company makes a range of different-sized beanbags with a similar look and function.

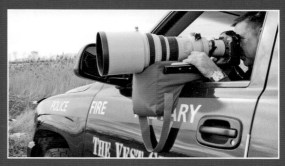

Fig. 42.11 The extra-large Bean Bag Support System from www.thevestguy.com being demonstrated.

for vehicle windows, hoods and/or the ground. One nice product made for this purpose is called the Puffin Pad. When moving, it's best to shoot handheld unless you have a special rig made for such situations. A fantastic article on this topic, with many options and suggestions, can be found at: www.kruger-2-kalahari.com/photographing-from-vehicles.html.

SET YOUR CAMERA FOR STOP-AND-GO PHOTOGRAPHY— Photographing while constantly on the move requires a quick trigger finger, or the ability to photograph well in broad sunlight and shadow. I suggest starting out shooting at as high an ISO as your camera will allow without sacrificing much detail. That might be ISO 400 on a lower-end compact mirrorless camera, or ISO 1000–2000+ on some DSLR or higher-end mirrorless cameras. High ISO combined with lower f-stops (f/2.8, f/4, etc.) and fast shutter speeds (about 1/250 second or faster) should all combine to give you a high percentage of sharp images. And when it comes to wildlife photography, you should play for the percentages as much as possible. I will average about 1,000 exposures on a 2- to 3-hour trip, but that's because I often shoot using my camera's burst mode, which can really make a difference when there is action. When I was on a 4x4 tour through a wildlife park, I noticed that all of my photos faster than 1/1000 second were sharp as long as I focused properly, even when I took the photos while the vehicle was in motion.

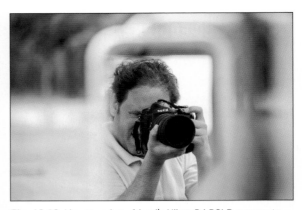

Fig. 42.12 I borrowed my friend's Nikon D4 DSLR camera to test it out and he captured an image of me in one of the safari vehicle's side-view mirrors. Photo credit: Ron Wyatt

Camera: Canon EOS 6D; Lens: EF 70-300mm f/4-5.6 IS @ 225mm; F-stop: f/5; Exposure: 1/1000 Sec.; ISO: 1250

An image-stabilized (IS) lens, also called Vibration Reduction (VR), Vibration Control (VC) and Optical Stabilization (OS), depending on the manufacturer, or in-body image stabilization system like that found on some Sony, Pentax and Olympus cameras, can help even more in getting clear, crisp shots on the go. I also highly recommend setting your camera (if possible and in most cases) to the center autofocus point (spot focus) so that you can more quickly and accurately lock in focus. And while you are out and about, take a few photos of yourself in vehicle windows, and of your friends and family, too, like in fig. 42.12.

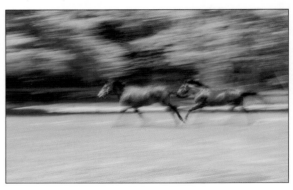

Fig. 42.13 There are few things as majestic as horses running without any saddles or people on them. And to capture their motion, I used the tracking technique described in Suggested Equipment for Tracking Shots: Monopods. They were going very fast and I was relatively far away, so 1/15 second worked well in this case to create the effect you see.

Camera: Canon EOS Rebel T4i; Lens: EF 28-135mm f/3.5-5.6 IS @ 65mm; F-stop: f/32; Exposure: 1/15 Sec.; ISO: 400

I only had a few minutes in this elevated location, which was an amazing experience. Luckily, the lovely creatures cooperated at just the right time without my even having to ask! A wide-angle lens was ideal in this situation, and having two cameras hanging from my photo vest made it easy for me to switch from wide to telephoto in a few seconds.

Camera: Canon EOS Rebel T4i; Lens: EF-S 18-135mm f/3.5-5.6 IS STM @ 18mm; F-stop: f/3.5; Exposure: 1/4000 Sec.; ISO: 400

This image is very sharp thanks in part to the very high shutter speed (1/4000 second) and the lens's image stabilization.

Camera: Canon EOS 6D; Lens: EF 70-300mm f/4-5.6 IS @ 110mm; F-stop: f/5; Exposure: 1/2500 Sec.; ISO: 1250

THREE WAYS TO PREP FOR *NATIONAL GEOGRAPHIC*

1. Take a series of photos from behind a chain-link fence and make the fence disappear. Note the distance you are from the fence and from the subject, as well as your camera lens's focal length. Virtually all zoom lenses show the current focal length in 35mm terms right on the lens barrel.

2. Take some photographs in front of a glass window at a zoo. Aim to capture some different expressions of a single animal, and try using the tracking technique.

3. Capture a series of images from a moving vehicle using some type of camera stabilizer. Take both tracking shots and photos in which you freeze the motion. Also do some ISO tests or some online research ahead of time to see what ISO your camera images begin to show too much noise (also keep in mind that some noise can always be reduced later on the computer). Lower f-stops and higher ISOs will allow you to use faster shutter speeds, so experiment with different shutter speeds to see what gives you a high percentage of sharp images with different lenses and focal lengths. A common rule of thumb is to use at least 1 over the focal length of the lens. For example, at 300mm, the rule says that you should be shooting at a minimum shutter speed of 1/300 second, but that's for when you are on solid ground. I recommend a minimum of 1/250 second regardless of what lens you have on your camera, and closer to 1/1000 second if you are shooting from a moving vehicle. As mentioned earlier in this tip, Shutter Priority mode works very well for this technique.

PHOTOGRAPHING LIFE ON A FARM

Civilization started on the farm. And ten thousand years later, the world is filled with an incredible variety of dramatic agricultural gems—from dairy farms in Ireland and rice paddies in Vietnam to expanses of wheat in the US. Having grown up in the United States, my favorite farms are those that include animals, especially horses, because where you find horses, you often find wide-open fields that make for dramatic photographs,

especially set against rolling hills, picket fences and old barns, as in fig. 43.1. Look for signature items to photograph at farms, like plows, tractors, silos, sprinkler/irrigation systems, etc., like in fig. 43.2. Any time water is being used to feed crops, there is an opportunity for medium- to long-exposure photography like the examples I showed in fig. 3.3–3.7 on page 14.

Fig. 43.1 This horse stopped me in my tracks, and I could not believe how nicely the red barn and the snow came together to create the background.
Camera: Canon EOS Rebel T4i; Lens: EF 28-135mm f/3.5-5.6 IS @ 53mm; F-stop: f/4.5; Exposure: 1/250 Sec.; ISO: 800

Fig. 43.2 I always like photographing things that are worn, rusted and show signs of wear, like this tractor at a farm. I think the shallow depth of field, thanks to shooting at f/5.6, added to the image's overall feel.

Camera: Canon EOS Rebel T4i; Lens: EF 28-135mm f/3.5-5.6 IS @ 135mm; F-stop: f/5.6; Exposure: 1/640 Sec.; ISO: 400

Fig. 43.3 Here, the tight crop and minimal background give a sense of where we are, while still allowing us to focus on the lamb's eyes.

Camera: Canon EOS Rebel T4i; Lens: EF 28-135mm f/3.5-5.6 IS @ 35mm; F-stop: f/5; Exposure: 1/50 Sec.; ISO: 400

PHOTOGRAPHY OF MOTION

Because farms offer you a setting where the animal world and human world collide, they can be the perfect space to practice photographing animals in motion, without the constraints of a safari vehicle or fences. In fig. 43.3, I photographed an adorable lamb using just available light coming in from outside the barn. Photos of running horses can be especially beautiful and perfect for practice or building your portfolio. I also covered a tracking technique that can produce amazing results in Suggested Equipment for Tracking Shots: Monopods on page 164.

PRO ASSIGNMENT

GETTING A BOUNTY OF IMAGES ON A FARM

1. Use a zoom lens or multiple cameras to capture both the big picture (wide-angle lens) as well as close-ups of interesting details at a farm, such as a person's hands on a horse's reins, a child feeding chickens, a large number of cows followed by a close-up photo of just one of them, etc.

2. Capture a photo of a few farm tools and vehicles. These might include hand tools, tractors, a horse trailer, etc.

3. Photograph a barn, silo and a farmhouse at different zoom levels, from wide angle to telephoto. Capture details like rusted locks and peeling paint.

4. Photograph one or more moving animals. First try freezing the horse in motion and then use the tracking technique described in Suggested Equipment for Tracking Shots: Monopods on page 164.

TIP 44

MASTERING FOOD PHOTOGRAPHY AT EVENTS AND RESTAURANTS

I love to eat, and I know I'm not alone! The number of restaurants, food trucks and events at which food is served across the globe is staggering. But if you look at a site like Yelp.com, where thousands of people upload photos of their latest burrito or surf and turf dinner, you will probably notice that the photos almost never look like what you might see on the cover of *Bon Appétit*. Here are a few tips for making your photos look as good as (or even better) than they taste.

USE SHALLOW DEPTH OF FIELD—Speaking of food magazines, they almost always have one thing in common: shallow depth of field and close-ups of the food. You can create this look by using Aperture Priority and small f-stop numbers, such as f/2.8–f/5.6, by using a medium to telephoto lens, and by zooming in on the food from at least a foot away. And be sure to turn off your camera's flash, unless the flash is being used remotely (off-camera), or unless you are using a shoe-mount flash on-camera with a reflector, and you are bouncing the light off of the ceiling.

ILLUMINATE YOUR MEAL WITH AN LED LIGHT—Whether you are at a restaurant or event, an LED pen light or cell phone LED light, held by a friend or family member, can do wonders to make your photos more appealing, as in fig. 44.1. Notice the subtle shadows from the overhead light falling just in front and to the right of each cupcake. You can look for details like that when moving your plates

Fig. 44.1 I could not resist photographing this plate of red velvet cupcakes. I show this image even though it was taken with an iPhone because, as they say, "the best camera is the one you have when you need it!"

Camera: iPhone 4S; Lens: Built-In @ 4.28mm; F-stop: f/2.4; Exposure: 1/20 Sec.; ISO: 80

around for the best angle and lighting. Just search for "flashlight" and the name of your phone to either find an app or native app that can control the LED light. For best results that allow you to control the depth of field, shoot in Aperture Priority mode, and ask someone to shine the light from about 8–20 inches (20–50 centimeters) onto the item(s) you are photographing (see fig. 44.2 for an example). For a "light-painting" effect that can be very dramatic, the light can be moved rapidly as you take the photo. You can also use one or more small LED lights in lieu of a cell phone light. Light painting is a technique that usually combines long exposures (for example, shutter speeds of one second to a minute or more) with

Fig. 44.2 (left) My secret lighting technique of using a smartphone's LED light (described in the text) can be seen here. The final image is in fig. 44.3.

Fig. 44.3 (below) Camera: Canon EOS 6D; Lens: EF 70-300mm f/4-5.6 IS @ 160mm; F-stop: f/6.3; Exposure: 1/60 Sec.; ISO: 1000

the "painting" of light using anything that creates light, from small flashlights or fire, to special lights designed specifically for light painting.

USE SIMPLE REFLECTORS FOR ADDED CONTROL—Another form of light is a reflector, which was covered in detail in Tip 21 (page 74) and Tip 22 (page 77). However, you probably won't be bringing a large reflector to IHOP, so it's helpful to know about some alternatives. One of the best "on-the-go"

reflectors when at a restaurant is a white or off-white menu (or white doggy bag if that's not available). Just hold the white item on the opposite side of where the light is coming from to help fill in the shadows, or it can be a main light if you use it to direct light from somewhere else, like a window that's shining light in the area, as in fig. 44.4. If you prepare in advance, you can also use a folded-up piece of standard letter-size paper or aluminum foil, which can fit in just about

any wallet or purse. Restaurants also almost always have foil wrap available if you ask.

Fig. 44.4 We happened to sit next to a large window at a restaurant, and when this pizza arrived, I had to almost hold my family back by force so that I could capture this image from just the right angle.

Camera: Canon EOS Rebel T4i; Lens: EF-S 18-135mm f/3.5-5.6 IS STM @ 35mm; F-stop: f/5.6; Exposure: 1/60 Sec.; ISO: 400

BRING YOUR CAMERA TO THE FOOD STATIONS AT EVENTS— If you've ever been to a party where there is a carving station, omelet bar or even a Baked Alaska demonstration, those can be great opportunities for interesting food photographs. Platters full of pasta and other foods can be photographed from many angles and zoom levels. And there are two words that just scream for photographs: Viennese table! A Viennese table usually consists of about 5–10 different areas featuring desserts, and they offer a bounty of colorful and interesting photo opportunities. These might include rows of chocolate mousse in martini glasses, large plates filled with sliced fruit or someone spinning cotton candy.

Sometimes the best photos are taken at your table once you've had a chance to arrange the items in interesting ways.

MASTERING FOOD PHOTOGRAPHY AT HOME

The previous tip covered how to take great photos of food at a restaurant or special event, but what about in your home? Some of my most memorable family events include many of my favorite foods, and when I lived in Japan for a summer with a host family, I took photos of almost every meal! The basic tips and techniques are similar between food photography at home and when outside your home. However, there are some things you can do (and quite a few types of photographs you can take at home) that you can't easily capture in a restaurant or other public place.

ANY TIME, ANYWHERE—Photos of food can be taken at any time when you are home, from when the food is in the refrigerator or pantry, to when it is being prepared, like in fig. 45.1, to when a meal is completed and on a table, as in fig. 45.2. If you're photographing the flames in the cooking process, I recommend using Aperture or Shutter Priority mode. If you use Shutter Priority, start with 1/50 second, and also try 1/100 and 1/125 second. If photographing a whole meal, using a wide-angle lens allows the eye to take everything in while still giving you a sense of the location.

FIND THE PERFECT LOCATION—In a restaurant, it's a bit rude to bring your plate of food over to another

Fig. 45.1 Fire on a grill can make for some very interesting images.
Camera: Canon EOS 20D; Lens: 11.0-18.0mm @ 11mm; F-stop: f/7.1; Exposure: 1/50 Sec.; ISO: 400

Fig. 45.2 I enjoy family meals before they are served, especially when they are colorful.
Camera: Canon EOS 20D; Lens: 11.0-18.0mm @ 11mm; F-stop: f/7.1; Exposure: 1/125 Sec.; ISO: 400

table to take a few photographs because that table has better light streaming through the windows. But at home, you can do just that, as I did in fig. 45.3. The wide-angle view and low perspective gives the food a different look and allows you to see what's happening outside. You can even take the food outside and photograph it from any angle, with any background or while someone is eating. Close-ups of food on a fork or someone holding food (shallow depth of field and lower f-stop numbers generally work best for these) are all possibilities (like in the photo of the corn on the grill in fig. 45.4).

SELECT YOUR LIGHTING—Having flexibility to use any lighting setup you'd like is another big advantage to taking food photographs at home. You can use whatever lighting is currently illuminating your food, from handheld LEDs to battery-powered shoe-mount flash units to powerful plug-in strobe lights. Of course, use caution with any plug-in strobe lights when around liquids.

Fig. 45.3 This plate of veggies jumped out at me at a family gathering and I could not resist! Sometimes, shooting from straight above is the best way to bring out the shapes, colors and textures in an image.

Camera: Canon EOS D60; Lens: 16-35mm @ 35mm; F-stop: f/2.8; Exposure: 1/125 Sec.; ISO: 400

Fig. 45.4 I often look for "action shots" when it comes to food at home, and this image of corn hot off of the grill is a good example of that. I used Aperture Priority and dialed in the widest aperture for my lens, which was f/3.5.

Camera: Canon EOS Rebel T4i; Lens: EF 28-135mm f/3.5-5.6 IS @ 30mm; F-stop: f/3.5; Exposure: 1/30 Sec.; ISO: 400

Fig. 45.5 I was drawn to this collection of fruit on a friend's kitchen counter.

Camera: Fujifilm FinePix S3 Pro; Lens: Tamron 17-35mm f/2.8-4.0 @ 21mm; F-stop: f/3; Exposure: 1/45 Sec.; ISO: 200

Fig. 45.6 I photographed (then ate!) this delicious berry tart at a friend's home. The lighting was a mix between daylight from large windows (camera right), and warm, incandescent light from above.

Camera: Sony A7R; Lens: Sony 28-70 f/3.5-5.6 OSS @ 33mm; F-stop: f/5.6; Exposure: 1/80 Sec.; ISO 500

PRO ASSIGNMENT

RING THE DINNER BELL AND START SHOOTING

1. Take photos of your ingredients. Ingredients can vary from simple spices in tiny glass bowls waiting to be added to a dish to a whole fish to a table full of colorful vegetables. These often look best when photographed from above. Take a few overall shots as well as some close-up images.

2. Bring your completed dish near a window. Window lighting is often very flattering to people as well as food, as was the case with the fruit in fig. 45.5. If your current eating location is not near a window with good lighting, move a small table near a window and place the plate on the table, possibly with a nice placemat, napkin, and fork or spoon. As suggested in Tip 44, you should experiment with different angles, including from directly above. This might require placing your food near the ground (just be careful if you have hungry pets!).

3. Set up some lighting (flash or continuous lighting) and photograph your meal as if you were being hired to do it. It's your kitchen, so who cares if it looks like a photo studio?!

TIP 46

TAKING STUNNING PHOTOS AT AN AQUARIUM

Aquariums offer an almost unlimited number of photo opportunities, from close-up images of exotic fish (see fig. 46.1) to dolphins and sea lions during a show. However, it can be challenging to get sharp, well-exposed images because it is often dark, and the animals often move quickly.

Fig. 46.1 I was able to capture a very sharp image of this clownfish and its surroundings by holding the camera extremely still and using a wide aperture, fast shutter speed and a relatively high ISO.

Camera: Canon EOS D60; Lens: 16-35mm @ 35mm; F-stop: f/2.8; Exposure: 1/500 Sec.; ISO: 800

SELECT THE RIGHT LENS—Regarding lenses, just about any lens can be used, but you'll probably find that wide-angle lenses (about 16–40mm in 35mm terms) are best for taking photos of fish tanks. First, they offer an angle of view similar to that you might experience if you were scuba diving or snorkeling. Wide-angle lenses also have smaller minimum focus distances compared with other lenses, which means that you can usually put the lens right up against the glass and take photos of fish that are just on the other side. A wide-angle lens can also really add to the expansive feel of a place, like in fig. 46.2.

USE APERTURE OR SHUTTER PRIORITY MODE—Flash may not be allowed in some of the aquariums you visit, and even if it is, it will probably cause reflections on the glass. The best settings to use without flash are either Aperture or Shutter Priority. Follow the wildlife photo tips in Tip 42 (page 160) and the bird photography tips in Tip 47 (page 177) for suggestions on how to get sharper images, as well as how to use Shutter Priority in different ways, including a tracking technique to create interesting images that will look as though the fish are flying by at almost warp speeds. Getting up close to the aquarium's glass and shooting at an angle will often yield some amazing results (see fig. 46.3 and fig. 46.4). See the window photo tips in Tip 15 (page 53) for more on this.

Fig. 46.2 I photographed this shark tank at a large aquarium.

Camera: Canon EOS D60; Lens: 16-35mm @ 16mm; F-stop: f/2.8; Exposure: 1/60 Sec.; ISO: 400

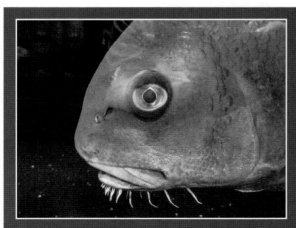

Fig. 46.3 This photo of a single fish from an aquarium shows how the 45-degree-angle technique worked to remove reflections (in this case with a Canon compact, fixed-lens camera).

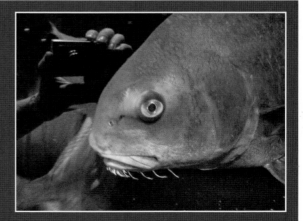

Fig. 46.4 You can see me with the camera because I moved a few feet away from the glass.

Camera: Canon Powershot SD790; Lens: Built-In @ 6.2-18.6mm @ 6.2mm; Aperture: f/2.8; Exposure: 1/60 Sec; ISO: 3200

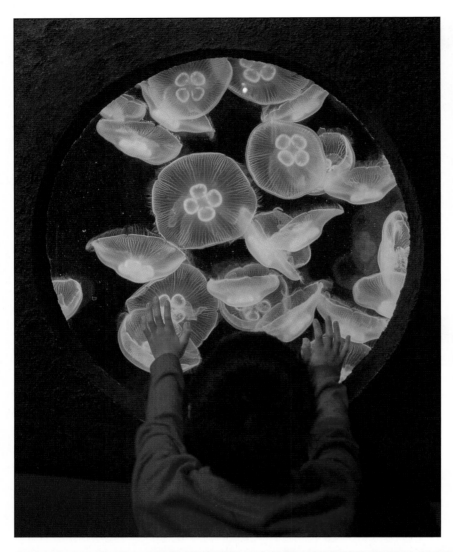

Fig. 46.5 I was truly moved when I observed this young boy connecting with the jellyfish in front of him. The 1/10 second shutter speed was just slow enough to allow the jellyfish to show a bit of movement in their hair-like cilia.

Camera: Canon EOS D60; Lens: 16-35mm @ 16mm; F-stop: f/2.8; Exposure: 1/10 Sec.; ISO: 400

DIVE IN AND CREATE AMAZING AQUARIUM IMAGES

1. Take a wide angle, medium and close-up (telephoto) series of photos of fish in a single tank. As you zoom in or change to telephoto lenses, keep in mind the minimum shutter speeds needed to get sharp images (about 1/125 to 1/500 second). Shutter Priority mode with Auto ISO (described in Tip 4) works well in these situations.

2. Take some images that include the backs of some people with them pointing to fish (as in fig. 46.5), or of people taking photos of fish with cameras or cell phones. These types of photos help set the scene and are often very interesting.

3. Some aquariums and zoos that have large tanks that allow you to view activity above and below the water line at the same time. Hippo areas are good examples of this. In these cases, take a series of photos that include both the underwater area as well as the above-water area, at both wide-angle and medium focal lengths.

TAKING BEAUTIFUL BIRD PHOTOS

Bird photography is one of the most popular types of photography...and for good reason. There are few things as stunning to look at as a cardinal perched on a tree limb blanketed in snow, or as adorable as a group of baby geese taking their first steps in the springtime sun. Because of the size and skittishness of most birds, there are some things you can do to increase your chances of getting sharp and, more importantly, striking photographs.

LENSES AND TELECONVERTERS—Many of the lens suggestions for zoos, wildlife parks and farms are also applicable for birds, but there are some specific things related to birds to keep in mind. If you'd like to get close to filling the frame with any bird smaller than an average goose from more than 10 feet away, you will need to have a lens with at least a 300mm reach in 35mm terms (400–600mm is ideal).

You'll also want a lens that's fast enough. That means it should have a maximum aperture (the lowest f-stop that can be used) that's not over about f/4.5. That should allow you to keep your ISO in the ISO 400–2000 range while keeping the viewfinder image relatively bright (assuming you are using the viewfinder of a DSLR). Electronic viewfinders and live view mode with a magnified hood on DSLRs and other camera types generally provide good brightness, but you may find those options very difficult when tracking and trying to focus on birds, depending upon how small the birds are, how fast they are moving, and the

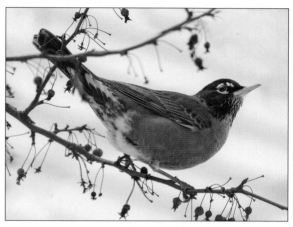

Fig. 47.1 This little robin was hanging out near my home on a winter's day. The lens's Image Stabilization and a 1/500 second exposure time helped to keep the image tack sharp. Camera: Canon EOS 6D; Lens: EF 70–300mm f/4-5.6 IS @ 300mm; F-stop: f/5.6; Exposure: 1/500 Sec.; ISO: 640

quality of the LCD or EVF. The ISO you choose should be low enough not to have unwanted noise, and the number will depend on your camera, how much light is available (the more light you have, the lower an ISO value you can use) and whether you shoot in Raw (highly recommended!). You'll see less noise in general if you shoot in Raw compared with JPEG, and you'll also have less noise if you don't underexpose your images.

You may think that you have to spend $1,000 or more on a lens to get to 300–400mm, and that would be true if you want a fixed focal length of 300 or 400mm, or something like a 100–400mm f/4.5–f/5.6 lens. However, you can find some excellent 70–300mm and similar zoom lenses for DSLR and mirrorless cameras from Canon, Nikon

and other brands for about $300–$700. When converted to 35mm terms, you will often reach 600mm (for example, the Micro Four Thirds system has a 2x crop factor, so a 70–150mm lens will produce a similar field of view to a 140–300mm lens on a 35mm camera). And, some "superzoom" cameras without interchangeable lenses, like the Nikon Coolpix B700 (under $500, includes the camera and a built-in 24–1440mm equivalent lens), can do a very impressive job when photographing birds and sporting events. That being said, a fixed focal length telephoto lens, like the Canon EF 400mm f/4 DO IS or 400mm f/5.6L (about $6,500 and $1,400 respectively), cannot be matched quality-wise by most zoom lenses at

their 400mm setting in terms of autofocus speed, image quality (contrast and sharpness), low amount of chromatic aberration and pleasing bokeh effect.

As I briefly mentioned earlier in the book, here's a very specific lens recommendation based on personal experience: I own and often use a Canon EF 70–300mm f/4–f/5.6 IS lens (approximately $650) for photographing birds on a full-frame Canon EOS 6D as well as few different Canon EOS Rebel 18MP DSLRs. I've used the lens very successfully photographing birds with both a Kenko AF 1.5x Teleplus DG and 1.5x Teleplus SHQ teleconverter ($150–$200), and I am extremely pleased with the

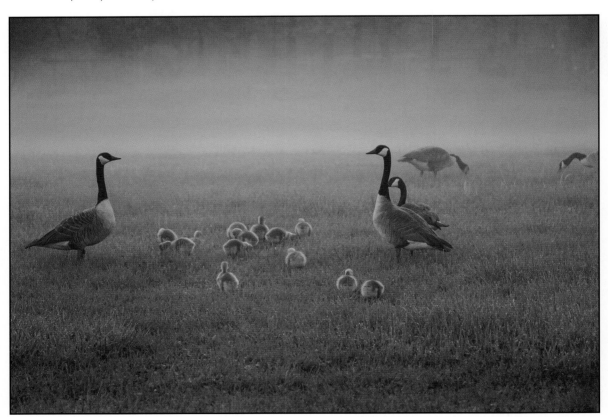

Fig. 47.2 I happened to be driving in my neighborhood during a pretty rare foggy morning and spotted this family of geese. Luckily, I was in the right place at the right time with my camera close at hand.

Camera: EOS 5D Mark II; Lens: EF 28-135mm f/3.5-5.6 IS @ 135mm; F-stop: f/5.6; Exposure: 1/250 Sec.; ISO: 500

results (I see no image quality difference between the two teleconverters).

The only negative I've found is that I occasionally get communication errors with each teleconverter, which requires me to turn the camera on and off. Be sure to clean the metal contacts on the small area of your camera body that touches the lens/converter contacts, as well as the contacts on any lenses and teleconverters to help reduce the chance of communication errors. The contacts look like a row of gold or silver dots; I recommend using a lint-free cloth and small amount of 91 percent isopropyl alcohol (available in most drug stores and supermarkets) to clean them.

A teleconverter is like a magnifying glass that is placed between your camera body and lens. Some magnify the focal length of the lens 1.4x, others 1.5x, and others 2x or more. With 1.5x teleconverters, you will lose one exposure value (EV) of light, and with 2x teleconverters, you will lose two EVs. The only way to really know how the quality of your images will be affected by a teleconverter is by testing one or reading reviews of specific models.

Two of the advantages of using teleconverters are that you can avoid the need for carrying (and buying) an extra lens, and you can often achieve focal lengths over 500mm in 35mm terms with a lens/teleconverter combination that weighs much less than most long lenses. I should add that not all lens/AF teleconverter combinations will allow autofocusing. Research this first before making a purchase. I consider autofocus a necessity when photographing birds because it is very difficult to adjust focus manually when trying to track a bird in the air.

A "Four Thirds" system lens (similar to the Micro Four Thirds system, but with a different lens mount) is very worthy of mention for bird photography. Four Thirds system lenses, like the 2.2-pound Olympus Zuiko Digital 50–200mm f/2.8–f/3.5 SWD lens can be used with many different mirrorless cameras from Panasonic and Olympus. The effective 35mm focal length of this lens is 100–400mm, and the price is about $1,200. However, Micro Four Thirds system cameras will require a $100–$150 adapter to use Four Thirds lenses, and you should test any lens first with the adapter to make sure the autofocus system works well enough for your needs. Also, if you have a Micro Four Thirds system camera, I would highly recommend first looking at lenses made for that system because they will generally be lighter and won't need an adapter.

BIRDS IN TREES AND ON LAND—Some of my favorite places to photograph birds are when they are perched in trees or on the ground. I particularly like photographing birds when they are walking around or preening (grooming) themselves because to me, they look almost like Broadway performers getting ready for a big show. For tree photos, it's often nice to zoom in just far enough on the bird(s) to include some of the foliage, flowers or interesting web of branches in the area, as in fig. 47.1. Capturing interesting interactions between "lovebirds," or parents and their offspring can be heartwarming and beautiful, such as the family of geese in fig. 47.2. It's also great to capture a series of images as a bird leaves a tree. To do that, set your camera to Continuous Shooting mode (a.k.a. Burst mode), and if you are lucky, you will capture a few images just as the bird leaves the branch or other perch, like I did in fig. 47.3. If birds are walking on the ground, the

best vantage point is generally to also be close to the ground. Early morning and late afternoon are especially good times to take photos like these. Early mornings with fog over land or water can really add to the drama, as you can see in fig. 47.2.

Fig. 47.3 I noticed this bird sitting on an electrical wire and just as I was starting to take a few photos with my camera set to Continuous Shooting mode (also called burst mode), it lifted off, resulting in a few images (this being my favorite of the group).

Camera: Canon EOS Rebel T4i; Lens: EF 70-300mm f/4-5.6 IS @ 300mm; F-stop: f/16; Exposure: 1/320 Sec.; ISO: 400

BIRDS AND WATER—Many birds spend a lot of time in or near the water, and there are countless opportunities for getting great shots there. Look for panoramic photo opportunities of long lines of birds in a formation on the water. Also look for reflections in the water, either of the birds themselves, or of clouds, trees, etc. And don't forget the beauty of winter! I think you'll find that some of the best bird photos can be found near ice- and snow-covered lakes, rivers, trees, etc.

BIRDS IN FLIGHT—Now to probably the most challenging type of bird photography: birds in flight (often abbreviated as BIF). There are few things as graceful-looking or awe-inspiring as a bird in flight, as shown in fig. 47.4 and fig. 47.5. Once you have a long lens, you are ready to start capturing this phenomenon. Following the back button techniques in Tip 10 (page 41) and Tip 11 (page

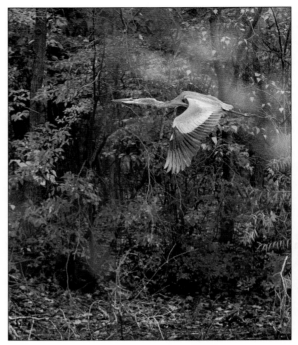

Fig. 47.4 I was taking a walk in my neighborhood in early November when I noticed a great blue heron walking in the water. I slowly raised my camera, focused, and luckily, just at that moment, the bird flew past me and in front of some beautiful trees. I had my camera set on Aperture Priority and burst mode, and my shutter speed (1/2000 second) was fast enough to capture a very sharp image of the bird. I then cropped the image quite a bit to highlight the bird.

Camera: Canon EOS 6D; Lens: Sigma 105mm f/2.8 Macro EX; F-stop: f/5.6; Exposure: 1/2000 Sec.; ISO: 800

44) is a good first step. The main thing to keep in mind if the birds are small and will be moving quickly is to consider turning on all AF points because you can more easily "catch" a bird as it enters your frame. If there are multiple birds and you want to retain more control over which ones are in focus, choose manual single point focus (usually with the center square highlighted). A good Autofocus mode for this type of photography is the mode that keeps adjusting the focus point as the subject moves (AI Servo on Canon and AF-C on Nikon). Also see Tip 10 (page 41) and Tip 11 (page 44) for more on this type of continuous focusing.

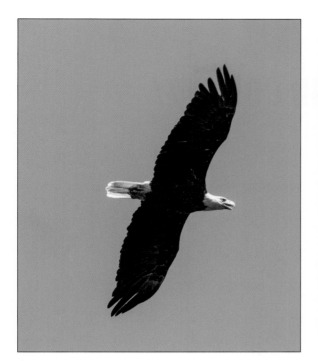

Fig. 47.5 I captured this image of a wild bald eagle from a boat near a lake in Pennsylvania. I was quietly watching it as it suddenly decided to leave the tree on which it was perching. I used spot focusing and Shutter Priority mode, set to 1/800 second. In hindsight, I should have chosen 1/1000 second because I noticed that some of the images were slightly blurred.

Camera: Nikon D5500; Lens: Nikkor 55-300mm VR @ 300mm; F-stop: f/8; Exposure: 1/800 Sec.; ISO: 320

BIRD PHOTOGRAPHY DONE RIGHT

1. Rent or purchase a telephoto lens (also consider a 1.5 or 2.0x teleconverter as an affordable tool for getting more "reach"). When you are driving around your neighborhood, take a mental note of parks and other locations where you often see birds, then return there when time allows (or just walk around an area where you often see birds). Then take at least 50 photos of five different birds or groups of birds in at least three different locations within a 10-day period for a total of at least 250 photographs. Take a mix of photos of birds flying, birds grooming, birds walking on the ground, and birds on water and/or ice.

2. Test some different stabilization methods as you complete the above assignment. For at least one location, use a special beanbag or a small pillow over the side of your car window (with the ignition off!). Then, take a series of photos using a tripod. Finally, try using a monopod. See Tip 23 and Tip 24 for some tripod and monopod tips.

3. Try some tracking shots, as described in Tip 42. Use Shutter Priority mode and take a series of photos at 1/4 second, 1/2 second, 3/4 second and 1 second as you carefully track a bird in motion. Ducks, geese and egrets are excellent subjects for this because they are larger and easier to track.

TIP 48

TAKING FESTIVAL AND COUNTY/STATE FAIR PHOTOS

Who doesn't love a fair or festival, especially if the weather is good? I absolutely love attending balloon festivals, cultural festivals and county/state fairs. They are full of color, excitement, and of course, delicious food! I've been fortunate to have lived and traveled throughout the US, Europe and Asia, and I've attended fairs and festivals in almost every country I've visited (always with a camera in tow). Before going on a trip or planning a weekend in or around your hometown, I highly recommend checking online to research what festivals may be happening.

BALLOON FESTIVALS—Balloon festivals and other events where hot air balloons can be seen offer incredible photo opportunities, as you can see in figures 48.1, 48.2, 48.3 and 48.4. Without a doubt, my first tip for any type of festival in which the action comes and goes within a short amount of time is to have at least two cameras. That could mean two DSLRs, a DSLR and a mirrorless camera, or even a DSLR and a compact camera or camera phone. This is, of course, not required, but here are two reasons for this:

First, gear can and will break down. Imagine being without a camera after spending so much time and possibly a lot of money to get to the event.

Second, you want to have a way to capture two very different focal lengths without having to change lenses during the peak of the action.

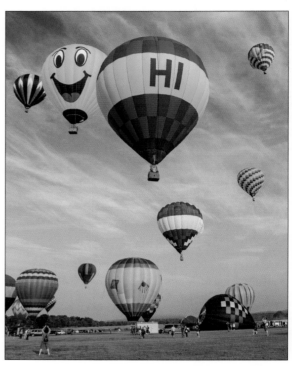

Fig. 48.1 With some planning, you can often find free or inexpensive ways to get on the main field at balloon festivals and related events.

Camera: Canon EOS Rebel T2i; Lens: EF 16–35mm f/2.8L @ 16mm; F-stop: f/5; Exposure: 1/2000 Sec.; ISO: 800

If you saw me during most balloon launches, you would see me flipping between two DSLR cameras, one with a 75–300mm lens and the other with a 16–35mm lens. That enables me to get a wide range of different images before all of the balloons drift off into the wild blue yonder.

Fig. 48.2 I love the look of balloons glowing in the night, and it's nice to include things like cars being illuminated.

Canon EOS Rebel T2i; Lens: EF 16-35mm f/2.8L @ 16mm; F-stop: f/4; Exposure: 1/15 Sec.; ISO: 800

Fig. 48.3 I photographed this image at sunrise at a balloon festival and really like how it shows a quiet moment before all the activity is about to begin.

Camera: Canon EOS Rebel T4i; Lens: EF-S 18-135mm f/3.5-5.6 IS STM @ 135mm; F-stop: f/5.6; Exposure: 1/4000 Sec.; ISO: 800

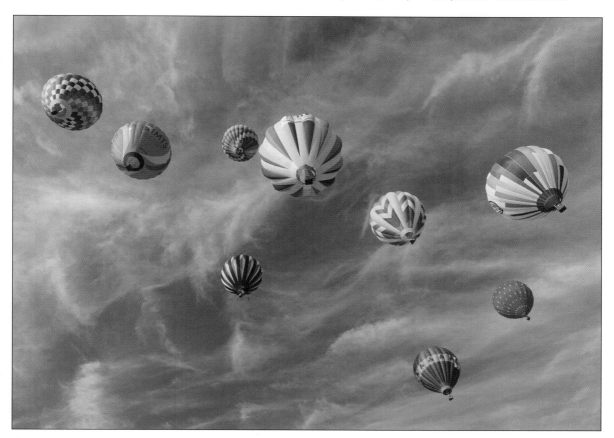

Fig. 48.4 I could not believe how amazing this site was above my head. A wide-angle lens made all the difference, making the balloons look almost like lanterns.

Camera: Canon EOS Rebel T2i; Lens: EF 16-35mm f/2.8L @ 16mm; F-stop: f/7.1; Exposure: 1/640 Sec.; ISO: 800

Fig. 48.5 An overview shot of real bees in a beehive, with the beekeeper working in the background.

Camera: Canon EOS Rebel T4i; Lens: EF 28-135mm f/3.5-5.6 IS @ 28mm; F-stop: f/3.5; Exposure: 1/60 Sec.; ISO: 1600

You may even want to shoot some video with one of the two cameras, or you can add a tripod-mounted camera to capture video of the action as it happens. If you choose to use a compact camera and a DSLR, it's probably best to use the DSLR for the telephoto images and the compact camera for the wider shots (assuming you have a good-quality telephoto fixed focal length or zoom lens).

ANIMALS—If you go to a state or county fair, there will often be farm animals on site. Look for areas where the light is best to capture interesting images, or use a flash (as long as it is permitted). I photographed an amazing bee display at a local fair (fig.48.5 and fig. 48.6) a few years ago that was an eye-opener!

ANTIQUE FARM EQUIPMENT—State or county fairs also tend to have farm equipment on display (sometimes over a hundred years old), such as the

Fig. 48.6 I always enjoy capturing images like this beekeeper's stand at county/state fairs.

Camera: Canon EOS Rebel T4i; Lens: EF 28-135mm f/3.5-5.6 IS @ 28mm; F-stop: f/3.5; Exposure: 1/50 Sec.; ISO: 1600

Who doesn't like to eat healthy foods like apples (covered in candy of course!) at festivals and fairs. I always try to capture images like this to give another dimension to the fair.

Camera: Canon EOS Rebel T4i; Lens: EF 28-135mm f/3.5-5.6 IS @ 135mm; F-stop: f/5.6; Exposure: 1/320 Sec.; ISO: 400

tractor in fig. 48.7. Farm equipment, including historic tractors and plowing equipment, often has interesting logos and weathered paint that is great to photograph. Close-ups of equipment tend to be most interesting to me, but great photos can be taken at just about any focal length.

CRAFTS AND TRADES—State or county fairs also frequently feature demonstrations of crafts and trades like horseshoe making and chainsaw sculpting of wood stumps (this is truly amazing!). Close-ups of an artist's hands working from beginning to end can make for a very interesting series.

Fig. 48.7 This tractor had just participated in a race at a county fair and I really liked showing the contrast between the farm equipment (not usually used for racing) and the racing helmet.

Camera: Canon EOS Rebel T4i; Lens: EF 70-300mm f/4-5.6 IS @ 70mm; F-stop: f/6.3; Exposure: 1/60 Sec.; ISO: 1600

CELEBRATE AND SOAR HIGH AT FESTIVALS AND FAIRS

1. If you're at an event with hot air balloons that are getting ready to take off, take at least 20 photos of each of the following (preferably with two cameras as mentioned above):

- A series of photos looking inside a balloon as it is being inflated with the flame from a gas burner. (This may require permission to get close to the action.)

- A wide-angle group of photos showing many balloons in the air, as well as spectators enjoying the event.

- A group of photos of balloons directly overhead (they often look like lanterns when in this position).

- A group of close-up images of one balloon in the air with or without some balloons in the background. Use the widest aperture you can (smallest f-stop number). Similarly, take a photo of an interesting balloon on the ground with some balloons in the air in the background.

- A set of photos with the sun behind one or more balloons. Auto Exposure Bracketing (AEB), as described in Tip 6, will increase your chances of getting just the right look because the exposures will vary widely depending on how much of the sun is in the frame.

2. If you can attend an early morning or late-afternoon glow, take at least 50 photos while it is dark or relatively dark outside. A glow is when a number of balloons are illuminated by the flames from their gas burners (usually starting at dusk). They often happen during concerts, which makes the whole scene even more amazing. Do some close-ups, and also include some interesting elements in the photos, such as the vehicles that are used to transport the balloons (see fig. 48.1 as an example).

3. Take at least 20 photos of signs at the fair or festival that impress you in some way. Take both horizontal and vertical photos, at wide and telephoto focal lengths.

4. Take at least 20 photos of a person's hands working on a grill filled with scrumptious-looking foods, or preparing something scrumptious, like a plate of deep-fried Oreos or funnel cake.

5. Take at least 50 photos of animals at a county or state fair. Take some photos showing the environment in which they are in, as well as some close-ups.

6. Take at least 20 photos of tractors, antique cars, etc. Get low and use a wide-angle lens for dramatic looks of cars, and focus on nameplates and details like rusty seats on tractors and other equipment.

GETTING GREAT BEACH PHOTOGRAPHS

The beach is one of my favorite places to visit and take pictures. And I know I'm not alone. There is something magnetic about a sandy beach and the sound of waves washing up on it. Fig. 49.1 is an image of my son as he was enjoying his time on the beach. Many lakes have the look and feel of an ocean, and other locations, like harbors, boardwalks, boat docks and pools are also prime spots for creating the look of paradise in your photographs. Here are some ideas and assignments for when you are ready to "get your feet wet!"

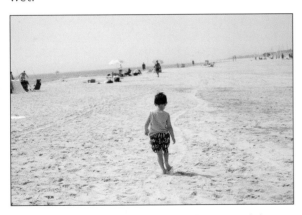

Fig. 49.1 The wide-angle view really adds a sense of place to this beach photo.
Camera: Canon EOS D60; Lens: Canon Macro EF 50mm f/2.5; F-stop: f/2.8; Exposure: 1/4000 Sec.; ISO: 200

LENS HOOD—A lens hood will often come in handy by reducing flare in your photos when at the beach, due to direct rays from the sun, or light reflections off of the sand and/or water. Also, without going too far into the topic, a circular polarizer filter can help increase contrast and saturation in skies, and reduce reflections off of water and other surfaces in some situations. For an excellent article on this topic, search the word "Polarizer" on www.cambridgeincolour.com.

PROTECTING YOUR GEAR—Protection of one's gear at the beach is no small feat. In general, try to avoid changing lenses when on the beach and keep every piece of equipment in its own resealable bag to reduce the chances of sand getting into anything. Most importantly, be very careful when cleaning lenses or even your LCD at the beach because sand can easily scratch them.

Using UV filters on your lenses can help protect them from scratches, and lens rear caps are essential. I should note that I don't normally use UV filters on my lenses because image quality often suffers (especially with telephoto lenses). However, I cover all of my LCDs with removable crystal clear glass covers that cost less than $10 each. You can find the ones I use online by searching for "GGS Optical Glass LCD Screen Protector."

Extreme heat is not good for gear, so keep your gear out of direct sun, and in extreme cases (over 100 degrees Fahrenheit; 38 degrees Celsius), consider placing your lenses and your camera with the main lens you plan to use attached in a small cooler with leak-proof ice packs (just don't let the ice packs touch any of your gear!). Also keep your main camera with lens attached in a resealable bag with a desiccant package to reduce the chance of condensation/fogging of your lens and camera mirror (for DSLRs) when you remove it from the bag (especially if you are driving in an

air-conditioned car). It's a good idea to wait to use the camera until it acclimates to the outside temperature (usually that's 10–15 minutes), especially if it is very hot and humid outside.

Also, hold on to your camera! This is no joke. It's easy to get knocked over by a wave and have thousands of dollars of equipment get ruined. A good camera sling or products like those I cover in Tip 7 (page 27) can be a lifesaver.

FOLLOW THE SUN—Like with most photographs taken outside, the most dramatic skies and shadows will be found early and late in the day. Consider waking up before the sun rises so that you can capture it before and during the time it rises. The best sunrise or sunset photos are those that add an interesting element, such as two people walking or standing on the beach, a few tall palm trees or a boat in the distance.

SHELLS—Close-ups of shells on the beach or being held by a child or older person make nice images.

FOOTSTEPS—Photographs of one or multiple footsteps are a lot of fun and are best done with wide-angle to medium telephoto lenses (20–50mm). Unless you are taking a photo of a single footprint from above, it's nice to include a bit of the shoreline in the photos.

PLAYING IN THE SAND—Photos of your friends, relatives and/or children playing in the sand are always great, such as fig. 49.2. Portraits of one or multiple people, as well as more creative photos using a shallow depth of field in which you focus on a child's hand or face as they create something (with an ocean, lake or pool in the background) can be very interesting. Use lower f-stop numbers and longer focal lengths for the close-ups. Look for opportunities to take photos from different angles, like fig. 49.3.

Fig. 49.2 My son playing with sand at the beach. Moments of discovery like this are priceless, and they happen a lot when you are relaxing with family.

Camera: Canon EOS D60; Lens: Canon Macro EF 50mm f/2.5; F-stop: f/11; Exposure: 1/200 Sec.; ISO: 200

Fig. 49.3 Here's my son hanging out amongst some sandcastles that he and his cousins made.

Camera: Canon EOS D60; Lens: 16-35mm @ 16mm; F-stop: f/5.6; Exposure: 1/500 Sec.; ISO: 100

SANDY FACES—Close-ups at the beach of peoples' faces (that you know) with sand on them will convey that wonderful "at the beach" summer feeling. I won't go into the many regulations around the world with regard to photography and privacy, but it's important to know what is and what is not permitted in different places.

ONE'S OWN LEGS OR FEET—Photos of one's own legs and feet with the water visible in the background while sitting on a chair or sitting up on a towel are best done with wide-angle to medium focal length lenses (20–50mm), and they can be both funny and interesting. Creating a shallow depth of field by focusing on your feet and letting the rest of the scene go out of focus will usually make for more interesting images because it adds an element of mystery.

RIDING THE WAVES—Photos of kids and adults riding the waves on a bodyboard are always great, especially later in the day when the light creates more shadows. Occasionally you might even get photos of real surfers, as I did in fig. 49.4.

LINE UP—A great place to capture emotions is by asking friends and/or family members to line up at the edge of the shore as the waves come in, as I did in fig. 49.5, or on a dock just before, during and after they jump in the water. They can then be photographed to include their entire bodies, or just their faces, feet, etc.

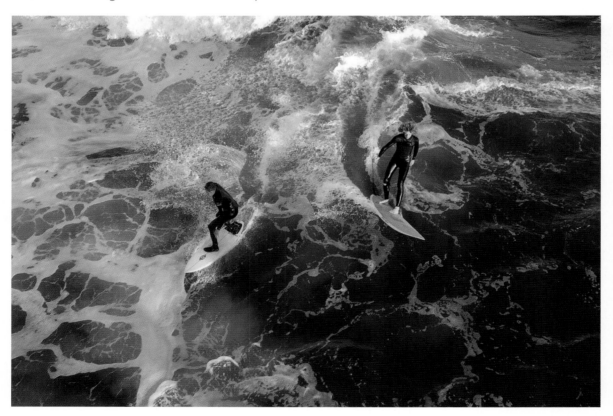

Fig. 49.4 I had a great view of these and other surfers from a pier. Always look for shooting opportunities like this, and consider including more than one person in the shot.
Camera: Fujifilm FinePix S3 Pro; Lens: 17.0-35mm f/2.8-4.0 @ 35mm; F-stop: f/4; Exposure: 1/350 Sec.; ISO: 200

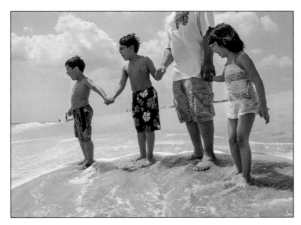

Fig. 49.5 A photo of some family friends at the Jersey Shore.
Camera: Canon EOS D60; Lens: 16-35mm @ 16mm; F-stop: f/4.5;
Exposure: 1/3000 Sec.; ISO: 200

FOOD STANDS—Like the tips discussed for photographing food stands at county and state fairs, restaurants and food stands at or near the beach are often great places to capture images of boats, birds looking for food that people drop, seafood, and fun foods like candy apples and fudge (see fig. 49.6).

Fig. 49.6 How could I resist the photo or the food?! I especially like that you can see a portion of one of the store's employees, which gives it added interest and scale.
Camera: Canon EOS 6D; Lens: EF 28-135mm f/3.5-5.6 IS @ 70mm;
F-stop: f/18; Exposure: 1/250 Sec.; ISO: 800

Fig. 49.7 This kayak on the water helps to give this image scale, and its yellow color really stands out from the beach, trees, sky and building in the background.
Camera: Canon EOS 6D; Lens: EF 70-300mm f/4-5.6 IS @ 70mm;
F-stop: f/4.5; Exposure: 1/4000 Sec.; ISO: 500

BEACH BACKGROUNDS—There are beaches in all types of places, from pools to lakes, and they can make for great backgrounds, like in the photo of the kayak in fig. 49.7.

PRO ASSIGNMENT

SURF'S UP! TIME TO HIT THE BEACH

1. Have a specific plan for your keeping equipment safe from the elements (and potential theft) if you are planning to bring it to the beach.

2. Take at least 30 photos of three or four of the themes discussed in this tip. Experiment with different shutter speeds, apertures and focal lengths if you are using a zoom lens or multiple lenses.

3. Take photos of some of the different foods and interesting locations you find on the boardwalk or at seaside restaurants. And don't forget to take photos of your own meals if they look photo worthy.

TIP 50

TAKING PHOTOS OF FIREWORKS THAT JUMP OFF THE SCREEN

Fireworks displays can be truly awe-inspiring, yet they can be very challenging to photograph in ways that bring back the feeling of being there in person. With the right equipment and a little preplanning, I think you will be amazed at the images you will be able to capture.

USE A CAMERA THAT CAN FOCUS MANUALLY—As it gets dark outside, most camera and lens combinations will have a difficult time focusing using auto-focus. This is especially true with fireworks if you are focusing into the sky without any landmarks, like trees or people. Also, if you are using an EVF or LCD hood with a diopter, make sure the diopters are set correctly for your eye so that you can judge sharpness.

USE A STURDY TRIPOD AND A WIRED OR WIRELESS SHUTTER RELEASE—A sturdy tripod with a good-quality tripod head will make all the difference because it allows you to set up your camera in exactly the spot you want, and at the same time, capture fireworks streaming through the air. If you can't use a tripod for some reason, consider attaching your camera to a sturdy clamp that's then attached to a small chair or picnic table umbrella. The Pedco UltraClamp is one good option.

SHOOT IN RAW MODE—There are many reasons to shoot in your camera's Raw mode (as opposed to TIFF or JPEG). The main reason is image quality. Shooting in Raw mode allows you to retain more highlight and shadow detail compared with JPEG or TIFF modes. It is also easier to adjust the color temperature of your photographs without degrading the image quality when you shoot in Raw mode.

INCLUDE FOREGROUND ELEMENTS FOR SCALE AND IMPACT—When you include foreground elements, such as people, buildings, trees, etc., the images give the viewer a lot more information about where the photos were taken, and the size of the subjects in relation to the sky and the fireworks, such as the tents in fig. 50.1. I especially like to include the backs of people, which usually end up looking silhouetted, to add interest, as in fig. 50.2.

USE MANUAL EXPOSURE MODE—Fireworks are very unpredictable, so experiment with various exposures and apertures until you see what you like

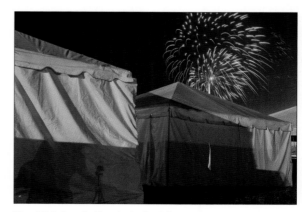

Fig. 50.1 I really like the look of the vendor tents combined with the fireworks, so I set up my tripod and got to work!
Camera: Canon EOS Rebel T4i; Lens: EF-S 18-135mm f/3.5-5.6 IS STM @ 35mm; F-stop: f/9; Exposure: 5.00 Sec.; ISO: 400

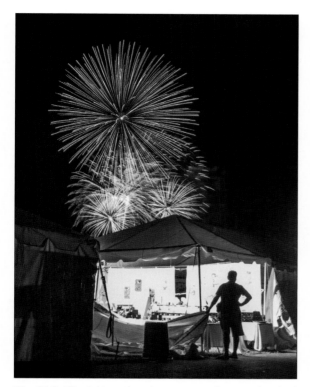

Fig. 50.2 After taking a few photos next to the tents, I noticed this gentleman watching the fireworks (probably after a long day of setting up or working at his stand at a balloon festival).

Camera: Canon EOS Rebel T4i; Lens: EF-S 18-135mm f/3.5-5.6 IS STM @ 27mm; F-stop: f/9; Exposure: 5.00 Sec.; ISO: 400

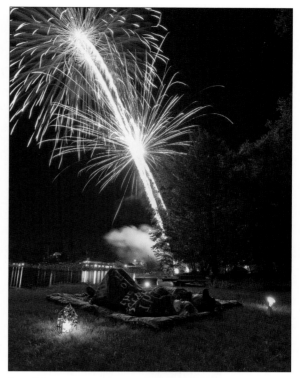

Fig. 50.3 I took this photo and many others of two family members just as July 4th arrived. The key in this case was to just keep shooting and to use a wireless cable release to help keep the camera still.

Camera: Canon EOS 20D; Lens: 11.0-18.0mm @ 12mm; F-stop: f/4.5; Exposure: 13 Sec.; ISO: 200

on the screen. Every shot will be different depending on when the fireworks go off. A good starting point is f/8, ISO 400 and 3 seconds. That's enough time to get nice trails of light in the sky without having to wait too long between shots. As you get closer to the finale, keep shortening your exposures.

USE MIRROR LOCKUP—Mirror lockup is a feature on many DSLRs and other cameras. By engaging mirror lockup (often through a custom menu setting), you can reduce vibration inside the camera because the mirror does not have to flip out of the way to expose the film or sensor. This can

result in sharper images when you have the camera on a tripod, though it is not a necessary step.

USE A CABLE RELEASE (A.K.A. REMOTE SWITCH) OR SELF-TIMER—A cable release (wired or wireless) allows you to keep your hands off the camera during an exposure, which can help to further reduce movement during a shot, helping to get photos like fig. 50.3. With a self-timer, which is built into almost all cameras, it is not nearly as easy to get a shot at a specific time, and you will almost definitely introduce shake into some of your photographs. Some cable releases, like Canon's wired Remote Switch RS-60E3 (about $20), also have a locking mechanism for very

long exposures. More good wired cable releases include those shown at the top of fig. 50.4. Canon and other companies also make wireless remote control transmitters. A nice feature of the Canon RC-6 is a switch that allows for a 2-second delay, which is great when you want to take self-portraits and hide the remote at the last second. There are also a number of other tools that will do the job. See Tip 24 (page 86) for more on those.

Fig. 50.4 Top: A Vello Shutterboss Version II Remote Switch with Digital Timer for Sony with an Aputure AP-TR1C Timer Remote Control for Canon on its right. Both of these products have extensive features for triggering a camera. Bottom: A Canon Remote Control RC-6 Wireless Remote Control Transmitter, which has a range of about 16 feet.

USE PORTABLE LIGHTS—Because it can be very dark during fireworks demonstrations, small LED flashlights or hands-free headlamps can be very useful when you are trying to adjust camera settings, or when you are searching for batteries or memory cards. Also, some cameras don't have a backlit function for their LCD display, so a flashlight can be a lifesaver when you want to adjust your shooting mode, aperture, ISO or shutter speed.

If your camera has a "Quick Mode" that brings up all the main items that can be adjusted on one screen, that's usually the fastest way to make adjustments. A flashlight can also add a beautiful dappled effect to a scene with or without fireworks when you take long exposures with your camera on a tripod. Finally, a car's headlamps can be used to light the foreground of a scene in interesting ways, and there are multiple intensities that can be used on most cars, from parking lights to high beams.

PRO ASSIGNMENT

CAPTURE SOME EXPLOSIVE FIREWORK IMAGERY

1. Take a series of photos that include some people and the location where you are shooting. These will usually be vertical, but if you are in a location like a baseball stadium, horizontal may work best. Wide-angle lenses will also usually work well in these situations because they provide a wide, sweeping view. A zoom lens allows you to recompose at any time without having to change lenses in the dark.

2. Take a series of photos of just fireworks in the night sky (a lens that can zoom to about 50–150mm in 35mm terms will be necessary for this). Set your camera to ISO 400 (if that produces too much noise with your camera, use ISO 200),

and try the following f-stops and shutter speeds: f/5.6 and f/8 at 2 seconds, 4 seconds, 6 seconds, 8 seconds and 10 seconds. As you get close to the finale, when many more fireworks are launched, shorten the exposure times to about 1/4 second or 1/2 second, or you may just see a big white blob in your images.

3. For exposures over 5 seconds, place a small board in front of the camera in between firework bursts to block most of the extra light coming in between bursts. That way, you can often get multiple, overlapping trails of light that will fill the image.

CONCLUSION

Thank you so much for taking this "Virtual Photo Tour" with me! It's been quite a journey and adventure creating the content, and I hope to hear your thoughts and see some of the images you've created. I also encourage you to review the sections that most interest you, and feel free to ask questions on the book's companion site at www.focusandfilter.com.

ACKNOWLEDGMENTS

It's difficult to fully express the gratitude I feel toward those who have helped make this book possible. There are hundreds of people I could list here who have inspired and/or helped me in some way to be a better photographer and educator. I've also made many lifelong friends by sharing a love for photography with others at workshops, exhibitions, private consulting sessions, industry conferences and other photo-related events. As this is a constantly evolving group, I've created a special acknowledgments page on the book's companion site at www.focusandfilter.com to help express my gratitude.

As a student of photo history and innovation, I thank all those who worked and who continue to work tirelessly to produce the materials and technologies that have allowed me to do what I love. It's easy to forget how far we've come in the fields of digital cameras, lenses, printers, papers, computers and imaging software.

Sincere thanks to everyone at Ulysses Press, starting with Keith Riegert, who reached out to me to discuss writing this book and who helped me get all of the moving parts to come together. It's been quite a ride, but I'm extremely happy I accepted the challenge! Thank you also to Alice Riegert and Renee Rutledge for their outstanding editing and sage advice along the way, and to Jake Flaherty for his magical hand in the layout of the pictures and words. And thank you also to Claire Chun and Molly Conway for their support on other critical parts of the book.

Finally, I would like to thank my family, starting with my mom and dad. They've always been there for me and have supported the vast majority of my decisions along the way (as crazy as they may have seemed at the time!), such as my desire to apply for a scholarship to live and study for a summer in Japan at age 18, which helped instill in me a greater love and appreciation for photography and other cultures. My big brother Matt has also been a guiding light and inspiration to me in so many ways, and I feel truly blessed to have him in my life. There are many other family members who have made a positive difference in my personal and professional life, from uncles to cousins to brothers- and sisters-in-law (you can see many of them in my photographs in this book!). And the dedication at the beginning of

the book expresses my sincere appreciation for my wife Belinda and son Tyler, who have been such an important part of my life.

To say that I'm fortunate to have the support I've had for so many years is an understatement. I sincerely hope that my thoughts, stories and images help inspire you to create photographic memories of those who are important in your life.

ABOUT THE AUTHOR

Andrew Darlow is a photographer, writer and digital imaging coach based in the New York City metro area. His passion is helping passionate photographers of all levels capture, print and protect their photos. He has lectured and conducted seminars and workshops around the world at photo-related conferences and for photography organizations, including: Professional Photographers of America (PPA); PhotoPlus Expo, the Arles Photo Festival (France); Columbia University; and the International Center of Photography (ICP).

His photography has been exhibited in many group and solo shows, and his prints are held in numerous private collections. His articles, tips and images have been included in many publications, websites, books and on-air programs, including *American Photo*, Animal Planet, *People Magazine*, *Photo District News*, photo.net, photofocus.com, *Popular Photography*, *Rangefinder* and *Women's World Magazine*. He's the editor of imagingbuffet.com and is the author of three award-winning photo-related books. For more information, free video and e-book training, and links to his books and websites, visit the book's companion site at www.focusandfilter.com.